SUCCESSFUL
UNDERWATER
PHOTOGRAPHY

For Judi & Terry,

Thanks For Every Thing
& For Saving The Sea!

Brian Skerry

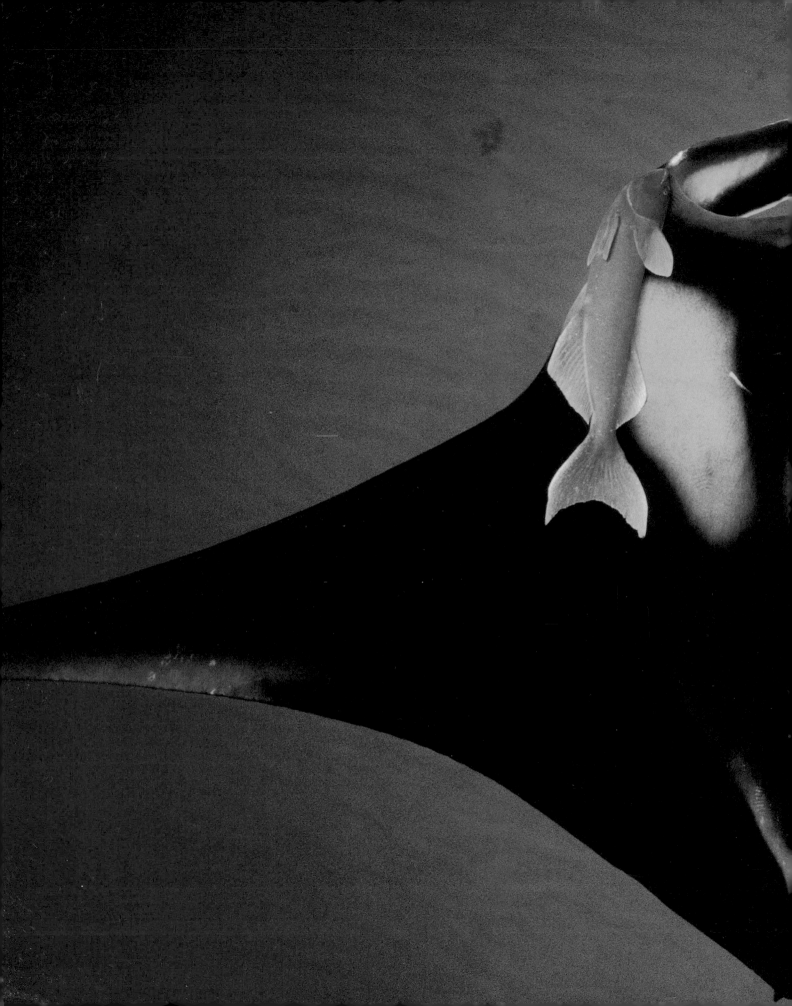

SUCCESSFUL UNDERWATER PHOTOGRAPHY

Brian Skerry
and Howard Hall

AMPHOTO BOOKS
an imprint of Watson-Guptill Publications
New York

ACKNOWLEDGMENTS

I wish to thank and acknowledge a number of people in regards to *Successful Underwater Photography* and in regards to my photographic career.

First and foremost, I wish to thank Howard and Michele Hall for involving me with this wonderful book that I have treasured for so many years. As a friend, I thank Howard and Michele for the beautiful memories and great adventures we have shared. As a fan, I thank them for their lifetime of work. Like so many others I have been continually inspired by the magical pictures they make and the stories they tell of the sea.

Thanks also to Victoria Craven of Watson-Guptill for her enthusiasm and vision for this project from the very beginning. For their help with photographic contributions to this book, I thank Jim Brady and Ethan Gordon.

I wish to also thank a number of people who have profoundly influenced my work and my photographic career. For guiding me to new oceans of possibilities and potential, I thank Kent Kobersteen and Susan Smith of *National Geographic Magazine.* I am deeply grateful for their continued support and for providing the tools required for excellence in photojournalism. Also at *National Geographic,* I owe great thanks to Editor-in-Chief Bill Allen as well as Connie Phelps, Kathy Moran, and Joe Stancampiano.

I owe a tremendous thank you to everyone associated with the Our World-Underwater Scholarship Society for creating unimaginable opportunities. The work this organization does in investing in people has greatly furthered the advancement of marine science and photography. I am grateful for their investment in me and look forward to many years of providing a substantial return on this investment.

To Tom Mulloy and Donnie Nelson, who have assisted me on assignments and who know just how "glamorous" the photo business can be, thanks for endless days of schlepping dive gear, cameras, and lights and for helping me "get the picture." For many, many years of technical support with everything photographic, I thank Fred Dion of Underwater Photo-Tech. The professionalism that Fred and his company have demonstrated has made a world of difference. Thanks also to Frank Fennell for his support in so many ways.

A world of thanks to Steve Drogin for having a heart and soul as big as the sea. Thanks to Bill Curtsinger for years of advice on everything from photo sales to building contractors. Thanks also to David Doubilet for taking the time and for sharing so much (and for appreciating really bad jokes).

Finally, I wish to thank Marcia and Katherine. Because of you, I am able to live my dream.

BRIAN SKERRY
Uxbridge, MA
December, 2001

Title page:
Manta Ray
Brian Skerry

First published in the United States in 2002 by Amphoto Books
an imprint of Watson-Guptill Publications
a division of VNU Business Media, Inc.
770 Broadway, New York, New York 10003
www.watsonguptill.com

Library of Congress Control Number: 2002108832

ISBN: 0-8174-5927-8

Manufactured in England

First printing, 2002

1 2 3 4 5 6 / 07 06 05 04 03 02

Senior Acquisitions Editor: Victoria Craven
Editor: Virginia Beck
Designer: Jay Anning, Thumb Print
Production Manager: Ellen Greene
Typeface: ITC Weidemann

CONTENTS

PREFACE 6

CHAPTER ONE
INTRODUCTION 8

CHAPTER TWO
FUNDAMENTAL
PHOTOGRAPHIC PRINCIPLES 14

CHAPTER THREE
WHAT HAPPENS TO
LIGHT UNDER WATER 26

CHAPTER FOUR
UNDERWATER PHOTOGRAPHIC
EQUIPMENT 34

CHAPTER FIVE
AVAILABLE-LIGHT
PHOTOGRAPHS 48

CHAPTER SIX
SILHOUETTE PHOTOGRAPHS 58

CHAPTER SEVEN
EXTENSION TUBE
PHOTOGRAPHS 66

CHAPTER EIGHT
REFLEX MACRO
PHOTOGRAPHS 78

CHAPTER NINE
MARINE WILDLIFE
PORTRAITS 88

CHAPTER TEN
PHOTOGRAPHING PEOPLE 96

CHAPTER ELEVEN
SHIPWRECK PHOTOGRAPHS 104

CHAPTER TWELVE
CLOSE-FOCUS WIDE-ANGLE
PHOTOGRAPHS 116

CHAPTER THIRTEEN
AUTOMATIC FOCUS
AND EXPOSURE 122

CHAPTER FOURTEEN
SELLING UNDERWATER
PHOTOGRAPHS 130

INDEX 144

PREFACE

I wrote the first edition of *Successful Underwater Photography* back in 1981. That was a long time ago. In fact, I actually wrote the first draft on a typewriter! The book went through two editions and four printings, the last of which was in 1990. During the years that followed, technology raced ahead at warp speed, leaving my simple how-to guide on underwater photography increasingly outdated.

In 1994, my good friends Mike and Lauren Farley, owners of Marcor Publishing, decided that *Successful Underwater Photography* was too antiquated for a fifth printing. I sadly agreed. The Farleys moved on to build a small resort in Baja California. I moved ahead with my film production career, and *Successful Underwater Photography* was left to slowly fade away into sport-diving history. But despite our neglect, the book just wouldn't die.

For years, dealers in sport-diving books called to ask when the book might be reprinted. At trade shows and film festivals, photographers requesting my autograph would present me with dog-eared, salt-stained copies of the book. Many of these people had far surpassed me in underwater photographic skill. Some had even found professions in underwater photography. They all loved the book and claimed it had been influential in developing their underwater photographic talent. And each expressed disappointment when I told them I had no plans to create a third edition. One of these photographers was Brian Skerry. Brian, however, would not accept my abandonment of the book.

Brian Skerry is one of those underwater photographers whose skills and talents long ago surpassed my own. He is widely published and is a regular assignment underwater photographer for *National Geographic Magazine.* I was proud when Brian showed me his tattered, waterlogged, taped-together copy of *Successful Underwater Photography.* When Brian expressed disappointment with my lack of plans for a rewrite, I had a great idea. "Why don't you do the rewrite," I suggested. He was quick to accept the challenge.

This edition of *Successful Underwater Photography* combines Brian's considerable experience and knowledge of current photographic technologies with my popular explanations of underwater photographic technique and composition. It's a combination that Brian and I hope will influence a new generation of underwater photographers in the years ahead.

HOWARD HALL
Author, *Successful Underwater Photography* (first two editions)

Eye of the Whale
Howard Hall

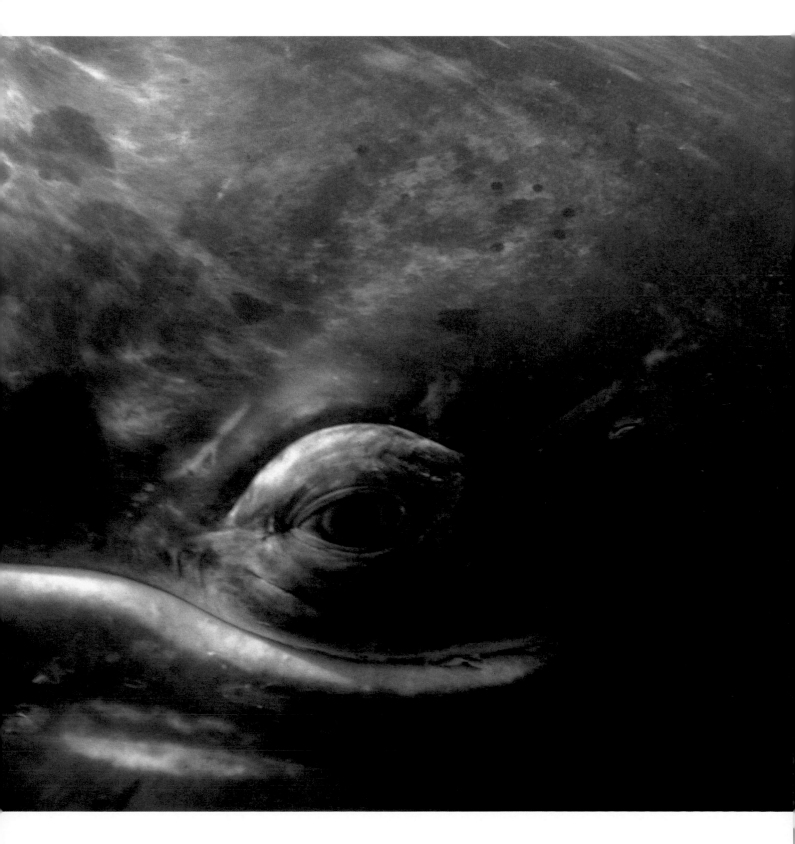

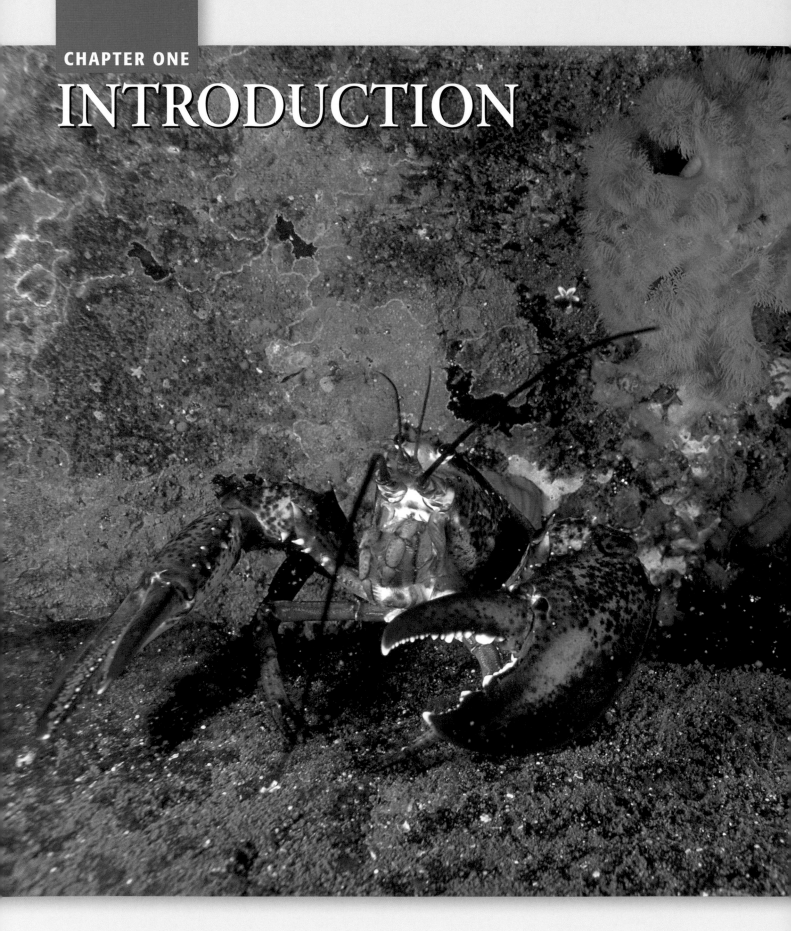

INTRODUCTION

ATRULY NEW IDEA is a very rare thing. The person who invented the wheel had a new idea, and ever since then civilization has been making countless modifications to that idea. The same is true of photography. Most of the beautiful underwater photographs you see published in magazines are not the products of new ideas. Instead, they are the result of old ideas that have been modified. The photographers who make these photographs simply apply well-known underwater photographic techniques to the subjects they encounter. The resulting photo is unique, a work of art perhaps, but the technique is generally as old as the double-hose regulator.

We are not implying that superior underwater photography requires no talent. Certainly, talent is a valuable asset to a photographer. It's what gives you the ability to go beyond merely pushing the shutter, to "seeing" the potential photograph in a subject. Choosing the lens, positioning the strobes, and balancing the exposures are simply the mechanical aspects of techniques that other underwater photographers before you have already worked out through a long process of trial and error. So why try to reinvent these techniques?

If you understand the formulas used to make the various kinds of underwater photographs that you see published, then you should be able to apply those same formulas to familiar subjects of your own. Only then can you test your talent. You do not have to come up with new underwater techniques. You only have to recognize your subject's potential, and then apply the formula.

Keep in mind that experimentation is still useful. Once you have mastered the fundamentals and learned the rules, it is often worthwhile to experiment with breaking them. Oftentimes this is how the most unusual photographs are produced. This rule-breaking technique, however, is only truly effective when it is intentional and can be repeated.

Northern Lobster
Brian Skerry

Northern lobster outside a rocky crevice in Maine.
The pink-colored rock creates a nice backdrop
and provides good separation for this subject.

UNIQUE APPROACH TO UNDERWATER PHOTOGRAPHY

This book describes the techniques that underwater photographers use to make the various types of underwater 35mm photographs that you see published. The 35mm format is the one most commonly used in wildlife and adventure photography, and it is the format most publishers expect to receive from professional contributors. The techniques described in this text, however, can also be applied to other film formats.

The approach used here is different from that taken by many other texts. Rather than discussing in detail everything there is to know about underwater photographic equipment, and then leaving it up to the reader to develop his or her own techniques, we have taken the opposite tack. This text starts with the photographs themselves and discusses the techniques used to create these professional-quality underwater images. It also includes numerous example photographs with specific descriptions illustrating the techniques and equipment used to make them.

Each chapter in this book tells you how to make a specific type of underwater photograph. The photographs have been categorized according to the techniques and equipment used to make them. We invented these category names as a means of breaking the field of underwater photography down into more manageable chunks. In some cases, the category names do not exactly define all the techniques used to make the photographs they describe. They do, however, serve to separate one set of techniques from the next.

There may also be considerable overlap between one chapter and another. A photograph categorized as a wildlife portrait might also be a macro photograph, and a silhouette is certainly an available-light photograph. Still, there are certain techniques that separate the material in each chapter from the next. These will become apparent as you read through the text.

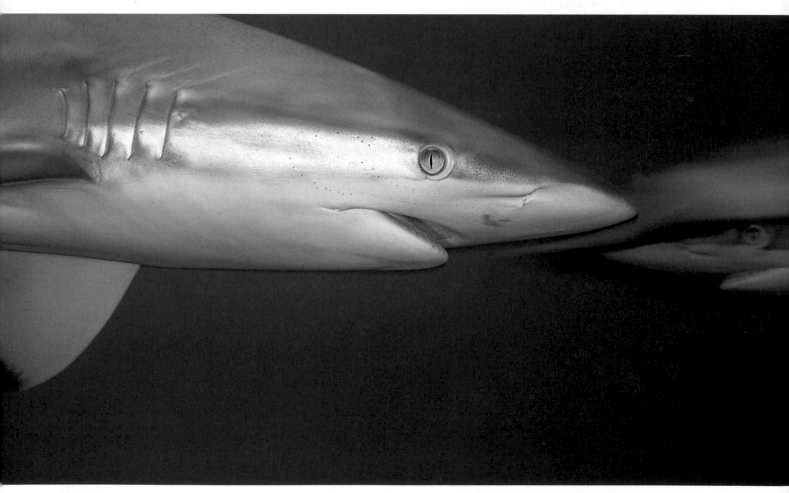

Silky Sharks
Brian Skerry

Once you have mastered the fundamentals of underwater photography, you can experiment with your own techniques to create new perspectives in your photographs.

THE LIMITATIONS OF EQUIPMENT

The ability to recognize what kind of equipment made a photograph is fundamental to your ability to evaluate it. Similar photographs must be made with similar equipment. Chapter 12, "Close-Focus Wide-Angle Photographs," shows particularly good examples of this need to know. These photographs were made with super-wide-angle lenses focused at nearly a foot, with an extreme upward camera angle, using a wide-angle strobe and an aperture setting of $f/8$ to $f/22$. This is a popular technique that produces beautiful photographs. The key ingredient is the super-wide-angle lens.

If you were to attempt to duplicate this technique with a Nikonos 35mm lens, however, you would be disappointed. The 35mm lens is good for several kinds of underwater photographs, but it cannot be used to make close-focus wide-angle (CFWA) photographs. If you did use the 35mm lens, you would probably get an image. But it would probably be soft, with poor perspective and poor colors, and it would almost certainly be a disappointment compared to the CFWA photographs that you see published.

It is probably best to approach underwater photography in one of two ways. The first is to evaluate a photograph that you like, then buy or borrow the equipment the specific formula requires. The second approach is to choose ideas with equipment requirements that lie within the limitations of the gear you have.

If, for instance, you have a Nikonos, a 35mm lens, and a small strobe, it's a better idea to work on photographs that this system is capable of producing well rather than trying several ideas without the proper equipment and obtaining consistently poor results.

The chapters in this book evaluate different types of underwater photographs that all require different camera systems. Reading these chapters, you should be able to decide what photographic techniques fall within the limitations of your equipment. Or, if you really like an effect that you are not presently equipped to work on, you can determine what you need to add to your system.

Chapter 4, "Underwater Photographic Equipment," includes photographs and descriptions of the equipment that are referred to in this book. It is a helpful reference designed to give you a better knowledge of the types of equipment discussed throughout this text. It can also give you a good idea of the variety of equipment available on the market so that you can better evaluate and determine the needs of your own system as your knowledge and expertise in underwater photography increases.

Male Lumpfish
Brian Skerry

Using a 60mm macro lens provided a close-up view of a male lumpfish aerating a clutch of eggs beneath a rock in the Gulf of Maine.

HOW TO USE THIS BOOK

The first time around, you should read the chapters in this book in sequence. Although an in-depth knowledge of photographic principles is an advantage to the underwater photographer, it is not entirely necessary for making professional-quality photographs. If you already have an understanding of basic photographic principles, you can skip Chapter 2, "Fundamental Photographic Principles." If, however, you are not sure what an *f*-stop is, then Chapter 2 is a must. If you are just starting out, Chapter 2 contains enough information to enable you to understand and employ all the techniques described in the chapters that follow.

After you've read this book through the first time, you will have an understanding of how to evaluate most underwater photographs. Try paging through a diving magazine to evaluate some of the photographs you see. Choose a photograph you like, then go back and study the chapter in this book that deals with that type of photograph. Make sure that particular kind of photograph falls within the limitations of your own underwater photographic equipment.

Next, begin thinking about what subject material there might be in your area that would lend itself to that kind of photograph. Then try your skills under water. Use an entire roll of film concentrating on that specific type of photo (instead of snapping photos of everything that swims by).

After processing your images, use your evaluation skills on yourself to locate any errors you may have made. Continue to work on that type of photograph before you move on to another type. In no time at all, your results will be of publishable quality.

PHOTOGRAPHIC EVALUATION

Each example photograph in this book is accompanied by a detailed evaluation of the techniques used. Once you have studied these chapters, you should be able to recognize the same techniques when paging through a diving magazine. In fact, you should be able to categorize nearly any published underwater photograph you see. You should be able to evaluate, in detail, the equipment that was necessary to make the photo and the techniques that were employed. You will then have developed the skill of photographic evaluation, an extremely important skill for any photographer.

Once you are skilled at photograph evaluation, the pages of diving magazines will hold few mysteries for you. You will know how to duplicate the results you see and, given similar subject material, you will be able to create photographs of equal quality. Soon every underwater photograph you see will become a stimulus for new ideas. You will see a photo that you like, evaluate it, and begin thinking of familiar subjects in your diving area to which the formula can be applied.

Northern Anemone
Brian Skerry

This northern anemone was framed in a way that draws the viewer's eye into the picture.

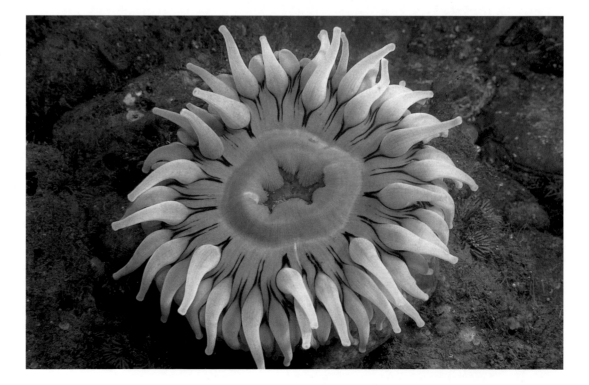

Florida Manatees, Florida
Brian Skerry

Marine mammals such as manatees are photo subjects with tremendous appeal.

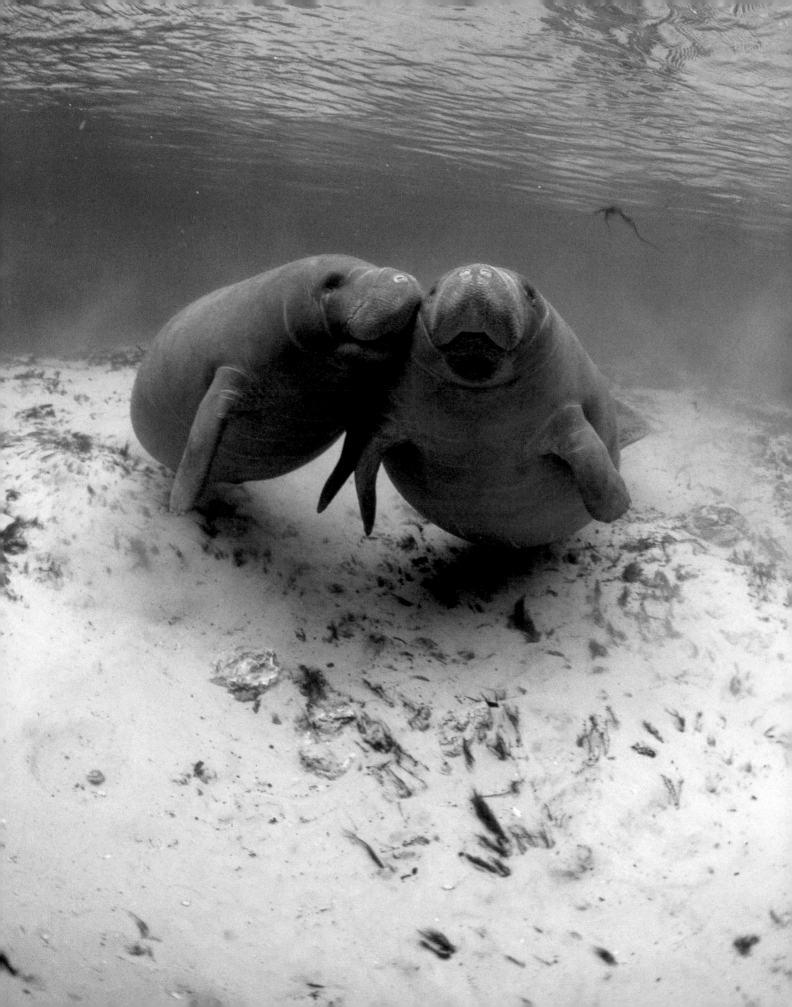

FUNDAMENTAL PHOTOGRAPHIC PRINCIPLES

THE TECHNICAL INFORMATION available on photography fills whole volumes. The complex nature of optics, camera movements, electronics, and film emulsions (not to mention the ever-changing technology of digital photography) often goes beyond the interest of most people. A good underwater photographer does need to know what an *f*-stop is (at least in a basic way), but you can get by quite successfully without knowing very much more.

Some photographers will overwhelm you with what they know (and what you do not know) about such things as emulsion reticulation, hyperfocal distance, and barrel distortion, but their knowledge does not necessarily make their photographs any better than yours. The real talent in underwater photography is in "seeing" the potential photograph in a subject, not in what you can memorize from a technical manual.

This is not to imply that the study of technical photographic literature will not enhance your photographic abilities. It simply means that you only really need the following three basic things to make excellent, professional-quality underwater photographs:

- A working understanding of a few important photographic principles governing exposure, depth of field (focus), and lens angles.

- An understanding of what happens to light under water (discussed in Chapter 3, "What Happens to Light Under Water").

- The ability to evaluate the underwater photographs you see published in order to apply similar techniques to your photography.

Grunt School
Brian Skerry

School of grunts
photographed in Cuba.

EXPOSURE

Three things determine your ability to achieve the proper exposure on the film: film speed (ISO rating), shutter speed, and lens aperture (*f*-stop, also called the *f*number). You make proper exposures by manipulating these three factors in a way that is very uncomplicated (especially under water).

FILM SPEED

Film speed is a measure of the film's sensitivity to light. It is represented on all kinds of film as an ISO rating (formerly called the ASA number). ISO numbers serve to compare one film to another, providing an index for setting your light meter. The higher the ISO number, the more sensitive the film is to light. A film with twice the ISO number as another film is twice as sensitive. Therefore, an ISO 100 film is twice as sensitive (twice as fast) as ISO 50 film, and so on.

You can choose from many different films for general photographic purposes. Most professional underwater photographers, however, choose to use a relatively limited number of color slide films. As a rule, most publishers prefer seeing and publishing color slides (transparencies), and the publisher's preference is an important consideration for professionals and aspiring pros. Also, it is much less expensive to develop slides than it is to develop negative film and then make prints (especially since about three out of four of the photos you and I shoot end up in the round file). If you want to make a print from one of your slides, a professional lab can easily do it.

The choice of what film to use for underwater photography essentially comes down to personal preference. Most professionals prefer films with fine grain (tiny grains of light-sensitive material within a film emulsion), especially for wildlife photography. It's generally true that the slower the film, the finer the grain. Film technology has improved greatly in recent times, however, providing a much wider range of acceptable choices. If you are just starting out, you should select one film and stick with it until you find a good reason to change. By staying with one film you can better measure your results when attempting various techniques.

Color rendition and reproduction are also important considerations. Certain films tend to favor warmer colors, such as reds and yellows, while other films lean more toward blues and greens. Some of the most popular films used by professional underwater photographers include Fuji Velvia (ISO 50), Fuji Provia (ISO 100), Kodak Kodachrome (ISO 64), and Kodak E100VS (ISO 100).

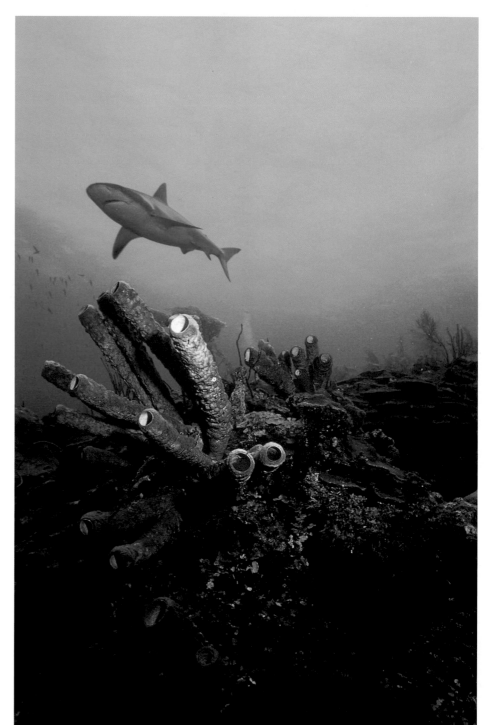

Caribbean Reef Shark
Howard Hall

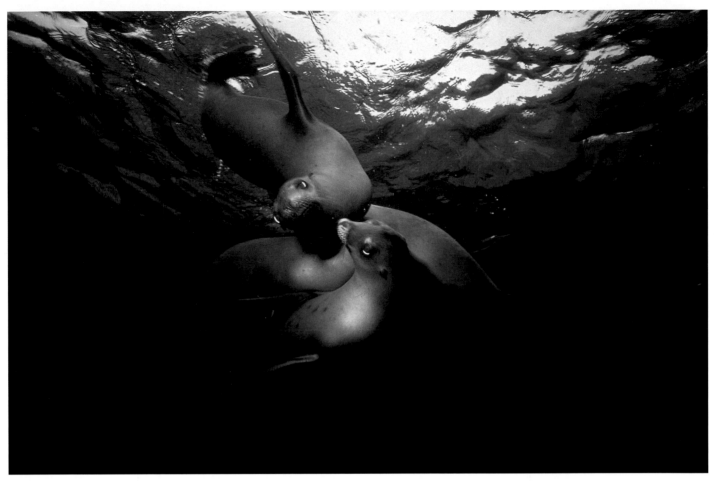

California Sea Lions
Howard Hall

SHUTTER SPEED

The second factor in determining exposure is shutter speed. Shutter speed determines how long the shutter stays open and allows light to reach the film. The shutter speed numbers you will see on your camera include 30, 60, 125, 250, and so on. These numbers mean that the film is being exposed for 1/30 of a second, 1/60 of a second, 1/125 of a second, and so on, depending on the number you choose. When you change from one number to the next, you are either halving or doubling the amount of light that hits the film. For example, 1/30 is twice as long as 1/60, and 1/250 gives you half the exposure of 1/125.

In general, faster shutter speeds have two basic advantages. At a faster shutter speed, you will stop the action of the subject (should the subject be moving), and you will minimize blurred pictures resulting from camera motion. Camera motion is usually a much bigger problem for novice underwater photographers,

who often get bounced across the bottom by water motion. If the camera is moving very much when you shoot, especially at slow shutter speeds, the photo may be blurred. It is therefore a good idea to try to hold the camera still. Subject motion under water is not as great a problem as camera motion, since most marine animals move relatively slowly and the density of the water tends to buffer sudden movements.

The most important factor to keep in mind when determining the shutter speed is the fact that, depending on camera design, strobes only synchronize with the camera at certain shutter speeds. The Nikonos 5, for example, syncs at 1/90 of a second. Older Nikonos cameras, such as the Nikonos II or Nikonos III, have sync speeds of 1/60 of a second. Many newer single-lens reflex (SLR) cameras, which can be used in underwater housings, have much faster syncs, such as 1/250 of a second. Keep in mind that the sync speed refers only to the *fastest* shutter

speed that can be used with strobes. You can use any *slower* shutter speed and still maintain proper strobe synchronization.

Occasionally, when photographing very fast-moving animals, like dolphins or sea lions, you may wish to forego the strobe and use a higher shutter speed to stop the action, especially if your camera's sync speed is fixed at 1/60 or 1/90 of a second.

The duration of the strobe flash is very short, only 1/1000 of a second in some cases. When photographing close subjects, where the strobe is your primary light source, the short duration of the flash will do an excellent job of freezing the motion. In this case, the slowness of your shutter speed is relatively unimportant.

In determining exposure, then, you have selected your film speed and determined your shutter speed. That leaves only one thing to worry about in order to get the right exposure under water: aperture.

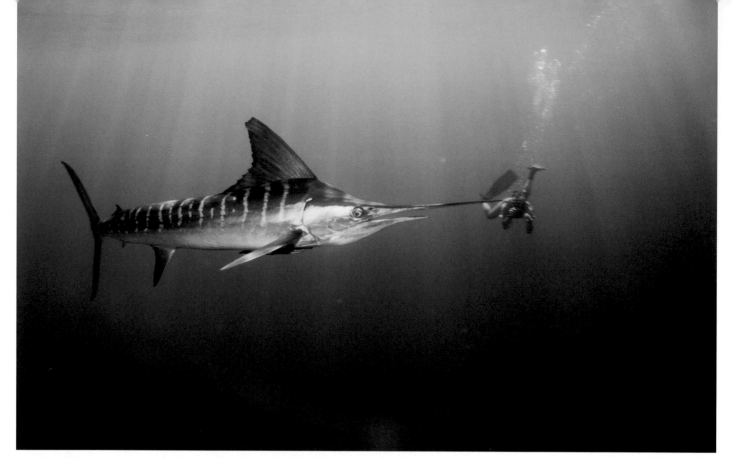

Striped Marlin
Brian Skerry

A faster shutter speed (1/125 in this case) helps freeze the action in encounters with fast-moving animals like this striped marlin.

APERTURE

The aperture is the size of the hole within the lens assembly that allows light to pass through to the film. You set the aperture by turning a control that adjusts an iris. The size of the hole, or aperture, is measured in *f*-stops, or *f*-numbers. You determine the aperture you need in one of two ways: either by checking a light meter, or by consulting strobe guide numbers (if, of course, you are using a strobe).

The *f*-stop reflects the number of times the aperture diameter can be divided into the focal length of the lens (where focal length is the distance from the center of the lens to the film). You do not have to remember that, but it might help you to understand why *f*-numbers seem to be so odd.

As with shutter speeds, when you change *f*-stops from one to the next, you either halve or double the amount of light that reaches the film. At *f*/5.6, you pass twice as much light to the film as you do at *f*/8; *f*/16 passes half as much light as does *f*/11.

If you change your *f*-stop by one stop, changing your shutter speed by one position can compensate for the change. Thus, *f*/8 at 1/60 is the same exposure as *f*/5.6 at 1/125.

RECIPROCALS FOR *f*-STOPS AND SHUTTER SPEEDS

Assuming a constant light source, each of the following combinations of *f*-stop and shutter speed settings will produce the same exposure. The camera's ability to stop, or freeze, the action of its subject varies with its shutter speed. The depth of field the camera is able to capture varies with the *f*-stop settings.

f/2.8 at 1/500

f/4.0 at 1/250

f/5.6 at 1/125

f/8.0 at 1/60

f/11.0 at 1/30

f/16.0 at 1/15

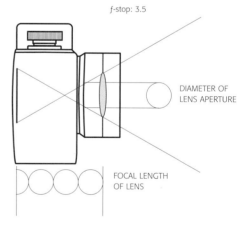

f-stop: 3.5

DIAMETER OF LENS APERTURE

FOCAL LENGTH OF LENS

f-stops are derived by dividing the diameter of the lens aperture into the focal length of the lens.

LIGHT METERS

Light meters are designed to measure ambient light. Your meter might be a separate, handheld device, or it might be contained within the camera itself. With most meters you simply set the ISO setting for the film you are using, set your desired shutter speed, and let the meter determine the proper f-stop as it measures the light. Or you can set the f-stop and let the meter determine the proper shutter speed.

Most cameras used today in underwater photography have built-in meters. This is especially true of SLRs used inside housings, which incorporate through the lens (TTL) metering. Using an SLR camera's meter allows you to continually monitor ambient light levels through the viewfinder while composing and focusing on your subject.

There are two types of light meters, incident and reflective. Incident meters measure the light falling on a subject. Reflective meters measure the light reflected from a subject. The light meters contained within cameras are reflective. You simply point the camera (lens) at your subject and read the meter.

Light meter technology has improved greatly in recent times. New metering systems are now capable of measuring overall scenes more accurately. While it is not crucial to understand all of the intricacies of light metering, it is worthwhile to have a working knowledge of your own camera's type of meter. Perhaps the most important thing you can know in this regard is exactly how much of the scene you are metering.

Reflective light meters can be set to measure various percentages of your overall scene. There are three common designations: spot, center-weighted, and matrix. Each of them reads different amounts of reflected light.

TYPES OF REFLECTIVE LIGHT METERING

Spot Metering
Spot metering is exactly what the name implies. The meter measures only a small area or spot of your subject. With spot metering, nearly 100 percent of the meter's sensitivity is concentrated within a 4mm-diameter circle representing about 1.5 percent of the entire frame area. With spot metering, then, you are measuring the reflected light of a very focused region of your subject.

Center-Weighted Metering
Center-weighted metering expands the measured area. Typically, center-weighted metering concentrates approximately 75 percent of the meter's sensitivity within an area in the center of your frame and the other 25 percent outside this circle.

Matrix Metering
Matrix metering involves an averaging of the entire frame seen through your viewfinder. When set to matrix, the camera's meter measures reflected light from corner to corner, placing the most emphasis, however, on the center region. Matrix metering can be extremely useful in surface photography when light is uneven or there are multiple subjects, each with various degrees of reflectivity.

Under water, we are most often metering the background water in order to produce the most pleasing overall color to the photograph. We need only point the meter (or camera) at the water behind our subject to obtain a reading. For this reason, either spot metering or center-weighted metering tends to work best. Matrix metering certainly can work well, but since we only need to measure ambient light levels of background water, matrix metering has the potential to read more of the scene than we want it to.

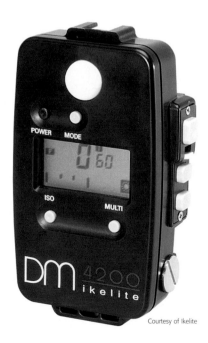

Courtesy of Ikelite

Ikelite Light/Flash Meter

Using a separate light meter is a good way to double-check your camera's meter. This meter, manufactured by Ikelite, can be used in reflective or incident modes. It also can be used as a flash meter to measure strobe light.

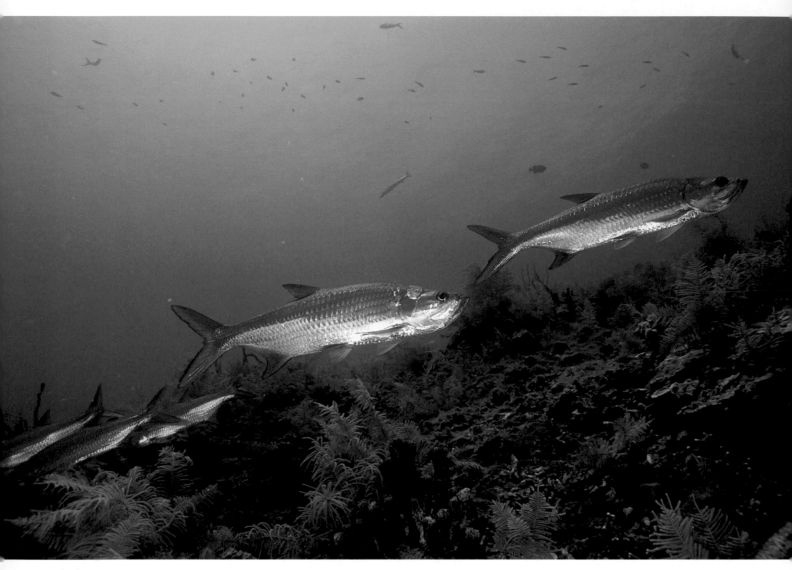

Flashy Tarpon

Brian Skerry

With highly reflective fish, like these tarpon, only a small amount of strobe light
is required to bring out the subject's detail.

GUIDE NUMBERS

If you are using a strobe as your primary light source (as opposed to available light), you will use guide numbers to calculate your f-stop settings. The strobe manufacturer usually supplies these numbers, which are determined by the brightness of the strobe and the power setting on the strobe you select. You use the guide numbers to tell you what f-stop to use when your subject is a certain distance away.

Above the water's surface, light from a strobe loses intensity in a geometric fashion as distance increases. The strobe manufacturer supplies a specific guide number with the strobe, which can then be divided by the strobe-to-subject distance to give you your f-stop. For example, let's say the supplied guide number is 80, and you intend to take a photograph from 10 feet away. You divide the guide number (80) by that distance (10). This gives you the correct f-stop, which in this case would be $f/8$.

Under water, this system does not work as well because the way water absorbs and disperses strobe light cannot be measured in the same geometric fashion. Underwater guide numbers are determined by testing the strobe at various ranges to determine the proper f-stop for specific distances.

Underwater strobes are seldom effective at distances greater than 8 feet (as the next chapter explains). That means you only have eight numbers to memorize or to write on the side of your strobe or camera housing for reference. Remember that variables such as water clarity and subject reflectivity can influence results.

Guide numbers calculated in tropical coral reef areas could need to be increased by a full f-stop in the darker waters of northern climates. Manufacturers' guide numbers might be a good place to start, but you will need to refine those numbers with tests you make yourself.

The following list gives typical guide numbers for ISO 50 film and an average underwater wide-angle strobe:

1 foot	$f/22$
2 feet	$f/11$
3 feet	$f/8$
4 feet	$f/5.6$
5 feet	$f/4$
6 feet	$f/2.8$

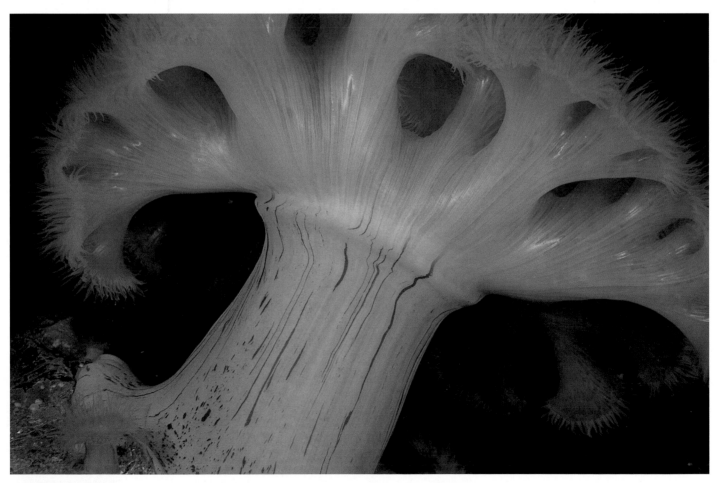

Metridium Anemone

Brian Skerry

With most subjects, such as this anemone, shutter speeds of 1/60 are perfectly adequate to create sharp photographs.

FOCUSING

There are two ways that you can focus on a subject, depending on the type of camera system you are using. If you have an SLR camera with TTL viewing, then you just look through the lens, adjust the focus control until the image in the viewfinder is sharp, and take the picture. If you have a Nikonos or Sea & Sea camera, you must decide how far away the subject is from you, set that estimated distance on the lens, and then take the picture.

Sometimes this latter method becomes a little confusing because water refraction through the mask makes things look closer than they actually are. So what do you do? Do you set the focus at the distance the subject appears to be or at the distance you think it is after taking refraction into consideration? This problem is further compounded by the fact that many experienced divers automatically compensate in their minds for the distance variation and generally see things at their actual distance.

The best answer to the problem is simply not to worry about it. Set the focus for the apparent distance and do not try to analyze it. Generally this setting will be close enough. If your first roll of film reveals a tendency to focus too far away or too close, then you can compensate on your next try.

Blue Shark Pair

Brian Skerry

This pair of blue sharks was photographed just below the surface of the water. The camera angle was nearly straight upward and the f-stop and shutter were set to expose for ambient light. Only a little fill flash was used to illuminate the shark's face.

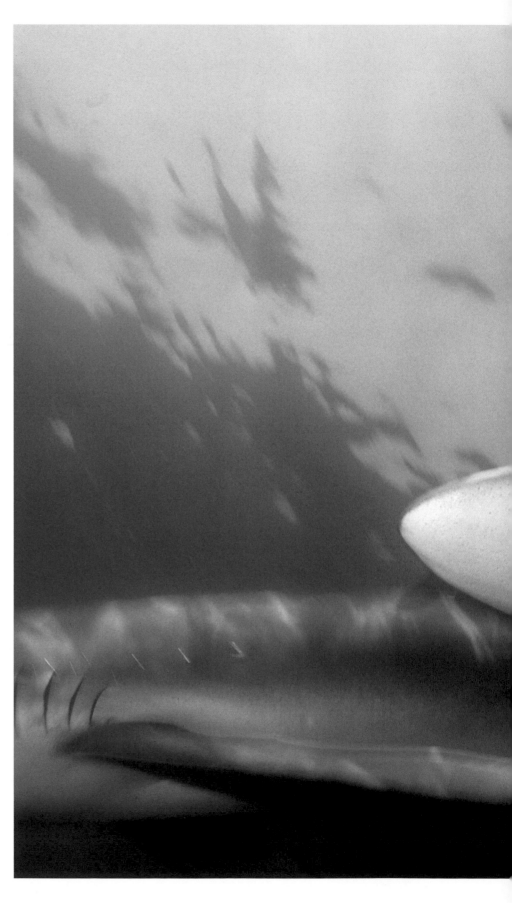

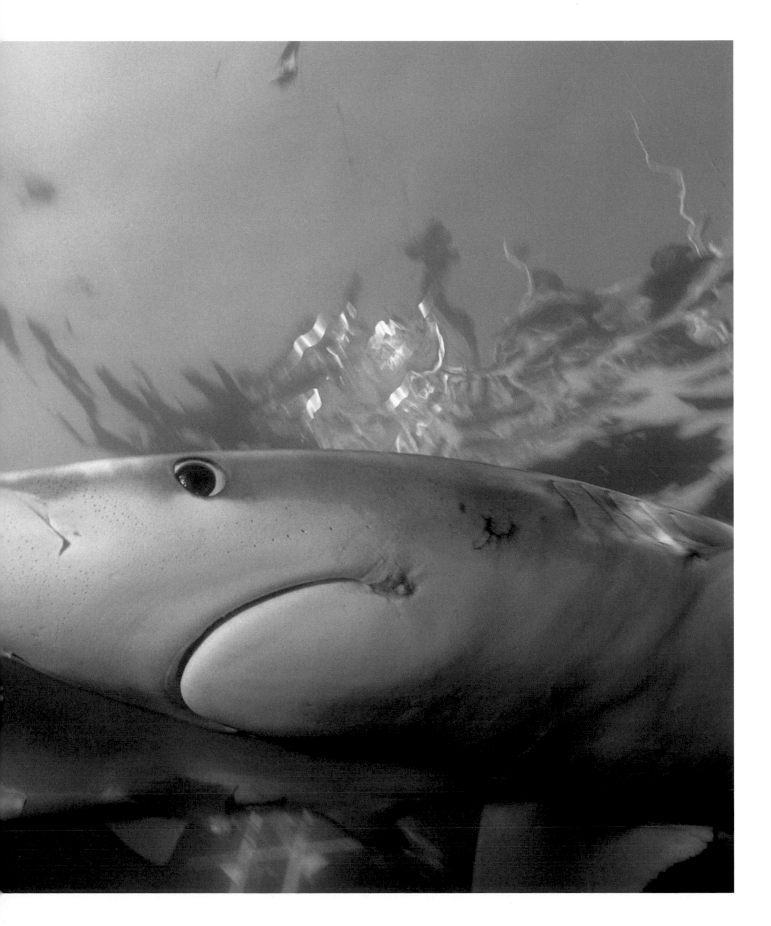

DEPTH OF FIELD

You will seldom be accurate in estimating distances under water, but much of the time the lens depth of field will negate your error. The term "depth of field" refers to how much of the area in front of the lens is in acceptable focus. Your depth of field varies with the lens aperture you select. On Nikonos lenses, depth of field is indicated by two red indicators that change with aperture adjustment.

A Nikonos 35mm lens at $f/8$ and set on a focus of 5 feet will yield a depth of field from 4 to 7 feet. In other words, objects are in focus as little as 4 feet and as much as 7 feet in front of your lens. The smaller the aperture you use, the greater your depth of field. At $f/16$ on a Nikonos 35mm lens set at a focus of 5 feet, for instance, your depth of field ranges from 3½ feet to 12 feet.

Depth of field also varies with the lens you choose. The wider the lens angle, the greater the depth of field you will get. For example, as noted above, the Nikonos 35mm lens set at $f/8$ and focused at 5 feet has a depth of field of 4 to 7 feet. However, the Nikonos 28mm lens (about 30 percent wider) set at the same focus and aperture has a depth of field of 3½ feet to 9 feet.

For most photography with Nikonos lenses, it is best to set the lens at focus settings that maximize the depth of field. For example, if you are shooting subjects at near infinity, set the lens so that the infinity symbol is just inside the depth of field indicator. This will maximize the area before the lens that will be in focus. This is especially helpful when photographing moving subjects.

This photograph illustrates the difference in depth of field between the Nikonos 28mm and 35mm lenses using the same focus and aperture settings.

Jim Brady

Depth of field will vary with the lens aperture setting that you choose.

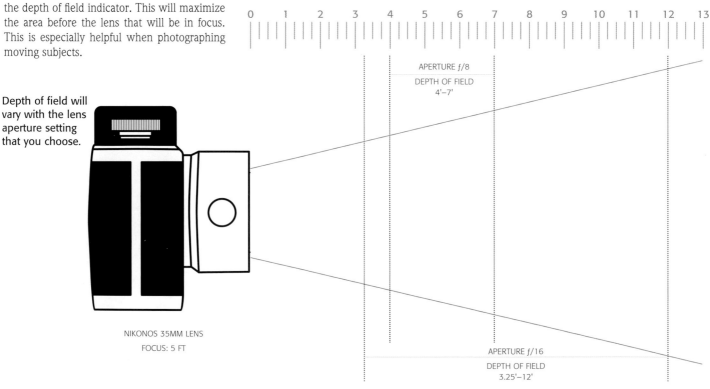

NIKONOS 35MM LENS
FOCUS: 5 FT

APERTURE $f/8$
DEPTH OF FIELD
4'–7'

APERTURE $f/16$
DEPTH OF FIELD
3.25'–12'

LENS ANGLE

A wide variety of lenses can be used for underwater photography. By studying this book and learning how to evaluate photographs, you can determine what lens you need in order to duplicate an effect you see here or in a magazine.

Generally, underwater photographs can be broken down into one of two categories in regards to lenses. Either they are macro photographs or they are wide-angle photographs.

Macro photography is covered in Chapter 8, "Reflex Macro Photographs."

When making wide-angle photographs, your choice of lens will have a great influence on the effects you can produce. You will gain an understanding of the effect lens angle has on photographs as you study the remainder of this book. It may be helpful, however, to compare the various wide-angle lenses available.

It's generally true, except in the case of some of the ultra-wide-angle lenses like the Nikon 16mm, that the greater the lens angle, the shorter the focal length of the lens. Lens angles are measured from corner to corner on the transparency. The following illustrations show how various common underwater lenses compare, according to lens angles. All of the photos were taken at a distance of 4 feet.

60mm lens

35mm lens

28mm lens

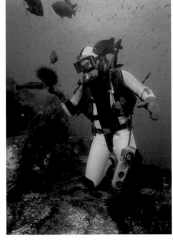

15mm lens

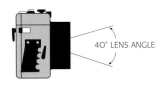

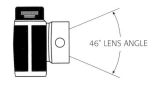

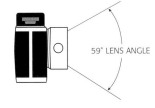

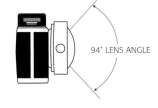

40° LENS ANGLE

46° LENS ANGLE

59° LENS ANGLE

94° LENS ANGLE

A comparison of common underwater lenses (all at a distance of 4 feet).

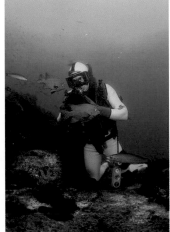

16mm lens

Howard Hall

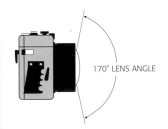

170° LENS ANGLE

WHAT HAPPENS TO LIGHT UNDER WATER

BEFORE YOU TRY to employ the techniques for making underwater photographs given in the following chapters, it is important for you to become familiar with the special properties of light under water and the limitations that these properties place on underwater photography. Although there are countless similarities between topside and underwater photography, there are also some major differences. In some ways, underwater photographic techniques are the opposite of topside techniques. The choice of lens angle is a good example of this.

In topside wildlife photography (as well as many other kinds of above-water photography), the telephoto lens is a primary tool. The idea is to use a telephoto lens to photograph an animal that is far away so that the animal in the photograph appears close up. Much of the time this is the only way you can get close to certain species of wildlife.

Under water, however, you do just the opposite. You start by getting close to the animal, and then you use a wide-angle lens to make it look farther away. There are several properties of light under water that makes this reverse approach necessary. It would be nice to be able to make telephoto pictures over long distances under water, but for several reasons (some obvious) it does not work.

Disappearing Humpback
Brian Skerry

Humpback whale off of Middle Caicos Island. Photographed using available light and a 20mm lens inside a housing.

GENERAL PROPERTIES OF LIGHT UNDER WATER

The unique qualities of underwater photographs are the result of the way light travels and behaves in the medium of water. Most of its underwater qualities are the same as what we see above water—we're familiar with the concept of refraction, for instance. As the underwater photographer will discover, however, the eye and the camera can sometimes see different things. If you understand what happens to light when it travels through certain depths or distances of water, you are less likely to be fooled by what you see and more likely to capture a great underwater image.

REFRACTION

Refraction creates a few minor problems for underwater photographers. The confusion it creates in estimating distance makes focusing with a rangefinder camera (like a Nikonos or Sea & Sea camera) a little frustrating at first. But with a little practice it is not difficult to get the hang of it. Refraction also creates some minor optical problems for cameras used in underwater housings. In addition, refraction sometimes makes the faces of people look distorted behind their masks.

The distortion of faces behind diving masks is caused by the bending of light as it passes from the air in the masks, through the glass, and into the water. The more the subject is turned away from the photographer, the greater the distortion. To minimize this problem, it is best to have your subject keep his face turned as much toward the camera as possible.

If you have a camera in an underwater housing, it may be of some value to understand the optics of dome versus flat ports. (The port is the part of the housing that the lens looks through.) Since nearly all professional-quality housed-camera systems are "through the lens" viewing systems, you will not have to worry about estimating distance when focusing. You will, however, notice some differences between dome ports and flat ports when it comes to focusing and image size.

A flat port is subject to refraction in the same way as your facemask. It tends to make things look (to the lens) about 25 percent larger and closer than they look to the naked eye. This effectively reduces the picture angle of the lens, making a 28mm lens take photographs with the picture angle of a 35mm lens.

Refraction through flat ports also tends to distort the edges of wide-angle photographs. Therefore, wide-angle lenses should be used behind dome ports. Dome ports allow the wide-angle lens to retain its full picture angle as well as prevent edge distortion.

Macro photography, on the other hand, may be more effective from behind a flat port, since refraction through the port gives you increased magnification. Macro photography can be done behind a dome port also, but if you can focus down to an image 3 inches across with a dome port, then you will be able to focus down to an image 2 inches across with a flat port. The flat port allows you to photograph smaller subjects more effectively.

SCATTER

If you look at distant mountains on a hazy day, especially through binoculars or a telescope, you will notice that the image is not well defined. This loss of definition is due to scatter. The path of light approaching you is altered, or scattered, as it travels through the suspended moisture and dust in the air, as well as by variations in air density. By the time light reaches you from the mountains, it has been scattered quite a bit, and the image has lost its sharpness and detail.

The same thing happens under water, only to a much greater extent. You may think that 200-foot visibility is clear water, but compared to water beneath polar ice, where visibility is in excess of 800 feet, the best tropical water would be considered murky. Even at 200-foot visibility, a lot of suspended material is floating around that can scatter images. Scatter can affect subjects only a few feet away and make them begin to lose sharpness and detail in your photographs.

The impact that scatter has on underwater photography is enormous. It is one of the pri-

LOSS OF LENS ANGLE
DUE TO REFRACTION

FLAT PORT

DOME PORTS MAINTAIN
LENS ANGLE BY CORRECTING
FOR REFRACTION

DOME PORT

The designs of flat and dome ports influence light refraction and, therefore, the amount of light that reaches a lens through each type of port.

DOME PORTS AND VIRTUAL IMAGE

The dome port is not a simple window. It acts as an additional optical element to the lens and has specific optical properties of its own. Although the dome port allows the lens to retain its full picture angle, it creates an image that the lens sees only a few inches outside the dome. This is called the "virtual image." The lens must be capable of focusing on this image.

For a subject focused at infinity, the virtual image is generally located at a distance twice the diameter (or four times the radius) of the dome away from the focal plane (where the film is). If your housing uses a five-inch dome, the virtual image will be ten inches from the focal plane. If the wide-angle lens you are using does not focus that close, you will have to add a diopter, or close-up lens, to the front of the lens to bring the focus in closer.

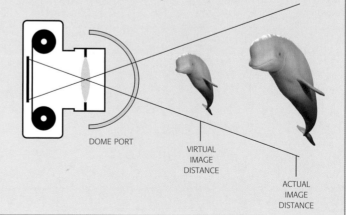

The image size you capture will differ depending on whether you use a flat or dome port.

DOME PORT

VIRTUAL
IMAGE
DISTANCE

ACTUAL
IMAGE
DISTANCE

mary reasons that wide-angle lenses are so important for the underwater photographer. It is also the reason that telephoto lenses are nearly useless under water. An image photographed with a telephoto lens from 50 feet away in 200-foot visibility will have almost no sharp detail.

A wide-angle lens would produce similar results from 50 feet, except that you would almost never use one at that range. Subjects photographed from only 20 feet in clear water are seldom very sharp. In order to get sharp images, even in clear water, you must get close to your subjects. The closer you can get, the better.

COLOR ABSORPTION

Color absorption is a major problem for underwater photographers. As light penetrates water, some of it is absorbed. But it is not absorbed evenly across the color spectrum. The long wavelengths of light (toward the red end of the spectrum) are absorbed faster than the short wavelengths (at the spectrum's blue end). By the time you have descended 30 feet, you will have difficulty seeing any red color. But this loss of red light does not suddenly take place at 30 feet; it begins within inches of the surface. Even a few feet down, colors are severely distorted toward the blue end.

Your brain has the ability to compensate for a large amount of this color distortion, so that at depths of even greater than 30 feet you can still see bright colors. Film, however, does not have this compensating ability. The film you will be using is balanced for daylight, which means that it will produce natural colors when exposed by light of very specific color proportions—the proportions found in sunlight. If you alter the balance of those colors very much, the colors in the photograph will appear very strange. You may have noticed this effect if you have ever seen pictures taken indoors under tungsten lights with film balanced for daylight. The colors appear very orange and entirely unsatisfactory, even though the light looked fine when the photo was taken.

The same kind of color imbalance occurs immediately below the surface in underwater photographs. At a depth of just 10 feet, colors that seem bright to the eye will appear blue and washed out in your photographs. Your eye compensates for this color loss, but film is incapable of doing so.

In order to combat this problem you must do one of three things. You can take the photo in extremely shallow water, perhaps using a color correction filter. You can use artificial light (that is, a strobe). Or you can make a kind of photo in which color contrast is not important.

HORIZONTAL COLOR LOSS

Color is not only absorbed as it passes vertically through water but horizontally as well. Although this seems obvious, it seldom occurs to novice photographers. If you do decide to shoot photographs in 10 feet of water or less, you still must get as close to your subject as possible in order to obtain good colors.

If the subject is 10 feet away from you, even in 6 feet of water, you will have very few warm colors in your photos since light must travel 6 feet down and then 10 feet from the subject to the lens. This is a total of 16 feet, enough to filter out nearly all of the warm colors from your image.

In order to get good colors under water, you must get close to your subjects. This is true whether you're shooting available light photographs in three feet of water or using a strobe in deeper water. This is seldom a problem with macro photographs, but when photographing divers, seascapes or large animals, it means you must use as wide a lens as you can.

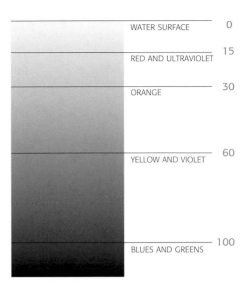

WATER SURFACE	0
RED AND ULTRAVIOLET	15
ORANGE	30
YELLOW AND VIOLET	60
BLUES AND GREENS	100

As light filters from the surface down through the water column, different wavelengths (or colors) of light are absorbed.

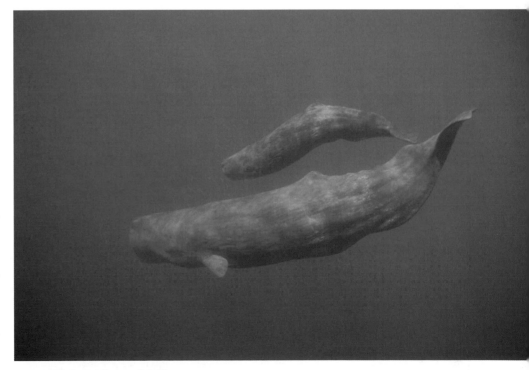

Sperm Whale Mother and Calf
Brian Skerry

The sperm whale mother and calf were approximately 20 feet away when this picture was made. Clear Azorean water and a 24mm lens behind a dome port delivered the results.

STROBES

Photographers use three sources of artificial light: movie/video lights, flash bulbs, and strobes. The most practical selection for the underwater still photographer is strobes.

Whenever you see an underwater photograph taken in more than a few feet of water that has any warm colors or any color contrast at all, you can assume that an underwater strobe was used. Often the artificial lighting in the photos you see published is very subtle. All the warm colors are there, but it is not obvious that a strobe was used to illuminate the subject. This is exactly the effect that the photographer wanted to create.

In wide-angle photographs, a strobe is often used only to "paint" in the colors that would not otherwise be there. Recognizing whether artificial light was used is an important ability to learn in evaluating underwater photographs.

Horizontal color loss decreases the effectiveness of underwater strobes beyond 8 feet, regardless of their power. When you use a strobe to photograph a subject 8 feet away, the light must travel 8 feet from the strobe to the subject and then an additional 8 feet from the subject to the lens. Again, this is a total distance of 16 feet, and you will lose many of your warm colors.

COLOR AND EXPOSURE

Strobes are used to do one of two things for an underwater photograph. They can either add colors to a photo that would otherwise have been monochromatic (blue in this case), or they can add exposure as well as colors.

In the first case, a strobe brings out colors in a photograph that otherwise would have been exposed solely by blue or green available light. The strobe is not used to influence the exposure of the photograph; it just "paints" in the colors. This technique is called "fill lighting" or "balancing" and is used extensively in wide-angle photos. The technique of balancing will be discussed at length in Chapter 8, "Reflex Macro Photographs." In situations where there is not enough light to produce satisfactory depth of field (as in close-up or macro work), the strobe is used as the primary light source. This is called primary source lighting and will be discussed at length in Chapter 7, "Extension Tube Photographs."

Strobe light (and other types of artificial light) has the same limitations as does natural light in regards to color absorption. Strobe light is absorbed as it passes through water. By the time it reaches the lens, it may be greatly dis-

torted toward the blue end of the spectrum. This is one reason it is best to get as close as possible to your subject, so that the strobe light has to pass through as little water as possible. Generally, this means getting closer than 8 feet. This distance limitation is one of the primary reasons that wide-angle lenses are so important under water.

No matter how powerful your strobe is, if you are farther than 8 feet from your subject, your photograph will tend to be monochromatic. The strobe may serve to fill in some shadows at ranges beyond 8 feet. It may also add some definition to subjects by making them a slightly different shade of blue than the background, but it can do little to bring out warm colors.

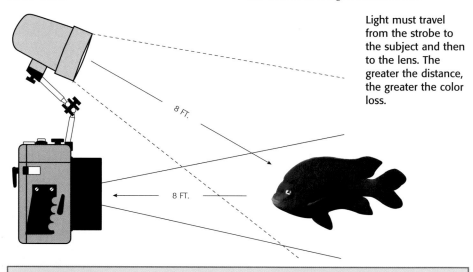

Light must travel from the strobe to the subject and then to the lens. The greater the distance, the greater the color loss.

8 FT.

8 FT.

FILTERS

If you attempt to shoot in very shallow water using available light only, you can reduce some of the remaining color distortion by using a color-correction filter like the CC30R. This filter is magenta in color and redistorts the light coming through it toward the red end of the spectrum.

Filters do not add color to the light that passes through them. Instead, they selectively remove some of the color from that light. In the case of the CC30R, the filter removes some blue light but allows red light to pass through unhindered. At a depth of 10 feet, the CC30R will significantly improve the color balance of your photographs. These improvements will be most noticeable in the way they correct skin tones on divers. But the deeper you go, the less useful the filter becomes. At depths of more than twenty feet, there is so little warm color left in the water that the filter may be of no value at all.

Since filters selectively hold back some light, they serve to reduce the overall quantity of light that reaches the film, thereby influencing your exposure. Filters come from the manufacturer with a "filter factor" number that tells you how much you must increase your exposure to compensate for the filter. If you are metering through the lens with an SLR camera, the meter will provide the correct reading since it is reading light passing through the filter.

Blue Shark with Parasite
Brian Skerry

A red-colored parasitic copepod attached to the dorsal fin of a blue shark is eye catching because of color. The use of a small aperture (f/11), strobes and a close working distance made the color and detail of this shark the picture's focal point. The small aperture and shooting straight down also created the black background that really makes the picture "pop."

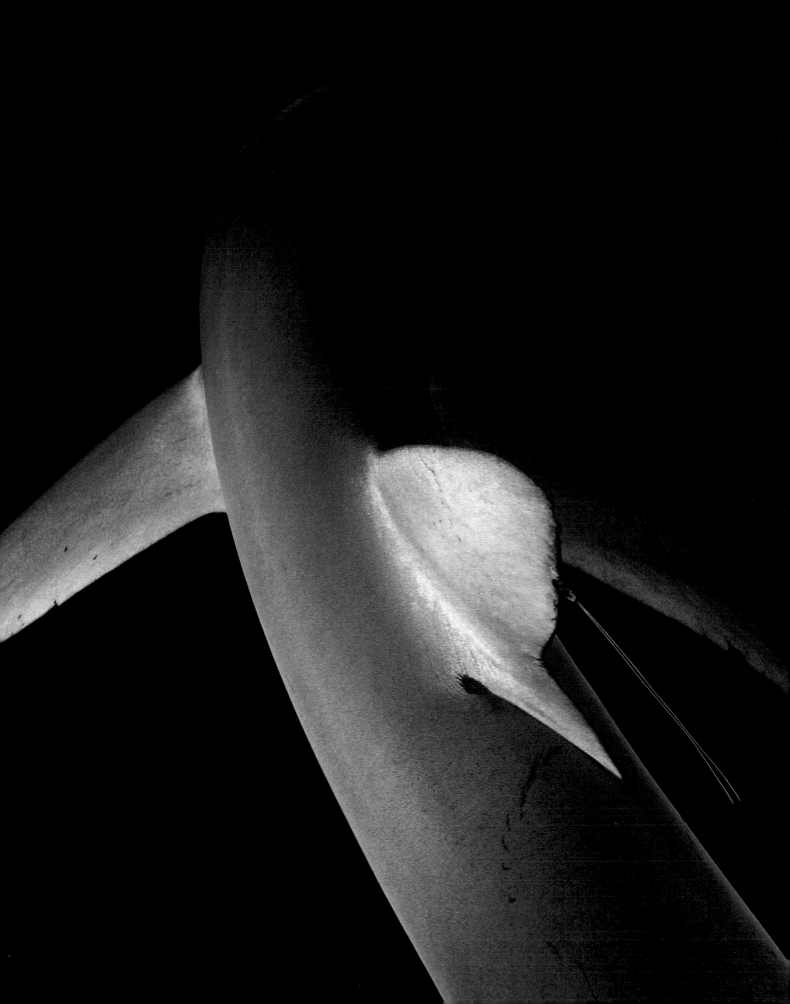

When you're using a strobe to photograph subjects at ranges approaching 8 feet, a color-correction filter (like the CC30R mentioned above) may help improve the strobe fill colors. This is a very reasonable technique; however, the authors seldom use it, preferring to concentrate on getting closer to the subjects.

The 8-foot measure is not some magic number in regards to strobe-to-subject distance. Colors brought out by the strobe at 7 feet will not always be satisfactory, and colors accentuated at 9 feet will not always be unsatisfactory. The colors your strobe illuminates will simply improve the closer you are to your subject. If the colors you capture at 5 feet are good, then the colors at 4 feet will be better.

BACKSCATTER

Backscatter is an underwater photography problem that is the direct product of the strobe. It appears on the photograph as spots like white snow. Some of the white spots will appear as tiny pinpoints of light while others will look like larger, out-*of*/focus white blobs. Backscatter is the result of the strobe's illuminating suspended particles that reflect back to the lens.

Water conditions play a great role in determining the degree of backscatter in your photos. The poorer the water visibility, the more debris there is in suspension and the greater the chance you'll get backscatter in the photo. Even greater contributing factors, however, are strobe placement and diving techniques.

STROBE PLACEMENT

Aside from the way you position yourself, you can minimize much of the remaining problem with backscatter by properly placing the strobes. The closer the strobe is to the lens, the more particles it will illuminate.

The particles closest to the lens produce the large, out-of-focus spots that can ruin a photograph. Particles near the subject appear as small pinpoints of light that may not affect the photograph's quality very much. By holding the strobe over the subject and away from the lens, you can avoid lighting up the particles most detrimental to your photograph.

Unfortunately, when you place a single strobe at too extreme an angle to your lens, it tends to throw extremely harsh shadows on the subject. This problem is most noticeable in photographs where the strobe is being used as the primary light source and available light contributes little to exposure. You can make dramatic improvements to your macro photography by using two strobes (as detailed in Chapter 7). Two strobes will not only greatly reduce harsh shadows but will also allow you to place the strobes in positions that nearly eliminate scatter.

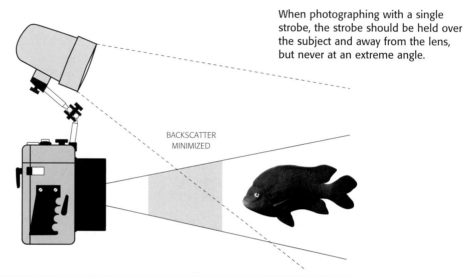

When photographing with a single strobe, the strobe should be held over the subject and away from the lens, but never at an extreme angle.

BACKSCATTER MINIMIZED

Basking Shark
Howard Hall

Using a wide-angle lens reduces the amount of water between the lens and your subject. In this photo, a strobe was used to bring out some of the detail in the basking shark.

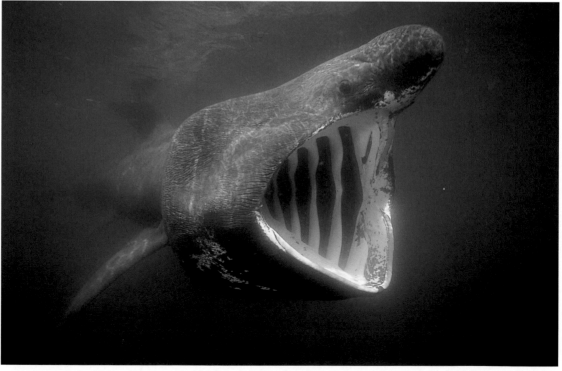

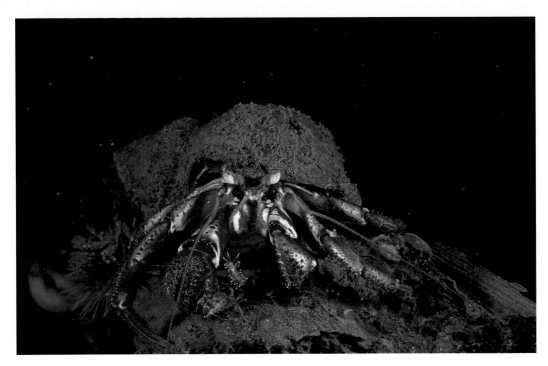

Hermit Crab
Brian Skerry

Backscatter is the illumination of small particles in the water column. Proper strobe placement (and the use of two strobes) helps to reduce the number of particles visible in the photograph.

DIVING TECHNIQUES

Most backscatter is caused by debris that the photographer or his buddy has kicked up into the water column. You can minimize this problem by taking a few precautions.

- Always try to use as little movement as possible when approaching a subject.

- If given a choice, approach the subject from downhill so that you will be below it when you position yourself for taking the photograph. Suspended material tends to drift down a slope rather than up. If you approach your subject from above, you will often cover it with a cloud of mud.

- Try to maintain neutral buoyancy when swimming over the bottom where you hope to find subject material. Once you have positioned yourself, let some air out of your compensator (or drysuit) so that you can remain immobile.

- If you are diving with a buddy, you might wish to threaten him with bodily harm if he kicks up the bottom around your subjects!

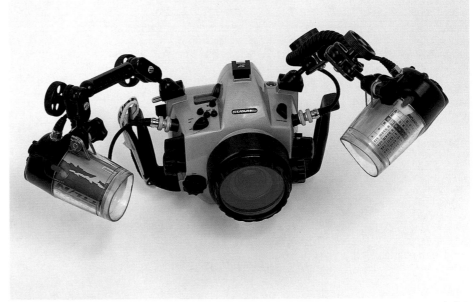

Jim Brady

Housing with Two Strobes

Proper positioning of two strobes, which reduce harsh shadows and help minimize backscatter.

UNDERWATER PHOTOGRAPHIC EQUIPMENT

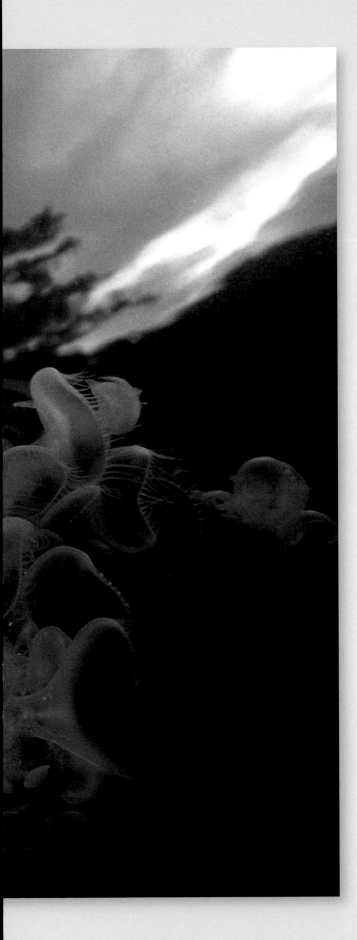

T HIS CHAPTER gives an overview of 35mm underwater photographic equipment. This subject could fill volumes, but to write about it with any integrity, one would have to become familiar with each piece of available equipment. The process could not only take years, by the time you were ready to publish your findings, most of the gear would be obsolete anyway.

The best way to choose your underwater photographic equipment is first to decide what you want your gear to do, then to shop for equipment that meets your needs. If you intend to take extension tube photographs, and you are shopping for a strobe, you should first decide on the specific features you want in the strobe. Small size would be important, as well as compatibility with your camera's brackets and strobe arms, be they Nikonos or Sea & Sea. A strobe for use with a wide-angle lens, on the other hand, would need a suitable beam angle for wide-angle coverage as well as variable power settings.

Once you know the features you want, go to a dive store or camera shop and ask a salesperson to show you what's currently on the market. Make sure the salesperson is an underwater photographer and has used a similar system. Most equipment manufacturers have plenty of literature available. Before you buy anything, you should investigate many different products. The Internet makes a handy tool for this kind of research. List all the manufacturers of the equipment you're shopping for. Then search the manufacturers' web sites and read their brochures. Once you've narrowed your choices, you'll be ready to visit dealers and actually see the products.

The following descriptions are meant to help you start selecting your equipment. The different kinds of equipment shown in this chapter are merely examples of specific types of gear. You'll find many other items on the market that are worth considering.

Helebe (Hooded Nudibranch)
Just Below Pine Forest
Howard Hall

AMPHIBIOUS CAMERAS

Amphibious cameras, as the name implies, are cameras that can be used in the water without a housing. They are designed to be both waterproof and pressure-proof (various models are pressure-proof to different depths). These cameras are usually relatively simple to use and are not cumbersome to work with under water.

Two major manufacturers offer products within this genre. The Nikonos camera, manufactured by Nikon, Inc., has been an industry standard for many years. The Nikonos has gone through several design changes, but essentially it remains the same. Nikonos cameras offer a variety of interchangeable lenses, including 80mm, 35mm, 28mm, 20mm, and the superwide 15mm. The optical quality of these underwater lenses is extremely high.

The Nikonos V is the latest model of the Nikonos; however, in 2001, Nikon announced that it would be discontinuing Nikonos production. The company stated that it would continue to sell existing stock and would continue service on the cameras. Nikon also stated that it does plan to continue manufacturing Nikonos lenses and strobes. Despite this announcement, it should not be difficult to obtain a Nikonos V for quite some time, given the number that have been produced over the years.

The other manufacturer offering amphibious cameras is Sea & Sea, Inc. These bright yellow cameras have greatly increased in popularity in recent years, and Sea & Sea has continued to expand its product line, offering a variety of accessories. There are currently three models of Sea & Sea amphibious cameras available: the MX-5, MX-10, and Motor Marine II EX. The MX-5 is primarily a "point & shoot" camera. The MX-10 offers a bit more versatility with three lens options. The Motor Marine II EX (the MM II EX) offers the greatest versatility, with interchangeable lenses and the capability to shoot wide-angle photographs (with either a 20mm or 16mm lens) or close-up and macro photographs with reproduction ratios of 1:2 and 1:3.

Both the Nikonos V and the Motor Marine II EX have internal light meters that are designed to incorporate TTL metering. Both cameras permit the addition of strobes. Sea & Sea also manufactures underwater lenses designed for Nikonos cameras, including their 12mm, 15mm, and 20mm offerings. Additionally, Sea & Sea offers a supplemental 16mm lens designed to fit over a Nikonos 35mm lens. You can put this supplemental lens on and take it off under water, thus providing additional versatility.

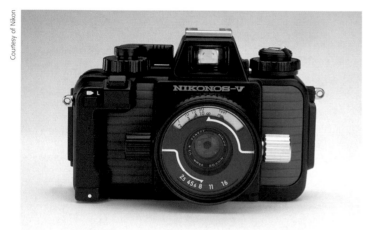

The amphibious Nikonos V camera

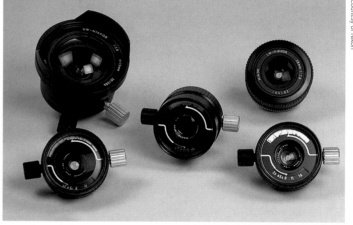

Nikonos lenses

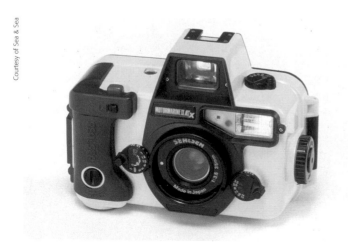

The amphibious Sea & Sea Motor Marine II EX camera

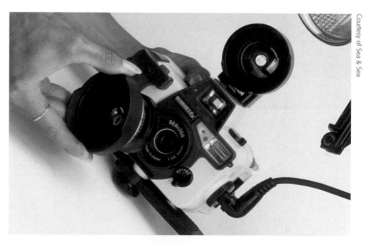

The Motor Marine II has interchangeable lenses and offers greater versatility than fixed-lens models.

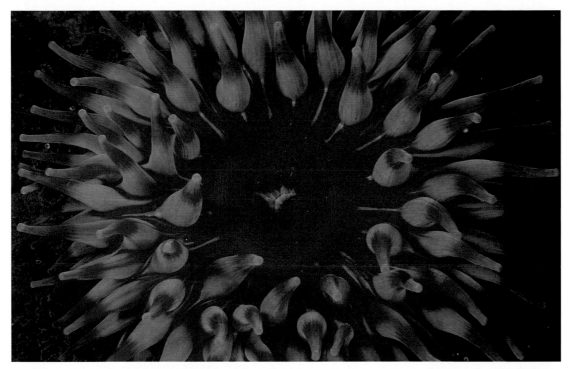

Northern Anemone
Brian Skerry

Northern anemone photographed with two strobes creates even lighting.

Emerging Blue Shark
Brian Skerry

A single strobe was used to bring out just a little detail in this blue shark's face.

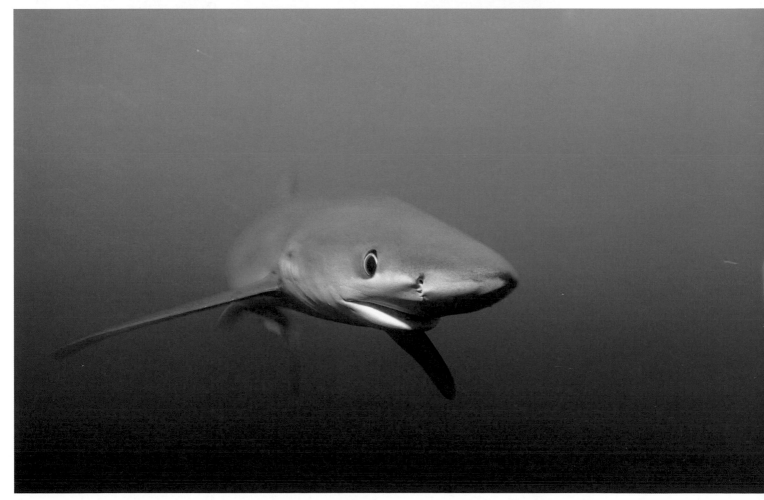

CAMERA HOUSINGS

Underwater housings are commercially available for a wide variety of above-water cameras. These housings are generally made out of either anodized aluminum or some type of plastic. All of these materials can be used to make equally excellent housings; however, the actual design of the housing itself is most important.

There are several important things to look for in a housing design. You want to make sure that the design is simple, allowing the camera to mount in the housing in a relatively foolproof manner that requires minimal adjustment. You will also want to have access to as many camera functions as possible. Although some camera functions may never actually be used in underwater photography, it's a nice plus to have the option to use them. Some housings,

for example, do not allow manual focus of certain lenses and rely instead on the camera's auto-focus capability. This could be a serious detriment since you may often need to manually focus your lens. If your camera has the ability to switch modes from aperture priority to shutter priority, you will probably want to be able to access this control under water as well.

Make sure that the controls are easy to reach and can be easily manipulated underwater. Remember that holding a camera housing in a camera shop is quite a different thing than holding one under water. This is especially true if you plan to dive with heavy gloves or mitts. The controls on some housings are too small to be easily adjusted with thick drysuit mitts and cold hands.

Also be sure to take time to look through the viewfinder to make sure you can easily see the frame as well as the camera's readouts. The major advantage of using a housing is to achieve reflex viewing (seeing through the lens), so you want to be able to see everything clearly. Once again, remember that viewing is slightly more difficult when you're wearing a dive mask. To truly be able to see from corner to corner within your viewfinder, you may need to have a camera that accepts an action-finder, also called a sportsfinder.

The actionfinder is a large prism that attaches to the top of the camera after the standard viewfinder has been removed. This actionfinder produces a very large image that can be viewed from several inches away, making it

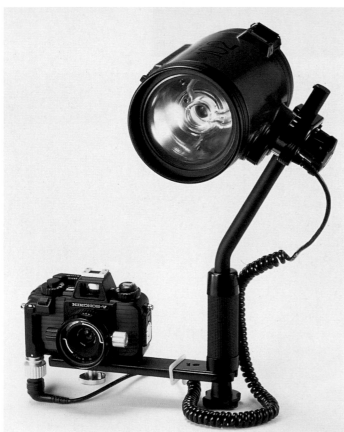

Courtesy of Nikon

Nikonos V camera configured with single strobe on tray.

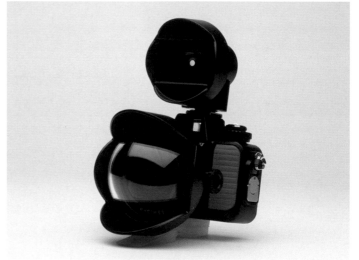

Courtesy of Sea & Sea

The Sea & Sea 12mm lens designed for the Nikonos camera offers nearly a 170-degree angle of coverage.

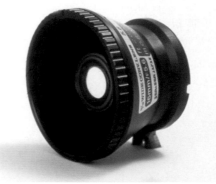

The Sea & Sea 16mm conversion lens can be added over a 35mm Nikonos lens while under water.

Courtesy of Sea & Sea

ideal for use in a housing. It can be an expensive feature, but it is one that improves underwater viewing tremendously. If you have a camera that is not designed to accept an action-finder, you are by no means out of luck. Several housing manufacturers, and some camera manufacturers, make supplementary lenses that attach to either the standard viewfinder or the view port of the housing. These supplementary lenses either increase or reduce the image so that viewing is enhanced. Since photography boils down to being able to "see," the viewing characteristics of your housing are critical.

It is also important that your housing have facilities for easy mounting of strobe arms, focusing lights, and external light meters. Most importantly, you want to be certain that the housing can accommodate the various lenses you plan to use. Although most housings are designed to work with the more commonly used lenses, you should check the range of what is available. In general terms, you will need a dome port for wide-angle lenses and a macro port for macro lenses. Some housings are designed for a single dome port to accommodate a number of wide-angle lenses. Other manufacturers match individual dome ports with individual lenses, so you would have separate ports for your 20mm lens, your 24mm lens, your 18mm lens, and so on. The theory behind this approach is that each port is optically matched to the specific lens being employed in an effort to produce the highest resolution.

Ports can also be made from materials varying from mineral glass to acrylic. Once again, arguments can be made on either side. Proponents of glass ports emphatically embrace glass's optical qualities, while acrylic aficionados tout their ability to easily remove scratches and dismiss the notion that they sacrifice image quality. The field of macro ports is a bit simpler in that they are designed for only a few lenses. The two most common are the 60mm macro and 105mm macro (with 200mm macro lenses also being fairly common).

Before you purchase an underwater camera housing, it is a good idea to talk with someone that uses or is familiar with housings for the type of camera you plan to use. Do your homework by reviewing manufacturer's brochures and web sites and by actually getting housings in your hands. Look at the design and features carefully and give thought to your intended application.

Housings such as those manufactured by Ikelite are constructed of durable, clear polycarbonate material.

Courtesy of Ikelite

An aluminum housing for the Nikon F100 camera, manufactured by Sea & Sea.

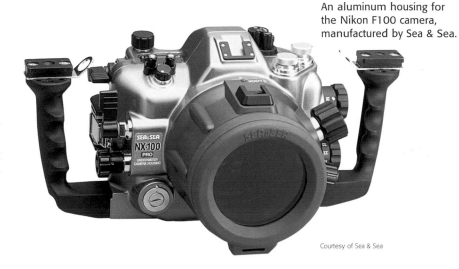

Courtesy of Sea & Sea

A selection of wide-angle dome ports and macro ports for housings.

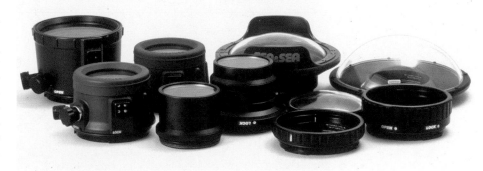

Courtesy of Sea & Sea

LENSES FOR USE WITH HOUSED CAMERAS

The number of above-water lenses that you can use in underwater housings is enormous. However, the number of lenses that are commonly used is relatively small. Still, the list of lenses being employed in underwater housing continues to grow as new lenses appear on the market.

For macro photography, most photographers use lenses in the 50mm to 60mm macro range (not to be confused with 50mm non-macro lenses). In clearer water, longer macro lenses, such as the 105mm macro or 200mm macro, are used in order to photograph animals from farther away. Many of these macro lenses have the ability to focus to a 1:1 ratio and therefore are extremely valuable in under water photography.

A greater variety of wide-angle lenses is coming into common use under water. Underwater photographers use wide-angle lenses from 35mm to 16mm fisheyes. The most common lenses used, however, are 24mm, 20mm, and 16mm. A 20mm lens has an angle of coverage of 94 degrees (the same as the Nikonos 15mm lens). Any of these three lenses is an excellent choice for wide-angle photography or close-focus wide-angle photography (CFWA). As you review the example photographs in this book, pay special attention to the lenses that were used to make each shot. You will see that the range is relatively small.

If you are using a wide-angle lens behind a dome port, you may find that the lens does not focus close enough to do CFWA work because of the closeness of the virtual image produced by the dome. You can solve this problem by adding a diopter (usually powers of +2, +3, or +4) to the front of your wide-angle lens. (See the "Refraction" section of Chapter 3 for more information.)

Many camera manufacturers are now regularly introducing versatile zoom lenses. In the past, zoom lenses rarely delivered the high-quality images of fixed focal lengths; however, the new zooms are a whole new breed. Many of these zoom lenses are of extremely high quality and offer exciting potential. Underwater housing manufacturers are also now offering ports to accommodate them. Some of the more popular zoom lenses being used for underwater photography include the 18mm–35mm, 17mm–35mm, and the 28mm–105mm. Some underwater photographic service centers also have the ability to custom-fit more exotic lenses, such as the 70mm–180mm macro, to be used inside housings.

Before buying a zoom lens to put into your housing, check to see if it will work. Check also to see *how* it will work. With many housings, the focus control is used to work the zoom, which means that you will have to use the camera's auto-focus mode to focus the lens. This can work extremely well, though if you prefer to manually focus your lens, you will be out of luck.

Chrysaora Jellyfish with Diver
Howard Hall

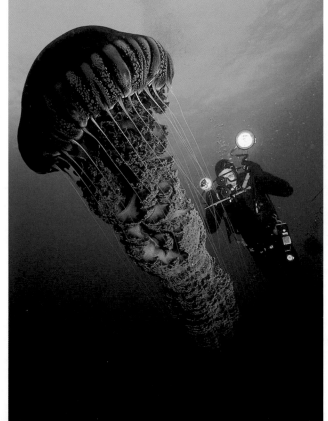

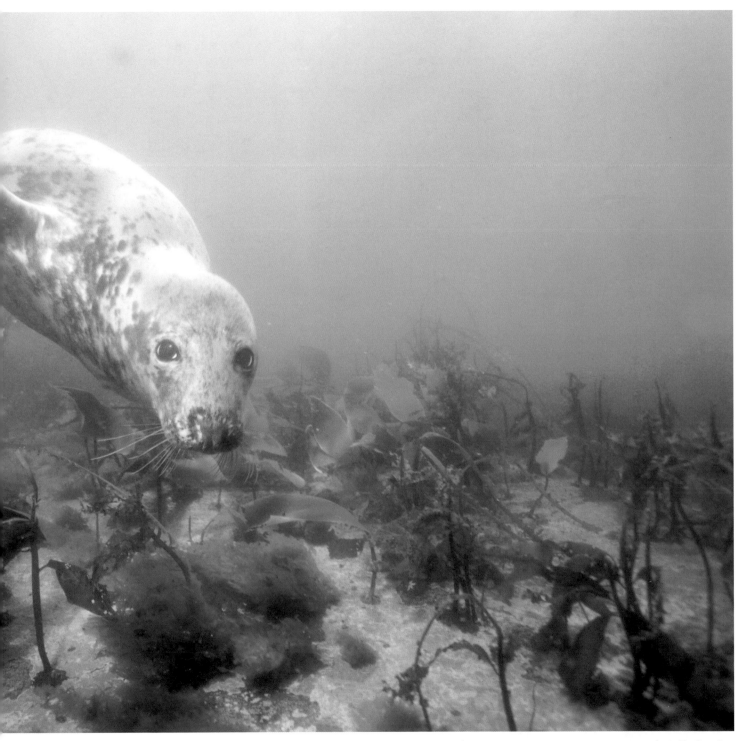

Gray Seal, Gulf of Maine

Brian Skerry

Gray seal in the Gulf of Maine photographed with a 20mm
lens inside a housing and a single wide-angle strobe.

STROBES

Underwater strobes fall into two general classifications: big, or wide-angle strobes, and little strobes. Beam angle is the primary difference between large, expensive strobes and those that are smaller and less expensive.

WIDE-ANGLE STROBES

Big strobes are generally used for wide-angle photography. They are quite powerful and produce a wide beam of light. Beam angles for wide-angle strobes are generally between 95 and 110 degrees. If you are using a 28mm lens, then 95 degrees is more than enough. If however, you are using a 15mm lens (which has an angle of coverage of 94 degrees), a 95-degree beam angle will give you barely ample coverage.

This is assuming that you position the strobe perfectly. In bright conditions when you are balancing exposures, it may be possible to get away with this; under many situations, however, it's likely that you'll end up with dark edges in your photograph. Using a strobe with a wider beam angle will, of course, solve this dilemma, as will the use of dual strobes. Another way to solve the problem is to use a diffuser.

Diffusers are attachments that fit over the front of the strobe and are used to widen the beam angle. They are most commonly made from a white plastic material and soften the light as well as diffuse it out over a wider area.

A diffuser may be all that is required to increase your strobe's beam angle in order to adequately light the full frame of wider-angle lenses. Diffusers also reduce the light, however, thus affecting your guide number. (See the "Guide Numbers" section in Chapter 2 for more information.)

Many diffusers reduce the strobe's output by one full f-stop. If your normal guide number is $f/8$ at a 3-foot distance on full power, a diffuser might change that to $f/5.6$. Diffusers can also change the color temperature of the strobe's light, often warming it considerably. It would be advisable to shoot tests with diffusers before using them on important subjects.

Another important feature to look for in a wide-angle strobe is variable power. A good wide-angle strobe should have at least two power settings, more if possible. Much of the time you will be using the wide-angle strobe as

Sea & Sea's YS-350 has the ability to control light output manually in 1/3-stop increments.

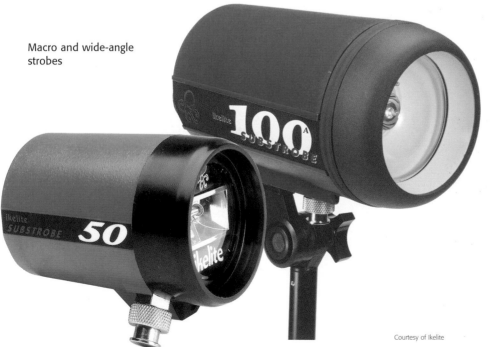

Macro and wide-angle strobes

Humboldt Squid

Brian Skerry

Six-foot-long Humboldt squid photographed at night with an 18mm lens inside a housing and two wide-angle strobes.

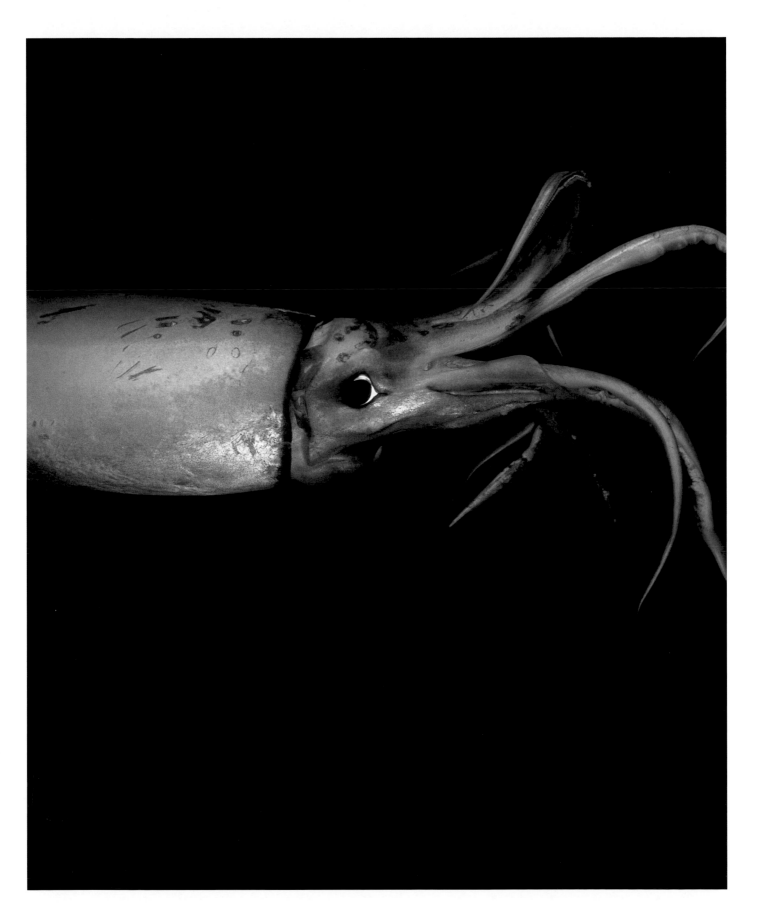

a fill light source. This means that you will be attempting to balance the strobe light with the available light reading. Balancing is much easier if you have some control over strobe power.

Chances are that every wide-angle strobe on the market is more than powerful enough to be effective in wide-angle underwater photography. It may not be extremely important that one manufacturer's strobe is twice as powerful as another's. In fact, some strobes are too bright for balancing in temperate waters, especially if they do not have variable power. Beam angle is a more important consideration than power when choosing a wide-angle strobe.

SMALL STROBES

Small strobes are smaller in size and less expensive than large, wide-angle strobes. For wide-angle photography they are of little value. But for macro photography they are superb since they are easier to position, carry, and maneuver.

Although not as large physically, most small strobes are quite powerful and often have guide numbers equal to that of bigger wide-angle strobes. Small strobes usually have a beam angle of 60 degrees or less.

As mentioned above, the addition of a diffuser will increase the beam angle of any strobe, including small strobes, should you wish to light a larger subject. When shooting macro subjects, however, a small strobe's beam angle is perfectly adequate, without the need for diffusers.

STROBE POWER SUPPLY

A strobe can be powered in two ways, either with rechargeable batteries or disposable batteries.

Rechargeable batteries have two advantages over disposable batteries. One advantage is that they recycle faster. Recycle time is the length of time it takes the capacitors in the strobe to become fully charged. These capacitors must be fully charged before the strobe can fire. The other advantage is a bit more obvious: you do not have to buy batteries for rechargeable strobes. You do, however, have to charge these batteries regularly.

The two types of rechargeable batteries used primarily in underwater strobes are nickel cadmium (NiCads) or nickel metal hydride (Ni-MH). Although both types of batteries are rechargeable, NiCad batteries have memories. This means that if you do not discharge the battery before each charging, the battery's lasting power or "memory" will shorten. When using

NiCad batteries, then, it is important to discharge them as much as possible prior to charging. Discharging them to the point where no current is left, however, will damage them. Given this delicate balance, some manufacturers sell battery dischargers that safely discharge your NiCad. You may also be able to buy a "smart battery charger" that will discharge and charge your battery all at one time.

Nickel metal hydride batteries do not have memories, and they can be charged at any stage without any loss of power. For various reasons, manufacturers use both types of rechargeable batteries in underwater strobes. It would be wise to investigate the type of battery used in the strobe you consider purchasing.

An advantage to using disposable batteries is not having to worry about keeping the batteries charged. When your batteries get low, you just throw them away, replace them with new ones, and the strobe is ready to be used again. When your rechargeable batteries get low, however, you may not be able to use the strobe again for several hours, assuming that you can even find a power supply to plug into.

Most strobes that are designed to use disposable batteries can also be used with rechargeable batteries (such as AA batteries). Check with the manufacturer if you wish to switch from disposable batteries to rechargeables.

SLAVE STROBES

A slave strobe has a circuit built into it that causes it to fire when the slave sensor picks up a sudden increase in ambient light. This circuit allows the slave strobe to fire simultaneously with another strobe.

The slave feature has several advantages. If you are photographing a person who is using a strobe with the slave feature, you can ask them to switch their strobe to "slave." This will cause their strobe to light when you are taking their picture. The resulting photograph will appear as though you timed your shot perfectly to capture the exact moment that the other photographer was taking a photograph. This "slave" setting is rather common in wide-angle strobes and can be used to enhance people photos when used in the above fashion.

The slave feature is also very useful in macro systems where multiple-source lighting is so important. Some small strobes are designed without sync cords and can be used only as slaves. Using a slave such as this eliminates the need for a double cord (or Y-cord) arrangement. Some cameras, such as the Nikonos for example, have only one sync socket permitting only

one cord. In order to use two strobes, you must either use a Y-cord that connects the two strobes via a single cord (which is an added expense) or use a cordless slave.

Many underwater strobes are now being manufactured with TTL capability as well. (See Chapter 13, "Automatic Focus and Exposure" for more information.) This technology opens up many new creative possibilities. When working with a macro subject, for example, you could have two strobes on your camera system (set on TTL) and a third slave strobe also set on TTL positioned behind the subject for a bit of back lighting.

CONNECTORS

For a primary strobe to fire when the shutter is pressed, the strobe must be connected to the camera with a strobe cord. The strobe cord attaches to the camera or housing through a sync socket. Various strobe manufacturers produce various types of connectors. For quite some time, the Nikonos connector has been the most commonly used connector type. Even if Sea & Sea, Ikelite, Seacam, Oceanic, or another company manufactures your strobe, you can request a Nikonos connector to be fitted to the strobe cord.

These various companies offer their own connectors as well. The advantage to using a Nikonos connector is that you can use it with your housing (if you have a Nikonos bulkhead connector installed) and Nikonos cameras alike. Other types of connectors require an adapter before they can be used with a Nikonos camera.

A tremendous advantage to strobe cords is the ability they give you to plug and unplug them under water. This ability lets you take down two camera systems and only one strobe. After shooting the film in the first camera, you can unplug the strobe from the first system, plug it into the second system, and go right on shooting. Over the years, various "wet connectors"

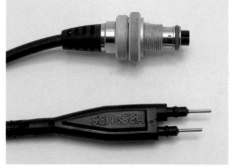

Jim Brady

The Nikonos connector (top) and the Nelson "wet" connector (bottom)

have been produced that permit exactly this option. One of these, the Nelson/Sealock Connector, is still readily available. Unfortunately, the Nelson/Sealock Connector is not designed for TTL strobe operation. You can install it and use it with any strobe, including TTL strobes; however, it will not permit TTL functions.

Several manufacturers have introduced TTL wet connectors. At present, the reviews (and availability) are mixed in terms of reliability. The emergence of a reliable TTL wet connector will be of enormous value to underwater photographers.

STROBE ARMS

In order to position your strobe properly when shooting, you must incorporate a strobe arm. Although it is possible (and sometimes quite useful) to handhold your strobe on a rigid arm, it is best to use a strobe arm that allows flexibility. Since lighting is the key ingredient in photography, it is crucial to attain perfect positioning of your lights (strobes).

The primary characteristics of a good strobe arm include great flexibility. You should be able to move the arm, and therefore the strobe, into nearly any position that you will need to perfectly light your subject. In reality, you will probably find that you most often use only a few different positions when shooting, but it is still important to have versatility. Strobe arms that incorporate ball joints tend to provide such versatility, but other means may achieve this as well.

Other features to consider include weight, durability, and modular design. An underwater camera system can be heavy to carry around, so you should avoid burdening yourself with the added weight of hefty strobe arms. You should also examine the overall construction of the arms you consider purchasing. Are the designs simple or complex? Will they last after repeated saltwater uses?

Using a strobe arm system that is modular in design can be extremely efficient. With such a system, you can purchase sections of varying lengths along with clamps to connect them together. This way you can "build" strobe arms for a variety of photographic uses, putting together small sections for work with macro subjects and longer sections when working with wide-angle subjects.

Every underwater strobe manufacturer offers arms to be used with their strobes. There are also companies that specialize in manufacturing strobe arms and camera trays. It would be wise to review the many options before committing to a single system.

Courtesy Aquatica

Strobe arms and trays such as these manufactured by Technical Lighting Control (Aquatica) offer a lightweight, modular design.

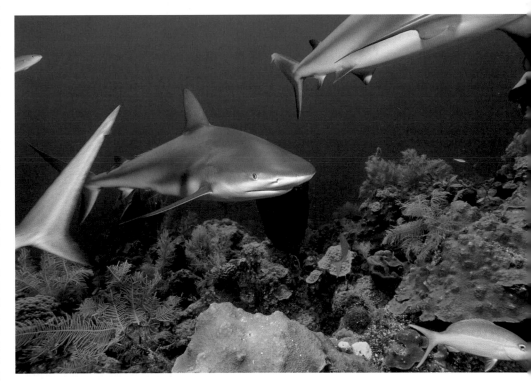

Caribbean Reef Sharks, Bahamas
Brian Skerry

Caribbean reef sharks photographed with a 20mm lens inside a housing and two wide-angle strobes.

DIGITAL CAMERAS

As digital technology continues to advance, it will equally continue to gain more and more prominence in underwater photography. Digital technology's ability to capture images in low light, the manipulative characteristics of the image, and its instantaneous viewing properties give it great promise in the underwater realm. While digital photography has many of its own unique characteristics, the techniques of photography remain the same. Although all of the photographs in this book were made with film, the techniques used to produce them can easily be applied to the digital realm. It is simply the storage medium that will change.

Undoubtedly, with each new generation of digital camera that appears on the market, new underwater housings created for them will be close behind. Strobe manufacturers are also producing strobes designed to work with both digital cameras and film cameras.

Stephen Frink

The Seacam underwater housing for Nikon's D1X digital camera.

Strobe Close-up

Howard Hall

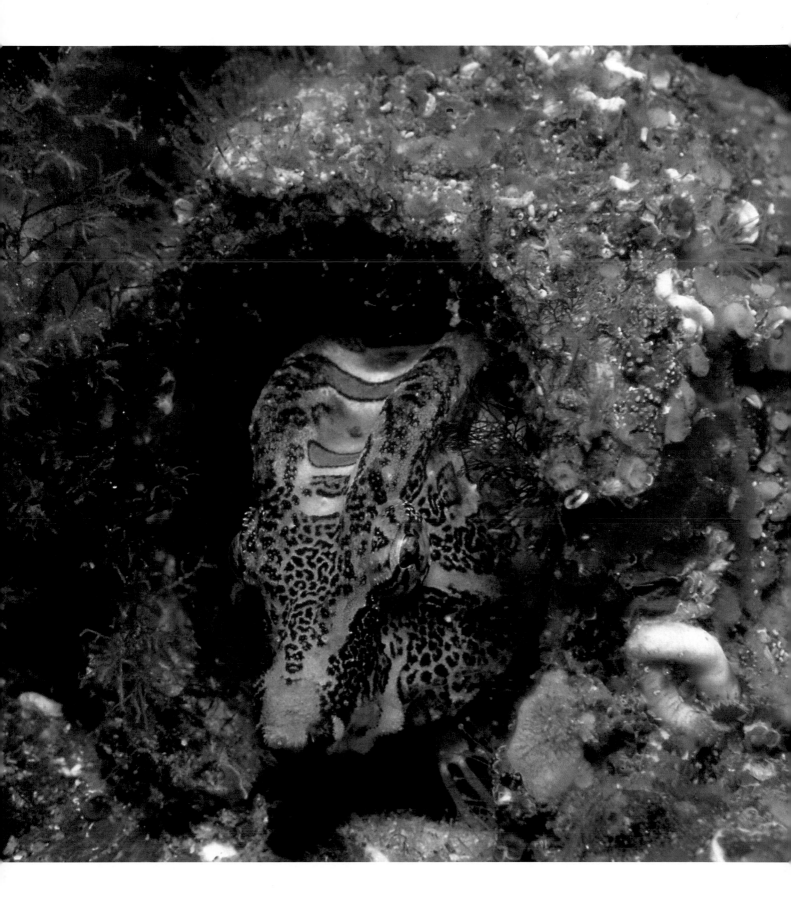

AVAILABLE-LIGHT PHOTOGRAPHS

A BOVE THE SURFACE OF THE WATER, it's possible to take a quick daytime snapshot and get an acceptable image. There's no need to worry about the difference between what your eye sees and the camera will record on film. On dry land, the camera and your eye perceive light in much the same ways. Under water, however, the principles of physics make those quick photographic impulses a little trickier.

Water has a different effect than air does upon the light that passes through it (as described in Chapter 3, "What Happens to Light Under Water"). Water quickly absorbs certain wavelengths, or colors, of light in a way that's easy for the beginning photographer to overlook. At the 15- to 30-foot range (vertical or horizontal distance), for instance, water absorbs light from the red/orange part of the spectrum. Your brain compensates for that color loss, and you continue to "see" reds and oranges. But the camera does not.

Blues and greens are perceptible to the camera at much greater distances, up to 100 feet. When you take photographs under water without using a strobe or any other supplemental light source, therefore, your images will tend to consist of those cooler colors. Because they are primarily composed of blues and greens, we should think of available-light photographs made under water as being monochromatic.

A monochromatic photograph is very much like a black-and-white photo except that instead of using gray, the photograph is composed of various shades of blue or green. Combined with the extensive scatter of underwater light, this monochromatic quality places important limitations on available-light underwater photographs.

Whale Shark Feeding
Brian Skerry

Whale shark in Western Australia photographed with an 18mm lens inside a housing.

ELEMENTS OF SUCCESS

Creating a successful available-light photograph requires you to pay attention to several key elements. Contrast, for instance, is critical, given the monochrome nature of these kinds of images. You will also have to pay attention to your choice of lens, along with such concepts as image separation, scatter and color, and negative space. The following sections provide detailed information on each of these elements of success.

CONTRAST

Contrast is an extremely important quality of any photograph. Without contrast, there would be nothing in an image to catch your eye or focus your attention. And although a photo without contrast may serve to identify a species of fish or to verify that your buddy did indeed catch a lobster, it will not be a picture that you would enjoy hanging on your wall or that a publisher would consider printing. Without contrast a photograph has no impact. It has the "blahs."

There are two types of contrast in color photography. The first type is color contrast. An example of color contrast is a bright red balloon photographed against a bright blue sky. If the balloon were blue, then the photograph would not have as much impact.

The other type of contrast is shade contrast. This kind of contrast is important both in black-and-white photographs and in available-light underwater photographs. A good example of a color photograph with shade contrast would be a picture of birds flying through a sunset. The photograph may only have one color (usually orange), but the birds stand out because they are silhouetted against the orange background. This is the kind of contrast you must look for in your underwater available-light photographs.

In the example of the balloon photographed against a blue sky, it is obvious that a blue balloon would have much less color contrast and impact than a red balloon. But, since this is a topside photograph, there would still be considerable difference between the blue color of the balloon and the blue color of the sky. The photo would still have some color contrast.

Under water, however, this would not be the case. It doesn't matter what color the underwater subject is because the light illuminating the subject is monochromatic. The color of the subject in the photograph will appear exactly (or very nearly exactly) the same as the background. You must remember that your film will seldom see any of the color contrast that you see with your eye. The first time you try to photograph brilliantly colored angelfish swimming over a coral reef, you will be amazed at the blandness of the results.

Therefore, for available-light underwater photographs, you should look for shade contrast. As with the example of the birds flying through the sunset, this means dark subjects against light backgrounds. With very few exceptions (a white, sandy bottom being one) the background in your available-light photographs should be open water.

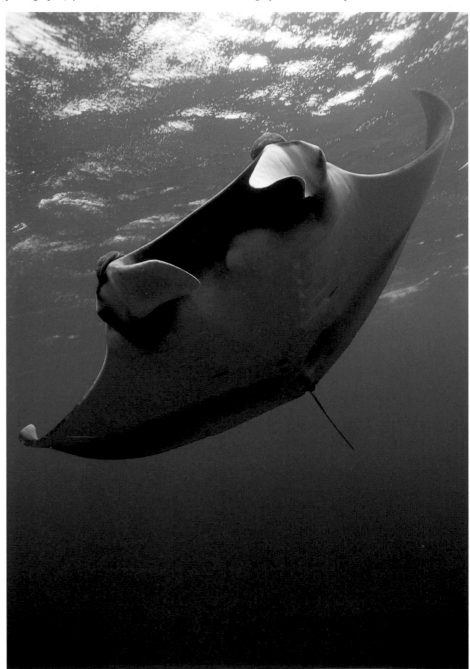

Manta Ray, Turks and Caicos
Brian Skerry

The orientation of this manta ray in the water column made it a perfect candidate for a vertical frame.

SEPARATION

"Separation" is another term underwater photographers often use in place of the term "contrast." In available-light underwater photography, you must concentrate on separating your subjects from their backgrounds. Generally, this means you must get below the subject and shoot at an upward angle. This will usually produce a silhouette, or a partial silhouette, depending on how extreme your upward angle is. You can also position yourself with the sun at your back. This will sometimes produce a relatively light subject with a dark water background (as illustrated in "Spotted Dolphins," on page 54). In both cases, the background is open water.

The important thing is to make sure you have completely separated your subject from the other objects in the photograph. If you are photographing a diver swimming over the bottom, you must get lower than the diver and make sure that open water entirely surrounds him before you take the picture (as shown in "Diver in Kelp Forest," on page 53). If part of the bottom is behind the diver, it will act as camouflage. The diver will appear to be part of the bottom in the photograph and will become difficult to recognize.

SUN POSITION

As with topside photography, the position of the sun has important effects on underwater photographs. If you want your subject to appear relatively light against a darker background of deep blue water, then you must position the sun at your back. If you want the subject to appear dark, and you wish to accentuate the sun's rays, then the sun should be positioned in front of the lens (as shown in "Diver in Kelp Forest," on page 53). The time of day will greatly accentuate the results you get when shooting into or away from the sun.

Florida Manatee, Florida
Brian Skerry

Florida manatees frequent shallow water, providing a perfect environment for available-light photography.

SCATTER AND COLOR

When photographing only with available light, there are two main reasons for you to get as close as possible to your subjects. First is the effect of scatter. The farther you are from the subject, the more scattered the image will be. In photographs that rely heavily on shade contrast, scatter can have especially detrimental effects. The sharpness of "Diver Beneath the Ice" (page 55) in the example photos is a result of its being shot from a distance of only one foot. Since the light from the subject traveled so short a distance to reach the lens, scatter had minimal effect.

The other reason you should get close to your subject is color absorption. Although available-light photographs will be monochromatic, the shades of blue color (or green) will become more

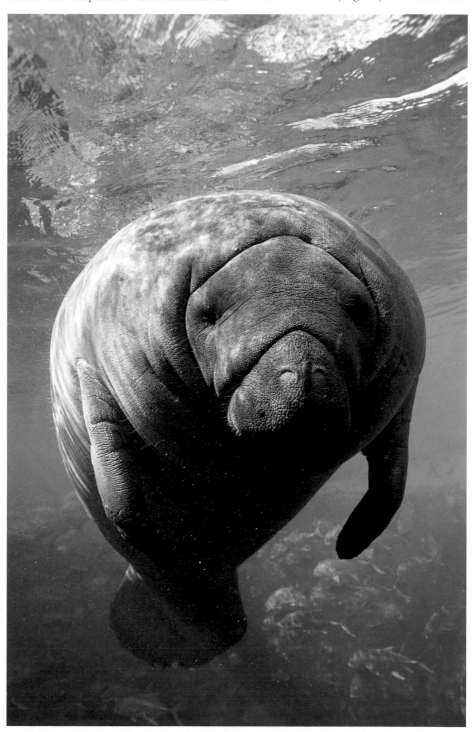

uniform with increased subject distance. The more the shade of the subject differs from the shade of the background, the more separation there will be in the image. This is most true when the sun is positioned at your back, when you can get light subjects against dark water backgrounds.

CHOICE OF LENS

Most available-light photographs are made with wide-angle lenses because the subjects are usually divers or other large subjects. It is not impossible to make available-light photographs of macro subjects, but it is difficult to get useful results. There are two reasons for this. One is that unless you photograph your macro subject in a rather extreme silhouette, you will be forced to use wide aperture settings. This means that your depth of field will be extremely limited and it will be difficult to get much of your subject in focus. Also, unless you do photograph your subject in silhouette, there will be little contrast and the photograph will suffer from a bad case of the "blahs."

Even if you do try to silhouette a macro subject, it will seldom be a subject that viewers can easily recognize without being able to see more detail. You are generally better off photographing macro subjects with a strobe. Wide-angle lenses are a much better choice than macro lenses for available-light photography. They allow you to pursue large subjects and seascapes that viewers can recognize even in silhouette.

NEGATIVE SPACE

Negative space is a key concept in photography. It is defined as everything in the photograph that is not the subject. Negative space can often make or break a photograph. Most beginning photographers think that the subject is all-important. But to the experienced photographer, negative space is often equally important and sometimes even more important.

This image of the red-gilled nudibranch clearly illustrates the importance of negative space in a photograph. Hundreds of photographers have photographed this species, so getting just a "good" photo of the animal itself would be of little professional value. The only way to make this photograph valuable is to create an exceptional composition. To accomplish this, consideration was given to the negative space.

It is not the nudibranch itself that makes this photograph exceptional but rather the shape and color of the rock it is on and the patch of water in the upper right of the frame. All of these things are part of the negative space in the photograph, and each was given careful consideration in the composition of the photograph before it was made.

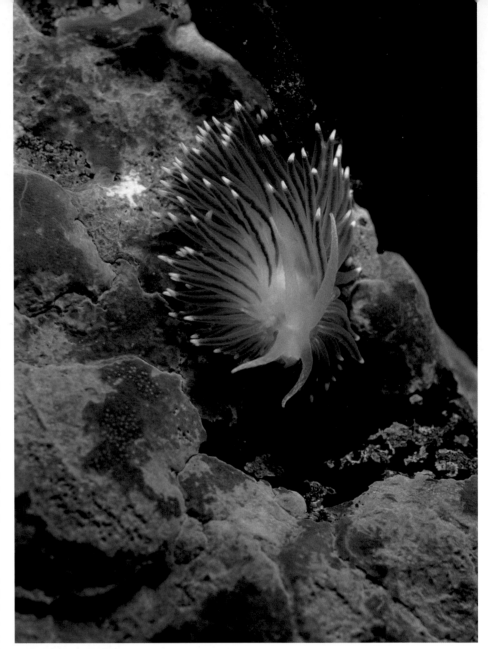

Red-Gilled Nudibranch
Brian Skerry

Negative space, defined as everything in the photograph that is not the subject, can make all the difference to the quality of an image. In this photo of a red-gilled nudibranch, the subject was framed vertically to include some background water in the upper right.

When composing macro shots, novice photographers usually spend most of their time looking for subjects only. Experienced photographers, however, will often spend more time looking for negative space and then search for subjects within it.

No matter what type of photograph you are making, the care you take in photographing the negative space is often as important as the care you take in photographing the subject itself. When you do a good job with both, your photograph will have excellent composition.

In available-light photographs, your negative space will not have the detail that it does in macro photography. It is still very important, however. Before you take your photos, evaluate every square inch of the frame for good or bad negative space. Do not just see the subject to the exclusion of all else in the frame. In some situations, you might even want to search for good negative space first, frame it just the way you want it, and then wait for a diver or fish to swim into the frame. Such was the case in the example photograph "Diver in Kelp Forest" (page 53).

MASTERING THE FUNDAMENTALS

Here are the points to remember for successful available-light photographs:

- In order to make successful available-light underwater photographs, you will need a camera with a wide-angle lens and a light meter. Study the examples in this chapter for a better understanding of the limitations of your lens.

- Once you are under water and have decided upon a subject (or perhaps a negative space), check your sun position and decide whether you will shoot into or away from the sun.

- Position yourself lower than your subject and take a light-meter reading on the water behind the subject.

- Check your composition. Make sure that your subject is entirely separated from the other objects in the frame by surrounding open water. Check your subject's size in proportion to the size of the frame itself. Evaluate your negative space and make sure that it complements but does not distract from the subject.

- Shoot both horizontal and vertical photographs if possible, bracketing your exposure with each. After your film is developed, evaluate your results carefully, taking note of which techniques produced the most pleasing results.

COMPOSING A PHOTO WITH IMPACT

I call this type of underwater photograph a seascape. In this image of a diver swimming through a California kelp forest, the initial point of interest in the photograph is the diver. It is a little deceptive, however, to call the diver the subject of the photograph since the image could stand alone even without the diver. But it is true that without the diver, the composition would lack considerable impact.

When you make this kind of photograph, it is the negative space that is important. You should spend your dive time searching for just the right background. Frame it with your lens so that every part of the image is exactly as you want it, from corner to corner. Then wait for your subject to swim into the frame. You should place your highest priority on the negative space. The subject (in this case, the diver) is what gives the photograph a point of interest.

This photo also illustrates the importance of getting below the subject. The camera appears to have been at an essentially level angle, but in this case looks are deceiving. I positioned myself close to the bottom and tilted the camera slightly upward to frame the diver against open water rather than against the bottom. Had even part of the diver been framed against the bottom, it would have been difficult to distinguish the subject from the background.

The lens I used to make this photograph was a Nikon 24mm on an SLR camera in a housing. Several other wide-angle systems would have worked equally well. The wide-angle lens allowed me to photograph a large panorama from a short distance away. This prevented the image from being beyond visibility or unacceptably scattered. Had I tried to use a 35mm or 28mm lens, I would have had to back up too far to get the same frame.

In this case the diver is 30 feet away, and visibility is only 60 feet. You will notice that the image of the diver is not entirely sharp. This is the result of scatter from 30 feet. But the small size of the subject and its relative unimportance makes the scatter of the image acceptable.

Since the light in the kelp forest was very dim, I used a shutter speed of 1/30 and the aperture ƒ/2.8, holding the camera as still as possible. Had there been less light, I would have had to resort to high-speed film (instead of my Kodachrome 64). The exposure reading was taken on the water behind the subject, and the sun was in front of the lens at the upper right.

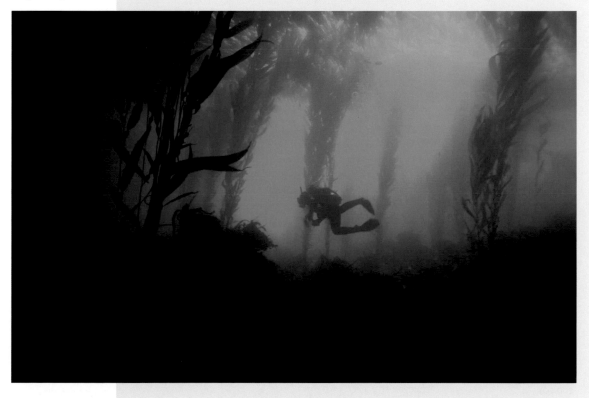

Diver in Kelp Forest

Howard Hall

Camera and lens: Nikon F2 with 24mm lens inside a housing. **Film:** Kodachrome 64. **Aperture:** ƒ/2.8. **Shutter speed:** 1/30. **Subject distance:** 30 feet. **Camera angle:** slightly upward. **Strobe:** none.

CAPTURING CONTRAST AND DETAIL

After repeated attempts to get close to pods of spotted dolphins in the offshore waters of the Azores, I tried letting myself be slowly towed alongside a large inflatable boat on a day when sea conditions were very calm. The dolphins were not as wary as they had been without the boat, and they came in quite close.

It was a bright, sunny day and the water was especially clear, with perhaps 80-100 feet of visibility. I used a Nikon N90 camera inside a Subal housing. I selected a shutter speed of 1/125 because both my subject and I were moving, and I needed at least that speed to freeze the motion. I also selected shutter-priority mode and let the camera select the aperture (with the boat was pulling me through the water, I needed both hands on the camera). Plentiful ambient light let me maintain an aperture of ƒ/8 and a good depth of field.

It can be hard to level the ocean surface in the frame and to properly frame the subject. Although the surface is fairly level here, it is not a critical factor if the subject dominates the image.

Before getting in the water I made sure I knew where I was relative to the sun. I asked the boat captain to keep the sun to starboard side, and I got in on the port side. At a subject-to-camera distance of 10 feet, the sunlight illuminated the dolphins extremely well and provided good separation and shade contrast of the lighter-colored dolphin against the rich blue background water. Shooting into the sun, the dolphins would have had almost no separation, and my resulting images would have lacked contrast and detail.

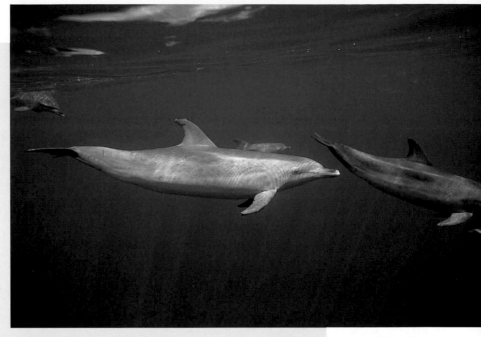

Spotted Dolphins

Brian Skerry

Camera and lens: Nikon N90 with 24mm lens inside Subal housing. **Film:** Kodak E100. **Aperture:** ƒ/8. **Shutter speed:** 1/125. **Subject distance:** 10 feet. **Camera angle:** level. **Strobe:** none.

CREATING A RELATIONSHIP WITH THE SUBJECT

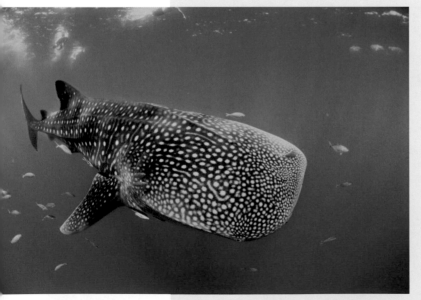

Whale Shark

Brian Skerry

Camera and lens: Nikon F5 with 16mm fisheye lens inside an Aquatica housing. **Film:** Kodak E100SW. **Aperture:** ƒ/5.6. **Shutter speed:** 1/60. **Subject distance:** 15 feet. **Camera angle:** slightly downward. **Strobe:** none.

This photograph was made in the waters off western Australia at a depth of about 15 feet. To capture the entire 25-foot-long shark in the frame, I clearly needed a wide-angle lens. I used a 16mm fisheye lens on a Nikon F5 camera inside an Aquatica housing. The 16mm fisheye lens has an angle of coverage of 180 degrees with exceptional depth of field. Although this fisheye lens produces an image with rounded edges, the distortion is not especially noticeable in open water scenes like this one.

At a subject distance of 15 feet, the 16mm lens keeps the whale shark in sharp focus from nose to tail while also giving the appearance that I am farther away. It also makes the divers at the top left of the frame look smaller, in turn making this large animal look even larger.

I got dropped off in the water a good distance ahead of this shark, which was approaching. I slowly snorkeled towards it, periodically checking the sun's position. Since the shark and I were swimming toward each other, I could have easily chosen to dive to either side of the shark, as long as I was sure to keep the sun at my back.

The shark and I were almost level when I made the picture, but I aimed the camera slightly downward for better composition. In general, it is almost always better to point your camera upward at your subject since down angles tend to produce poor light. In this case, however, the combination of shallow, clear water and plenty of ambient light gave me lots of latitude. I aimed my light meter at the water behind the shark and adjusted my settings down a full stop to slightly darken the background. The photo would still have come out fine at the meter's recommendation, although my decision to stop down simply gave me a slightly richer blue backdrop. Even with that one-stop adjustment, the bright ambient light provided more than adequate shade contrast to separate the shark from the background.

EXPLORING THE UNKNOWN

This photo was made in the Adirondack Mountains in upstate New York. It illustrates exploration of the rare world below a frozen lake's surface. To give the viewer a sense of perspective, it was important that the photo include the triangular hole in the ice that let us enter (and exit) this underwater world.

An image depicting exploration should also include an explorer, a diver. I needed a wide-angle lens that could keep the diver and the hole in the frame and give the perspective of distance. My camera system was a Nikon F3 with a Nikon 20mm lens inside an Aquatica housing. Visibility was perhaps 30 feet horizontally and slightly greater vertically.

Because your eye is drawn to the diver first, he is the primary subject. I needed to frame the diver against the lighter ice canopy above to achieve separation. With the diver and my photograph oriented vertically, I would have needed to be almost directly below the diver to completely contrast him against the lighter green above.

Instead, I chose to position myself slightly below and about 20 feet away and to point my camera upward about 45 degrees. This angle provided separation on most of the diver's body, allowing his lower half to darken toward the bottom of the frame. Under these conditions, the diver is rendered as a silhouette, and scatter and detail become less of a concern.

Light levels were fairly low on this dive. A level, horizontal available-light shot would not have produced good results, and an upward vertical perspective yielded a much more dramatic image. The diver's flashlight adds further interest to the photograph, and even my own tether line does not detract. My camera's light meter provided the setting of ƒ/4 at 1/60at this particular angle. Either ƒ/2.8 or ƒ/5.6 might still have produced acceptable results, given the gradual top-to-bottom darkening of the frame.

A fair number of the photographs in this book are vertical. There are two reasons for shooting both horizontal and vertical photographs. An important one is that book and magazine layouts need both horizontal and vertical images. You will probably need to submit a horizontal picture if you want it published as a double-page spread. But if you're shooting for the cover, you will almost always need a vertical shot. A more important reason for alternating from vertical to horizontal is that the subject's orientation will lend itself better to one of the two formats.

The diver is about a third of the way from left of the frame and about an equal distance up from the bottom. An old composition trick is to place a mental grid over a potential image, dividing it into horizontal and vertical thirds. The image is most appealing if its subject is placed where a vertical and a horizontal line intersect.

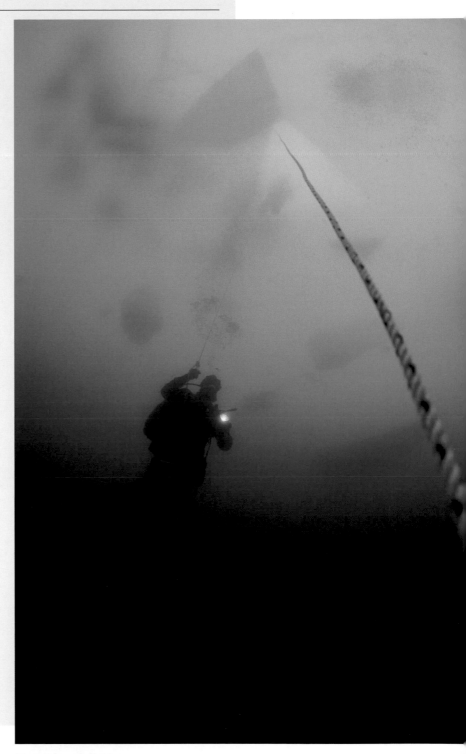

Diver Beneath the Ice

Brian Skerry

Camera and lens: Nikon F3 with 20mm lens inside Aquatica housing. **Film:** Kodak E100. **Aperture:** ƒ/4. **Shutter speed:** 1/60. **Subject distance:** 20 feet. **Camera angle:** approximately 45 degrees upward. **Strobe:** none.

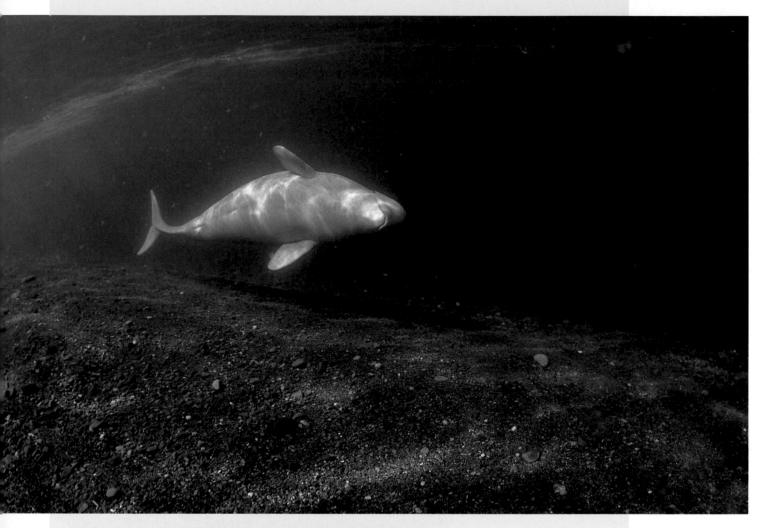

REVEALING THE SUBJECT IN ITS ENVIRONMENT

This photograph of a beluga whale was made in Nova Scotia, Canada. I used a Nikonos 5 camera with a Sea & Sea 12mm lens. This lens is superwide and offers great depth of field. The region in which this whale was photographed is an estuary, where water clarity varies greatly. I wanted to take a picture that would show something of the animal's surroundings, which could be a challenge with limited visibility. I chose the 12mm lens because it allowed me to get close to the whale and reduced scatter in the water column. It also showed some of the bottom geology and held everything in focus. This photo, however, could have been made with any one of several wide-angle lenses, such as the 16mm fisheye in a housing.

I positioned myself in a slight trough in the gravel bottom with the sun at my back and waited for the beluga to swim into position. Although there was a fair amount of ambient light because I was only about 15 feet deep, the background water was dark green in color. Fortunately, the whale was white, which provided good shade contrast. The sun shining on the subject also brought out some of the details in the animal's body.

I used an upward camera angle of approximately 45 degrees to further separate the subject from the background and a shutter speed of 1/125 of a second to reduce blurring resulting from movement. I metered the water behind the subject and adjusted my aperture to the f/4 setting indicated by the light meter.

It is important to consider the composition of a swimming animal, like the beluga in this photograph. For the photo to imply that the animal is in fact swimming, the composition must be framed with sufficient negative space in the proper direction. In this photograph, plenty of negative space was created on the right side of the frame. This allows the person viewing the photograph to imagine the whale swimming over the bottom and gives "movement" to a moment in time.

Beluga Whale

Brian Skerry

Camera and lens: Nikonos V with Sea & Sea 12mm. **Film:** Kodak E100. **Aperture:** f/4. **Shutter speed:** 1/125. **Subject distance:** 8 feet. **Camera angle:** approximately 45 degrees upward. **Strobe:** none.

WORKING WITH NEGATIVE SPACE

This photograph of a gray reef shark was taken in the Coral Sea. I used a Nikonos camera with a Nikonos 15mm lens. I prefocused the lens at a distance of 1 foot before the shark approached.

Having the sun at my back did two important things for the photograph. First, it darkened the water above the horizon; second, it illuminated the white face of the shark. This combination provided acceptable separation between subject and background. A slightly upward camera angle was used to create separation between the white face of the shark and the dark blue open water above the horizon. Had the shark been photographed against the sand, its white face would have closely matched the white shade of the sand, resulting in a loss of contrast and a useless photograph. As in most available-light photographs, the upward angle was of critical importance.

There are two important components of negative space in this photograph. The diver, although out of focus, provides a secondary point of interest and adds depth to the photograph. The diver was darkly dressed and contrasted well with the bright sand. The sandy horizon is also of value to the photograph because it tells something about the environment in which the animal lives. Although this photograph would still carry considerable impact if the negative space was composed only of blue water, the two additional components of diver and sandy bottom extend the photograph's value. It is, however, very important that components of negative space be simple and of secondary prominence in the frame to keep them from distracting from the subject.

You might suspect that I wasn't thinking of all of these factors while preparing to photograph an approaching shark. Although I may have instinctively considered many factors subconsciously (such instincts come with experience), I was consciously thinking of only two things: one, shoot when the shark is at the right distance; and two, get below the subject.

Shooting at the proper distance gave me a sharp image. Getting below the subject gave me good separation. These were the two most important considerations. I gave other factors of composition much more careful consideration several weeks later when I edited the photographs. The shots that did not have the proper ingredients were stored in my round file, never to be seen again.

The wideness of the 15mm lens did two important things for this photo. First, it allowed me to shoot the entire face of the shark from a foot away. This nearly eliminated the scattering of light from the subject to the lens. Had I taken the same photo with a 35mm Nikonos lens, it would have been less sharp. This is not because of the quality of the lens but because I would have had to be three feet from the subject and the light would have been more scattered. Also, the wideness of the 15mm lens allowed more of the background to be included, which would have been eliminated with a narrower lens.

Gray Reef Shark

Howard Hall

Camera and lens: Nikonos II with 15mm lens. **Film:** Kodachrome 64. **Aperture:** ƒ/8. **Shutter speed:** 1/125. **Subject distance:** 1 foot. **Camera angle:** slightly upward.

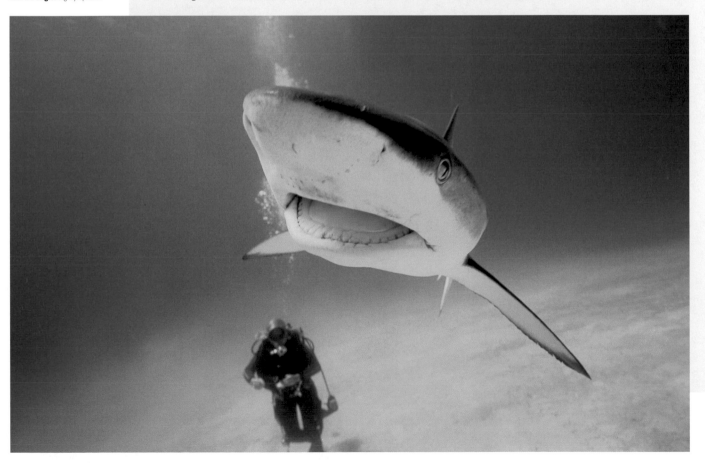

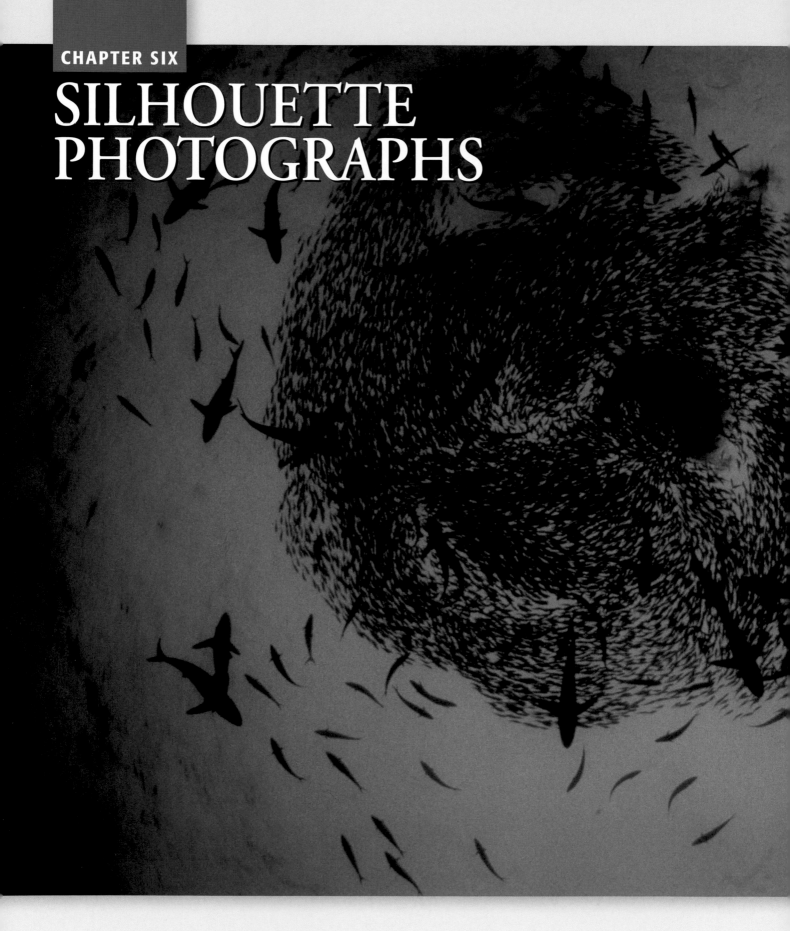

SILHOUETTE PHOTOGRAPHS

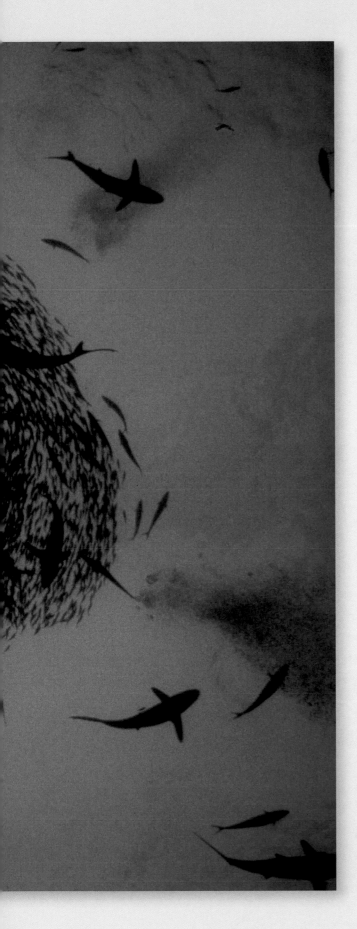

nderwater silhouettes are surprisingly easy to photograph, and they require a minimal amount of photographic equipment. If you are on a budget, you can get by with just a camera and nearly any wide-angle lens. Light meters are certainly useful, but if necessary you can get by without one. In addition, good silhouette photographs can be taken in a wide variety of conditions. Silhouettes are often the best type of photograph to take when water conditions and subject material make separation, or shade contrast, difficult.

The idea in making silhouettes is to take an exposure of the bright water overhead with your subject between you and the surface. The subject will then be underexposed, making it appear very dark against the bright background. It is best to position yourself to aim your lens at the brightest part of the surface. This is where the sun will be.

Circle of Feeding Sharks
Howard Hall

ELEMENTS OF SUCCESS

The elements involved in creating a successful silhouette photograph are very basic. You must control your relationship to your subject and to the sun, and you must calculate correct exposure. The following sections provide details on creating a sunburst effect in your silhouette photographs and on controlling your exposure.

SUNBURST EFFECT

If it is a sunny day and you are within sight of the surface, the sun will appear as a bright light with dramatic rays penetrating down and out to the sides. Usually, you will want to include this sunburst in the frame. You may also want to place your subject directly between the sun and the lens. This will produce the most dramatic silhouette effect, with your subject in the center of a brilliant pool of light with the sunbeams shooting out in all directions.

Since these sunbeams move very rapidly, it is best to shoot at a shutter speed of at least 1/125 in order to freeze their motion. The faster the shutter speed, the more dramatic the sun's rays will appear.

The center of the pool of light is always extremely bright. If you take your exposure reading directly there, you will usually get a maximum reading. Therefore, to achieve the sunburst effect, you should take the reading to one side of the sun by about 20 degrees. Under most clear water conditions and on a clear day, where the surface is visible and you are aiming into the sun, your exposure will be about $f/11$ at 1/125. This provides a good guide for bracketing if you do not have a light meter (based on ISO 64 film).

EXPOSURE

You will find that an unusually wide range of exposures will work when making silhouette photographs. If $f/11$ gives you a good photograph of the sunburst with your subject in silhouette, $f/8$ will probably be equally acceptable. The difference is that the pool of light around the sun will be larger.

To a large extent, you'll get good exposure results with an educated guess. Even if you use a light meter, you should bracket your exposures. Most exposures should produce good results, but you might find that you like one effect better than another.

If your subject is on or near the bottom, make sure that enough of it is surrounded by bright water so that it will be easily recognizable when seen in outline.

The subject does not always have to be in the center of the sun. Sometimes you might want the sun to be at the top of the frame with the subject in the middle. If that's the case, take the exposure reading on the water directly behind the subject, the most important part of the shot to expose properly. The water above the subject may be underexposed, but if the water directly behind the subject is exposed properly, then the photograph will usually be acceptable.

If the sun is not visible, or if you prefer to shoot against a more evenly exposed background by aiming away from the sun, then the background will appear an even blue or green color. If the subject occupies a large amount of the frame, as with a school of fish or sharks (as in the example photo, "Hammerhead Sharks," on page 62), you should take your reading at the lowest part of the frame, where the subject is still visible. It is better to have the top of the frame overexposed than to have the bottom of the frame underexposed, as with underexposure you would lose that part of the subject.

Great White
Brian Skerry

Great white shark photographed in South Australia.

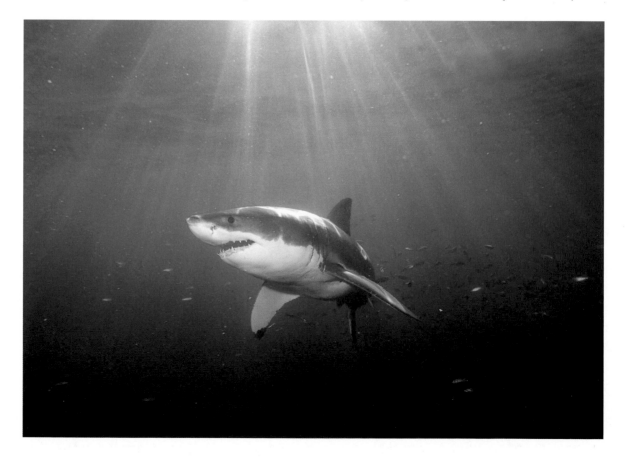

MASTERING THE FUNDAMENTALS

Here are the points to remember for taking successful silhouette photographs:

- Use a camera with a wide-angle lens (35mm or wider), and use a light meter if you have one. Set your shutter speed at 1/125 (unless you need the additional exposure of 1/60), and focus on your subject's distance.

- Position yourself so that the subject is between your lens and a bright part of the surface. Take your light-meter reading about twenty degrees to one side of the sun, if you have positioned your subject directly in the sun's path. If your subject is not in the sunburst, take your reading on the water behind the subject. Bracket your exposures.

Diver and Shark
Howard Hall
Camera and lens: Nikonos III with 21mm lens. **Film:** Kodachrome 64. **Aperture:** f/16. **Shutter speed:** 1/125. **Subject distance:** 10 feet. **Camera angle:** straight up. **Strobe:** none.

Beluga Whale near Buoy
Brian Skerry
Camera and lens: Nikon N90 with 20mm lens inside a Subal housing. **Film:** Kodak Lumiere. **Aperture:** f/16. **Shutter speed:** 1/125. **Subject distance:** 12 feet. **Camera angle:** straight up. **Strobe:** none.

SETTING UP A SILHOUETTE

This is a silhouette of a diver and a blue shark. I used the Nikonos with a 21mm lens focused at 10 feet and then shot the photo straight up into the sun. I positioned myself below the diver so that he remained between the sun and the lens. I then swam with the diver, holding that position until the shark approached him.

I estimated the exposure to be f/16 with a shutter speed of 1/125. This exposure proved to be about the minimum possible, given that the shark turned out to be just barely exposed. Exposure increases of one or two stops might also have produced acceptable results: the effect of increasing exposures in this type of photograph is to enlarge the pool of light surrounding the sun.

Estimating exposures for silhouette photographs is not all that tricky. It's likely that the exposure would have been acceptable if I had shot anywhere from f/16 to f/8 at 1/125. This means that it is possible to shoot good silhouettes without a light meter under most conditions, especially if you bracket your exposures. Setting the shutter speed at 1/125 produced the dramatic sun beams in this photograph by freezing their motion.

WAITING FOR THE SHOT

This photograph shows a beluga whale swimming near a navigational buoy in a Canadian bay. The visibility on this day was only about 10 feet and very murky. I noticed that the whale had been swimming around this buoy and decided to try making a silhouette since the visibility was poor.

I swam down the buoy's anchor chain to a depth of about 12 feet and pointed my camera straight up at the surface. I used a Nikon N90 in a Subal housing with a 20mm lens. I wanted to use a shutter speed of at least 1/125 to freeze the motion of the sunbeams. I metered the water off to the side of the sun and obtained a reading of f/16. At f/16, the majority of the frame is well exposed, except that the corners have darkened. At f/22, the darkened portion of the frame would have increased and left a much smaller portion of area for shade contrast in the center.

The element I could not control was whether the whale would swim into the perfect position within the sun's pool of light. After waiting for quite some time, the beluga moved to the magic spot and I fired the shutter. Because I did not have to wait for a strobe to recycle, and because my camera had a built-in motor drive, I was able to fire several frames very quickly. Even so, this was the shot I liked best as I edited my results.

COMPOSING YOUR SUBJECT AND CHOOSING AN EXPOSURE

This school of hammerhead sharks was photographed in the Sea of Cortez in Mexico. In this case I wanted a dramatic shot of a large group of animals and not just an individual. Although water visibility was nearly 100 feet at the time, I still faced challenges in achieving the shot I had in mind.

In order to get a large group of sharks in a single frame, I had to shoot from at least 10 feet away, rendering a strobe all but useless. And since the hammerheads were at a depth of 50 feet, a level shot would have produced a photograph with scattered images and no shade contrast. Thus, I chose to enhance shade contrast by shooting the sharks in silhouette.

The lens I chose was the Nikonos 28mm lens. In this situation, using the 15mm lens would have been a mistake. The school of sharks was spread out with about 6 to 10 feet between the animals. With the 15mm lens I could have framed one shark properly in the foreground, but at more than 10 feet away, the sharks would have been uselessly tiny in the frame.

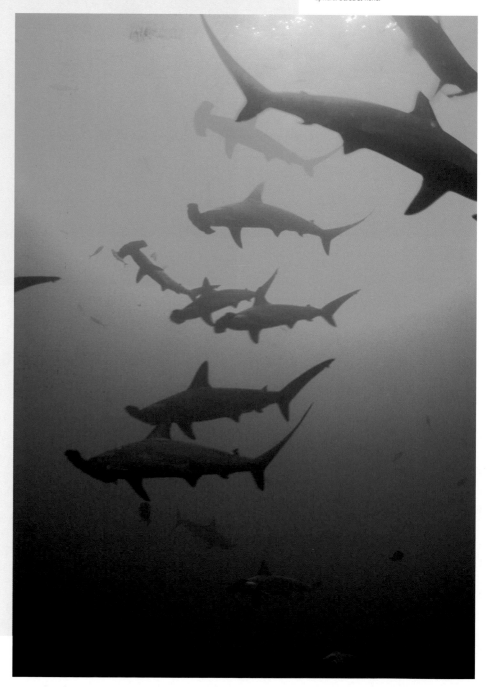

Hammerhead Sharks

Howard Hall

Camera and lens: Nikonos III with 28mm lens. **Film:** Kodachrome 64. **Aperture:** ƒ/5.6. **Shutter speed:** 1/60. **Subject distance:** about 15 feet on the sharks in the center of the frame. **Camera angle:** 45 degrees upward. **Strobe:** none.

With extreme wide-angle lenses such as the 15mm, the subject-to-camera distance is critical. If you are too close, the subject overfills the frame; if you are too far away, the subject becomes a tiny speck. Therefore, in the case of the school of hammerheads, it was better to shoot from a greater distance with the 28mm lens and get more of the sharks in the frame at a more acceptable size. A 35mm Nikonos lens may also have been an effective choice for this type of photograph.

Unlike the example photograph "Beluga Whale near Buoy" (on page 61),this photo was taken not by aiming straight up into the sun but rather by aiming upward at a 45-degree angle. This angle produces an exposure problem with a wide-angle lens. The top of the frame will include the sun (at an exposure of about ƒ/16), while the bottom of the frame, which is only a few degrees above horizontal, will have an exposure of about ƒ/5.6. The challenge is this: how do you set the exposure when the subject extends from the top of the frame to the bottom?

You take your reading on the lower part of the frame. If the top of the photo is overexposed by several stops, it will still produce acceptable silhouettes. But if the bottom of the frame is several stops underexposed, the subject will not be visible there. In this case, I took my reading from where I thought the bottom of the frame would be and used ƒ/5.6.

The exposure problem would have been greatly minimized if I had shot a horizontal rather than a vertical photograph, but the subject was oriented vertically and was much better framed that way.

Since ƒ/4 would have given me poor depth of field with the 28mm lens, I chose to set the shutter speed at 1/60 instead of 1/125. The faster shutter speed, however, would have produced a sharper image.

CREATING DRAMA

I made this photograph of a manatee with the intention of portraying a solitary endangered animal within its environment. I had made other pictures of manatees, including portraits, which showed them as endearing, playful animals. For this picture, however, I wanted something that illustrated less of an individual's features but rather an image that better represented all manatees. I therefore chose a silhouette.

With a 16mm fisheye lens and its 180-degree angle of coverage, I was able to include a great deal of the surrounding environment in the picture. Because this lens has such extreme depth of field, I was able to photograph the manatee and the surrounding environment from a close distance of about 10 feet.

From my position under water, the sun was low in the frame. This would not give me a sunburst effect, but it was still enough to provide enough light, and therefore shade contrast, for a silhouette. Additionally, given that the sun was not directly behind my subject and that my depth was shallow, I was able to capture blue sky in the photograph. Although the freezing of sunbeams is a very dramatic effect, the presence of surface features such as clouds and sky adds a pleasing element to a photograph. Non-divers can easily relate to such elements in underwater photographs. In this case it was especially poignant since manatees are air-breathing mammals.

I was using a Nikon F3 camera inside an Aquatica housing, and I pointed it straight up to get my meter reading of f/8 at 1/60. Even though the manatee was moving, it was not swimming too fast, and an exposure of 1/60 still produced a sharp photograph. I got into position and simply waited for the manatee to swim into frame. Swimming upside down, I moved in unison with the animal, shooting several frames.

Manatee

Brian Skerry

Camera and lens: Nikon F3 inside an Aquatica housing with 16mm fisheye lens. **Film:** Kodachrome 64. **Aperture:** f/8. **Shutter speed:** 1/60. **Subject distance:** 10 feet. **Camera angle:** straight up. **Strobe:** none.

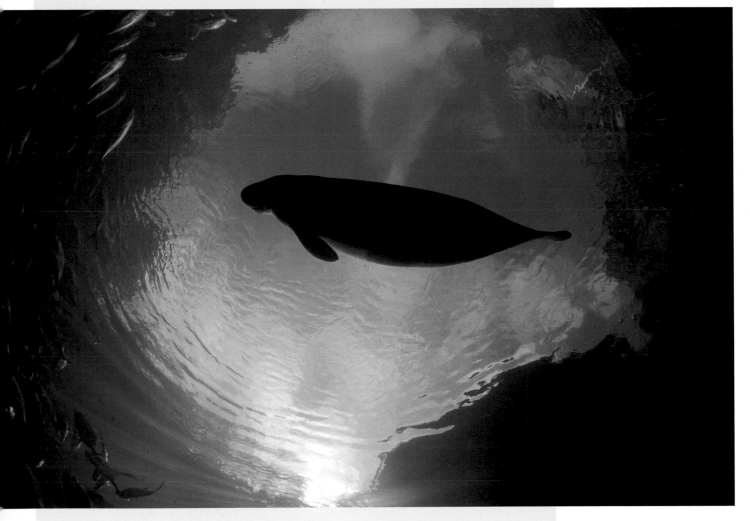

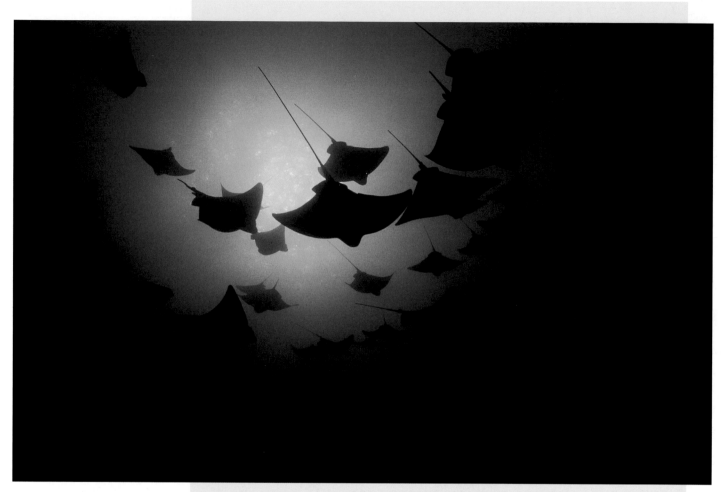

Bat Rays

Howard Hall

Camera and lens: Nikonos III with 15mm lens. **Film:** Kodachrome 64. **Aperture:** *f*/8. **Shutter speed:** 1/60. **Subject distance:** 10 feet. **Camera angle:** slightly less than straight up. **Strobe:** none.

MULTIPLYING INTEREST WITH MULTIPLE SUBJECTS

This photograph of bat rays was made off of San Clemente, California. It was late in the day with the sun low on the horizon, and I was swimming at a depth of about 100 feet when a great shadow passed over my head. I looked up to see hundreds of bat rays silhouetted against the golden light.

Water visibility was about 60 feet, more than adequate for a silhouette photograph. In some respects this photograph is similar to the example photograph "Hammerhead Sharks" (on page 62). The difference, though, is that the spacing of the bat rays was tighter and there were layers upon layers of rays. The 15mm Nikonos lens worked extremely well in this scenario, permitting me to get closer (within 10 feet) and still include many bat rays in the frame. Set at a distance of 10 feet, at *f*/8, the Nikonos 15mm lens has a depth of field from 2 feet to infinity. With rays "flying" all around in this scene, this lens' incredible depth of field assured that nearly all of them would be held in sharp focus.

I obtained my light meter reading with a separate meter (as the Nikonos 3 has no built-in light meter) by aiming at the water just to the side of the sun. At this setting, the frame would gradually darken away from the brightest point, which is the sun. With the number of bat rays in the frame, I knew that enough of them would be silhouetted to make the photograph interesting. Unlike silhouette photos taken with the sun high in the sky, this one gives more of a feeling of dusk, with the late-day sun already setting and its light more diffused.

TAKING ADVANTAGE OF A NATURAL COMPOSITION

Shortly after beginning a dive on a French Polynesian reef, I looked up and noticed a gray reef shark cruising near the surface. As I was at a depth of about 25 feet, the shark was quite a distance away. I liked the way the shark looked, naturally silhouetted and swimming all alone within the rich Pacific blue sea—although I did fear that this might indeed be the infamous "lone shark" I had heard tell of!

I had a 24mm lens on a Nikon F5 camera inside an Aquatica housing and brought it to bear on the shark above. Despite the distance, the view was appealing. It gave the sense of the apex predator at the top of the food chain. Normally, scatter would have a negative effect on sharpness at this subject distance. The exceptional visibility on this dive, however, permitted this shot without any loss.

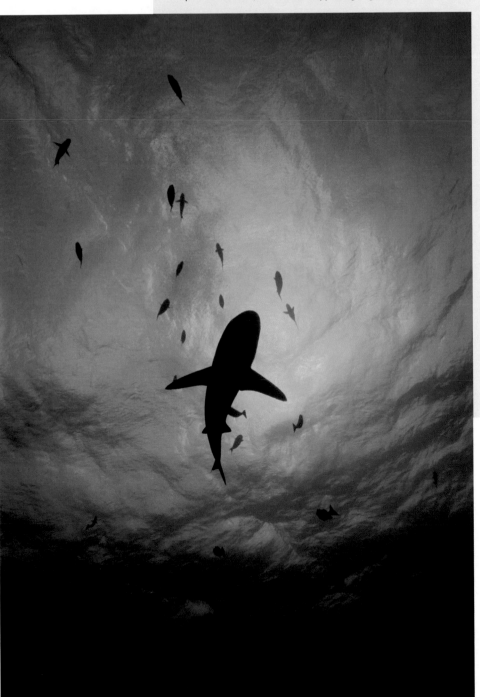

I manually focused on the shark, which meant my lens focused at infinity, and metered the brightest part of the surface water. Although the sun was fairly bright in the sky, it did not create the sunburst effect. This could have been because of some cloud cover and because of my depth. At ƒ/11 and 1/125, however, the light did give a nice texture to the surface water.

I waited for the shark to swim into position within the area of brightest light and fired the shutter (all the while trying to keep my exhalation bubbles from getting into the frame). I fired several frames, but I preferred this image for the positioning of the shark's body.

With the shark framed at the center, the negative space in this photograph would allow it to be used effectively as a magazine or book cover. There's plenty of room at the top and on the sides for text. Because of the negative space and the subject's sharpness, the image could also be cropped tighter in publishing without sacrificing any of its quality.

Gray Reef Shark
Brian Skerry
Camera and lens: Nikon F5 with 24mm lens inside Subal housing.
Film: Kodak E100SW. **Aperture:** ƒ/11. **Shutter speed:** 1/125.
Subject distance: 25 feet. **Camera angle:** straight up. **Strobe:** none.

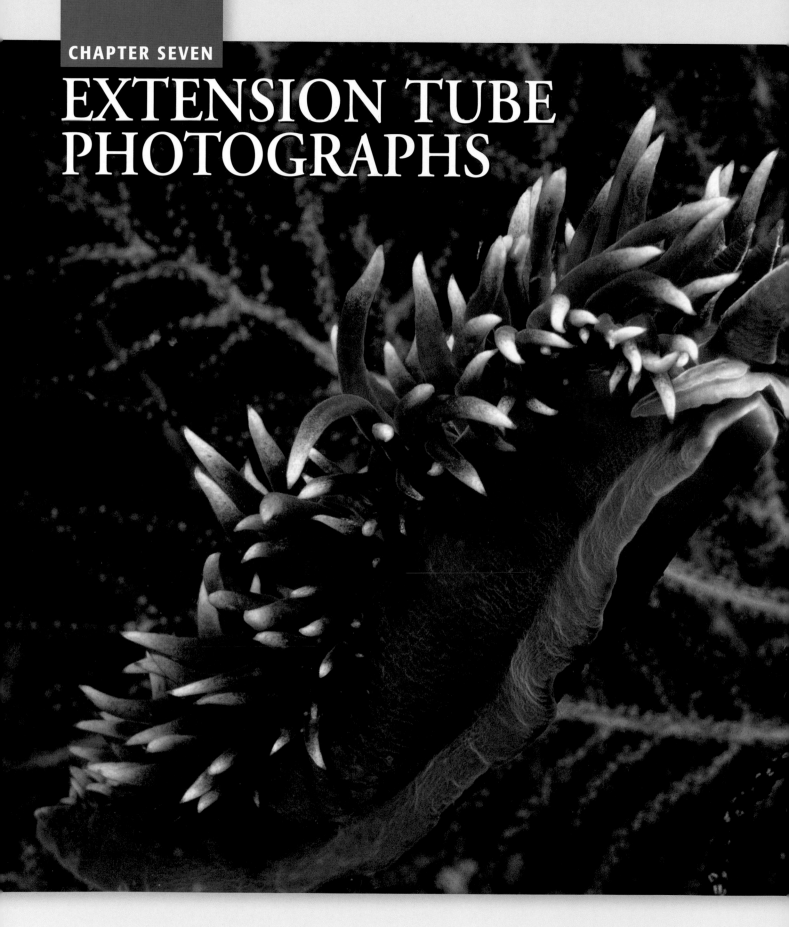

EXTENSION TUBE PHOTOGRAPHS

E XTENSION TUBE PHOTOGRAPHY is a type of underwater macro photography. It is easy to do, relatively inexpensive, and can produce professional quality results. For these reasons, extension tube photography underwater photograph is ideal for the beginning underwater photographer. The example photographs discussed in this chapter were taken with equipment consisting of nothing more than a Nikonos camera, one or two strobes, and extension tubes.

Extension tube photography also provides the beginning photographer with a little extra latitude when it comes to finding interesting subjects. As a form of macro photography, the subjects you capture using extension tubes are small. Their interest usually comes from a plethora of detail, intricate color arrangement, or striking natural geometric form. Getting up close to a small subject also generally allows you to capture expression that is easily missed with the naked eye.

Composing this type of photograph requires attention to color contrast. As the example photos demonstrate, extension tube photography is a good way to produce images with rich, deep color. It's a good idea to understand how light behaves under water, especially the way underwater distance affects the way color is captured on file. Chapter 3, "What Happens to Light Under Water," should provide plenty of information on the subject.

Nudibranch
Michele Hall

ELEMENTS OF SUCCESS

When you're starting out in underwater photography, it is best to specialize in one kind of photographic technique and become adept in that technique before moving on to another type. Too often, novice photographers insist on trying to make all kinds of underwater photographs before they have ever mastered one kind. This often results in consistently mediocre photography.

You will become a much better photographer if you choose one of the techniques in this book and master it thoroughly before moving on. Extension tune photography is an excellent place to start. The equipment is simple, the techniques are simple, and the resulting ratio of good to miserable photographs is very high. Even without knowledge of basic photographic principles (though this approach is not recommended) it is quite possible to achieve publishable images using extension tubes under water.

WHAT IS AN EXTENSION TUBE?

An extension tube is an aluminum tube that mounts between the Nikonos camera and the 35mm lens (also available for the 28mm lens). Extension tubes come in various sizes, described as 1:1, 1:2, 1:3, and so forth. These numbers represent the ratio of subject size to image size on the resulting 35mm transparency. In a 1:1 extension tube photo, the image is life size on the transparency. In a 1:2 shot, the subject is half its full size, and so on. The manufacturer's description of extension tube size, however, is not always the actual subject-to-image ratio. This means that one manufacturer's 1:3 extension tube may be a slightly different size than another manufacturer's similar product.

The extension tube comes with a framer that tells you exactly how far the subject should be from the lens and how large the subject should be for proper framing. The framer is

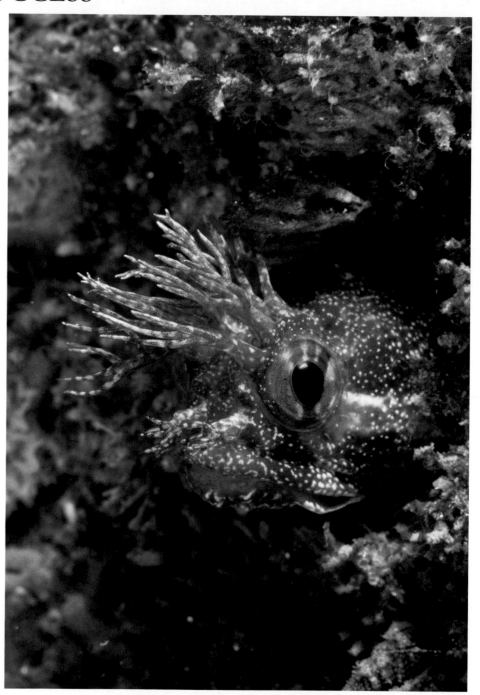

Tidepool Blenny
Howard Hall

Jim Brady

Nikonos V camera fitted with a 28mm lens and a 1:2 extension tube.

necessary because extension tubes create extremely limited depth of field. Without the framer, you would be unable to locate the focus distance and would have difficulty properly framing your subject. The framer makes it easy to choose the size of extension tube that you want to use. You can simply look at the framer and decide whether it will fit the subjects that you want to photograph.

EXPOSURE

In extension tube photography, the strobe is used as the primary light source. This means that the light, which creates the exposure on the film, comes primarily from the strobe (as opposed to coming primarily from ambient light with, possibly, some strobe fill). Because you need to maximize the depth of field, the strobe must be held very close to the subject for you to use a minimum aperture (usually $f/22$). In most cases, ambient light will have no influence on your exposure.

Camera settings for extension tube photography are simple. You preset them before you dive. Aperture is $f/22$ (to maximize depth of field). Shutter speed is 1/60 (to synchronize with the strobe, assuming your camera synchronizes at 1/60), and the focus setting is whatever the extension tube manufacturer specifies (usually 2.75 feet).

Your exposure is determined by how close to the subject you place the strobe. The longer the extension tube (not the framer, but the tube itself), the closer you must hold the strobe to the subject. Since placing an extension tube between the lens and the camera increases the focal length of the lens, aperture calibrations on your lens are no longer accurate. The longer the tube, the less light actually reaches the film. With a 1:1 extension tube, therefore, you must hold the strobe closer to the subject than you do with a 1:3.

This table gives strobe-to-subject distances for bracketing 1:1, 1:2, and 1:3 extension tube exposures. These are only estimates, of course, based on an average-powered strobe and ISO 64 film. You may have to modify these guidelines slightly for your strobe and also make adjustments for various film speeds.

EXTENSION TUBE EXPOSURE GUIDE

Tube Size	First Bracket	Second Bracket	Third Bracket
1:3	6"	9"	12"
1:2	4"	6"	10"
1:1	2"	4"	8"

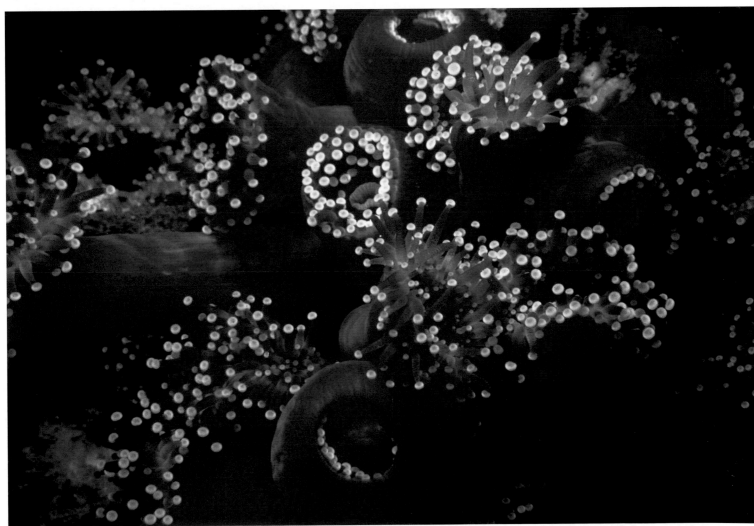

Corynactus
Howard Hall

To bracket your exposures, hold the strobe very close to the subject for the first exposure. Move it back twice that distance for the second exposure and then that far again for the third. One of these exposures will almost always be acceptable. Because the reflectivity of subjects will vary, you should always bracket your exposures.

BACKSCATTER

Backscatter is a major problem for those who are just starting out in extension tube photography. Except in murky waters where visibility is already less than 6 feet, backscatter is almost always caused by the photographer stirring up the bottom in the area around the subject.

There are two ways in which the photographer can stir up the bottom enough to ruin an extension tube photograph. One is simply by flailing on the bottom with his or her arms and legs while trying to stay in one place long enough to make the photograph. The other cause is less obvious. The photographer will often stir up the bottom immediately around the subject by striking it with the framer. If you must use the framer to entice the subject into a better position, do it carefully. Beating the subject senseless with the framer will not only stir up the bottom, but it will usually convince the subject to leave (if it can). It can also bend the extension tube framer, causing it to appear in the photograph. Always approach the subject carefully and place the framer over it as gently as you can.

FRAMING

Framing a subject with an extension tube is not as easy as it might appear. Often minor errors in the positioning of the framer can render the photograph useless. Just as you bracket your exposures, it is a good idea to bracket your framing.

It is best not to leave the framer on the subject between photographs. For one thing, you will have a tendency to disturb the subject when you advance the film. Another reason to remove the framer between shots, perhaps a better one, is that if you shoot all of your photographs with the framer in one place, and it is not placed properly, all your shots just might end up in the round file.

When framing your subjects, draw an imaginary X from the corners of the framer and then try to position your subject at the center of the X. After you shoot, gently lift the framer off the subject, advance the film, and then reposition the framer for the next shot.

The only additional ingredient for making good extension tube photographs is composition. Developing the photographer's eye, or the ability to "see the photograph before you take it," comes with experience. If you can learn to visualize what both subject and negative space will look like in the photograph before you make it, then you will know whether or not to bother with that shot.

SEPARATION

As with other types of underwater photography, getting good separation, or contrast, is also of major importance in extension tube photography. However, unlike in available-light and silhouette photographs, in extension tube photos you must rely primarily on color contrast instead of shade contrast.

Because you will be using a strobe as your primary light source, and because it is often not possible to photograph macro subjects at upward angles to get open water behind them, your strobe will usually produce an even exposure of both subject and negative space. Shade contrast will thus be minimized. But if the subject is a different color than the negative space, then your photographs will have color contrast. Color contrast produces excellent separation.

You must learn to look for color contrast when searching for macro subjects. A photograph of a brown anemone sitting on a brown piece of algae will have very little impact, especially in comparison to a photograph of a red anemone sitting on a piece of blue coral. You can often improve the impact of your macro photographs by aiming upwards to incorporate a water background. With the aperture set at $f/22$, the low ambient light will produce almost no exposure on the film and the background will be black (unless you aim directly up into the sun). Brightly colored subjects against black backgrounds are always exciting.

It is sometimes possible to obtain a blue background in your macro photograph, but it is usually rather difficult. (See example photographs "Spiral Gill Worm" and "Kelp Plant," on pages 73 and 74.) In order to get blue water in the background the lens must be pointed at the part of the surface where the exposure is $f/22$. This means you must point the lens directly at the sun. You will end up with a black background instead of a blue one if your aim is not accurate, but this can also produce a pleasing effect.

COMPOSITION

Photographs should be simple, especially underwater macro photographs. Subject material and negative space should be uncomplicated and very easy to recognize. When you look at a photograph (or more importantly, when your friends and publishers look at it) there should be no question about what the subject is. The subject should reach out and grab your attention immediately, and the shot should include few distractions.

Underwater macro subjects, however, are often unusual and complicated in form, and the negative space in this kind of photograph is also often extremely complex. Although you may readily recognize the subject in your own photograph, laymen or even divers who are unfamiliar with that species of marine life may be confused. There are several things you can do to help simplify your photographs.

Subject size in the framer is very important. If the subject occupies only a small part of the frame, it will often be lost within the complexity of the negative space. You should try to choose subjects that occupy large areas of your frame, say half or more. This way, viewers will not have to search the photograph to decide what the subject is supposed to be.

NEGATIVE SPACE

Your choice of negative space will strongly influence the simplicity of your photographs. If your photograph has a complicated negative space, and your subject occupies a small part of the frame, viewers may have difficulty determining just what you intended to photograph. It is acceptable to have secondary points of interest in your negative space as long as these distractions are minor and do not interfere with a viewer's immediate recognition of the subject. As you read the evaluations of the photographs in this chapter as well as those in Chapter 8, "Reflex Macro Photographs," and Chapter 9, "Marine Wildlife Portraits," you will better understand the techniques involved in using negative space effectively.

USING THE STROBE

Extension tube photographs are best made with a handheld strobe. Usually the Nikonos is mounted on a bracket that has additional mounts for one or two strobe arms. One of these arms should be as short as possible and should be easy to remove from the bracket when you want to make a photograph. Handholding the strobe allows you to bracket your exposures by varying the strobe-to-subject distance as well as varying the position of your light. Holding the strobe by hand also allows you to easily alternate between shooting vertical and horizontal photographs.

It is very important to remember that the strobe is meant to simulate natural light sources: the sun and the sky. One thing that is always true about natural light is that it comes from above. Although this seems blatantly obvious, it is quite surprising how often photographers light their subjects from below or directly from the side and then wonder why their photographs do not look right.

For a good example of the effect of improper strobe positioning, try taking a flashlight into a dark room with a mirror. Stand in front of the mirror and turn on the flashlight from underneath your chin. Perhaps you will like the way your face looks with all the shadows in the wrong places, but this is not very likely.

Remember that your strobe is an artificial sun. Its light should come from above or at a 45-degree angle to either side, but it should never come directly from the side or from below. We are used to seeing shadows in certain positions. If the shadows in your photographs are not in these typical positions, the photograph will be disturbing and unpleasant to view.

MULTIPLE-STROBE LIGHTING

Although one strobe is sufficient to get professional-quality results in extension tube photography, two strobes are markedly better. The reason, again, has to do with simulation of natural light. Natural light comes from two sources: the sun and the sky. The sun produces bright highlights and the sky produces soft shadows.

Light is different on the moon, where there is no atmosphere and therefore no sky. There the sun is the only light source. As you may have noticed in photographs taken on the lunar surface, the shadows are always extremely harsh. Shooting extension tube photographs underwater with one strobe at $f/22$ produces the same effect. You get bright highlights, but the areas where the shadows fall will be pitch black.

The use of two strobes will better simulate natural light. By positioning them at a 45-degree angle on either side of the subject, you will greatly minimize the harsh shadows. If you position one strobe farther away than the other, you will obtain highlights on one side and soft shadows on the other.

The use of two strobes in extension tube and other types of macro photography will significantly increase the number of "keeper" photographs you get from a roll of film. It will minimize photos lost to backscatter as well as photos ruined because important points of interest were shadowed. In addition, using two strobes will increase the quality of the photographs you would have kept anyway.

When you use two strobes in extension tube photography, you will often hold one in your left hand or attach it to the left side of the bracket when it's not in use. The other is attached to the right side of the bracket with a movable arm. Several brackets or trays that are currently on the market allow two strobes to be incorporated. Even older trays not originally designed for two strobes can usually be modified quite easily.

STROBE SIZE

The size and power of the strobe you use for this kind of photograph is relatively unimportant.

Small strobes work just as well as large strobes and, in fact, often much better. If your small strobe is only half as bright as a large strobe, you compensate by simply holding it a little closer to the subject. Thus, power is not very important. Small strobes have the added advantage of being easier to carry, easier to position, and cheaper to buy (so you can afford two). Attempting two-strobe lighting with a pair of large, wide-angle strobes can be extremely awkward.

Jim Brady

Your extension tube photography can be dramatically improved through the proper use of two strobes. In this set-up, a larger strobe is used on one side and a smaller "slave" strobe is used as the second light source.

Bluebell Tunicates
Brian Skerry

The correct positioning of two strobes in macro photography will produce more natural-looking lighting, as with these bluebell tunicates photographed in Cuba.

MASTERING THE FUNDAMENTALS

Here are the points to remember for taking successful extension tube photographs:

- Choose an extension tube that properly fits the size of the subject that you have in mind. Or, when under water, search for subjects that properly fit your frame size.

- Once you have found a subject, draw an imaginary X between the corners of your extension tube framer and place the center of the X carefully on the center of the subject.

- Hold the strobe close for the first photograph. Then remove the framer to advance the film and prepare to bracket your next exposure.

- Use the following guidelines for exposure as a place to start.

 · For a 1:1 extension tube, try holding the strobe 2 inches away from the subject, then 4 inches, then 8 inches.

 · For a 1:2 tube, try 4 inches, then 6 inches, then 10 inches.

 · For a 1:3 tube, try 6 inches, then 9 inches, then 12 inches.

- For nearly any strobe that you use under water, these guidelines should provide good exposures. After your first roll of film, you may need to modify the guidelines slightly, depending on your own equipment.

- If you are using two strobes, your exposures will be the same. Using two strobes instead of one will not greatly affect your exposures.

- Before the dive, preset your camera to $f/22$, 1/60 (or another proper synch speed) and at minimum focus. (See the extension tube manufacturer's specifications for focus settings.) If your strobe has multiple power settings, use medium or low power to decrease the recycle time.

ANTICIPATING THE SHOT

Michele Hall took this photograph of an olive sea snake in the Coral Sea. Instead of chasing after the sea snake and photographing it with a downward angle as it swam over the bottom, Michele positioned herself at the edge of a reef near where the snake was searching for food. In order to get a level or upward angle on the animal, she waited until the snake approached the edge of the reef. She anticipated where it would go and positioned her extension tube framer accordingly. Often the snake went in the wrong direction, and Michele had to reposition herself. But occasionally the snake swam right where she predicted and into her framer.

By positioning herself at the edge of the reef, Michele was able to photograph the sea snake at a slightly upward angle. Had she been on top of the reef, all she could have achieved would have been downward shots. The upward angle created the contrast between the white coral and the dark water background. It also gave the photograph more impact by allowing the viewer to better see the face of the snake and increasing eye contact. Because the photograph is taken at an upward angle, the snake seems to be looking at you as it swims directly in your direction.

Michele illuminated the photograph with two small strobes. One strobe was handheld at the upper left of the frame, and the other was mounted on the bracket at the upper right.

Olive Sea Snake

Michele Hall

Camera and lens: Nikonos II with 35mm lens and 1:3 extension tube. **Film:** Kodachrome 64. **Aperture:** $f/22$. **Shutter speed:** 1/60. **Subject distance:** 8 inches with lens set at infinity with 1:3 extension tube. **Camera angle:** slightly upward. **Strobe:** two small strobes, one hand-held at upper left, the other mounted on bracket at upper right.

COMPOSING A UNIQUE SHOT

Michele Hall also took this photograph of a spiral gill worm. In this photograph she used a 1:1 extension tube, which means the size of the image on the 35mm transparency is the actual size of the subject itself.

Spiral gill worms are one of the most common macro subjects found in coral reef areas, and thousands of photographs of these tiny animals have been published. But the composition of Michele's spiral gill worm photograph makes this shot unique. More than the subject itself, it is the way in which she photographed the negative space that gives this photograph its impact.

She chose to shoot the photograph vertically and managed to position the sun at the top of the frame, creating a blue water background. This is not an easy thing to do given that the lens must be very carefully pointed toward the sun to get this effect. Some of her attempts resulted in missing the sun, yielding more typical black backgrounds (which, though effective, are not nearly as striking as this photograph).

Michele made this exposure by holding the strobe very close to the subject—about 3 inches away. She bracketed the exposures by first positioning the strobe as close as possible, then backing off about an inch and a half, and then backing off another inch and a half. Her middle bracket proved to be the best exposure.

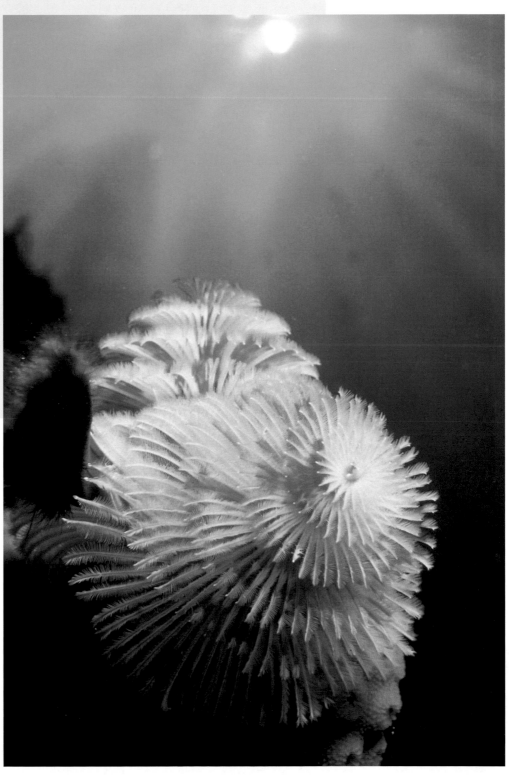

Spiral Gill Worm
Michele Hall
Camera and lens: Nikonos II with 35mm lens and 1:1 extension tube.
Film: Kodachrome 64. **Aperture:** ƒ/22. **Shutter speed:** 1/60.
Subject distance: 1:1 extension tube (focus preset at 2.75 feet).
Camera angle: straight up.
Strobe: one small strobe held directly over the subject.

ORIENTING THE SUBJECT IN THE SHOT

This photograph of a kelp plant is also Michele's. This time, she used a 1:3 extension tube and two small strobes. As she did in the example photograph "Spiral Gill Worm" (on page 73), Michele chose an extremely common subject and created a unique photograph with her careful consideration of negative space.

Again, she managed to create a bright water background in the photo by shooting straight up at the sun. Although she did not actually get the sunburst in the frame as she did in the example photograph "Spiral Gill Worm,"

her results were close enough to produce nice color. The negative space composition makes this photograph a standout among hundreds of other kelp shots.

Michele also recognized the obvious vertical orientation of the subject and therefore shot the photograph vertically. A horizontal photograph of this subject in the same position would have produced an awkward composition.

Michele used two small strobes for this photograph, which helped produce even exposure and soft shadows. The strobe on the upper right was attached to her Nikonos bracket and the strobe on the left was handheld.

The exposure was determined with the handheld strobe. Michele bracketed by first holding the strobe about 3 inches from the subject, then 6 inches, and finally a foot away. Her second strobe was already positioned at a distance of a foot, allowing it to fill in shadows without greatly influencing the exposure.

Kelp Plant

Michele Hall
Camera and lens: Nikonos III with 35mm lens and 1:3 extension tube.
Film: Kodachrome 64. **Aperture:** ƒ/22. **Shutter Speed:** 1/60.
Subject Distance: 1:3 extension tube (lens focus preset at 2.75 feet). **Camera Angle:** straight up.
Strobe: two small strobes.

Garibaldi

Howard Hall
Camera and lens: Nikonos II with 35mm lens and 1:3 extension tube. **Film:** Kodachrome 64. **Aperture:** ƒ/22. **Shutter speed:** 1/60. **Subject distance:** 1:3 extension tube (lens focus preset at 2.75 feet). **Camera angle:** about 45 degrees upward. **Strobe:** one wide-angle strobe placed at the left of the frame about 10 inches from the subject

CREATING AN IMAGE WITH PATIENCE (AND BAIT)

This photograph of a Garibaldi was among the first three rolls of film that I ever shot under water. It was taken with a 1:3 extension tube and a single wide-angle strobe.

In case you think that I simply approached this fish with an extension tube and put it on his face without his knowing it, I'll let you in on a secret. I used the old underwater photographer's trick of bribing the animal with a food handout. I placed the food on a rock and positioned the camera with the extension tube pointing up about 45 degrees, right over the food. When the fish tried to get a bite, he also bumped into the extension tube. Every time he did, I took a picture.

This process took nearly an entire dive. I waited as quietly as possible with the strobe handheld at the left of the lens (about 10 inches from the fish) as the fish worked up enough courage to try for another bite.

I shot 36 exposures during the dive and most of them yielded ludicrous results. Some had only a pectoral fin. Some were poorly exposed brackets. Some were miserably out of focus, and in some there was no fish at all. But among these I got one "lucky" shot. Remember, however, what luck is. The more you shoot and bracket with a technique, the better your chances of getting "lucky."

The negative space in this photo is simply black. This is typical for most extension tube photos that are shot against an open water background. Although the black does not serve to describe the subject's environment, it is quite effective in terms of composition in photographs with brightly colored animals.

Had I taken this photo against a rock, causing the background to be other than black, I would have lost some of the impact. To get clean, black backgrounds, you must shoot at upward angles. Upward angles also produce photographs with more interesting perspectives and increased impact.

FRAMING WITH AN EYE TO NEGATIVE SPACE

This photograph of soft coral combined techniques that are described in some of the previous extension tube photo chapter. The translucent white branches of the coral would naturally contrast well when framed against a black water background. Because of the coral's translucent body, some of the black background can actually show through, which adds a nice effect.

To achieve this contrast, I searched for a section of coral that provided the proper negative space for framing nicely against the background water. The camera angle was straight up. The branches were also framed for a pleasing composition, with the center branch pointed diagonally towards the upper left of the frame. Although a horizontal photograph could have been made, the orientation of the branches lent themselves better to a vertical format.

Unlike the example photographs "Spiral Gill Worm" and "Kelp Plant" (on pages 73 and 74), the straight upward camera angle did not result in a brighter background. That was because this photograph was taken during a night dive. This subject was also at a greater depth than the subjects of those other two photos and was not pointed directly at the sun. Even if it had been photographed during the day, therefore, a black background would still have resulted.

Two strobes were used, with the right one remaining mounted on the camera tray bracket and the left one being handheld. The right strobe provided fill lighting, while the left handheld strobe was moved gradually away to bracket exposures.

Soft Coral

Howard Hall
Camera and lens: Nikonos III with 35mm lens and 1:3 extension tube. **Film:** Kodachrome 64. **Aperture:** ƒ/22. **Shutter speed:** 1/60. **Subject distance:** 1:3 extension tube (lens focus preset at 2.75 feet). **Camera angle:** straight up. **Strobe:** two small strobes, one handheld at upper left, the other mounted on bracket at upper right.

SHOOTING FOR DEPTH AND DETAIL

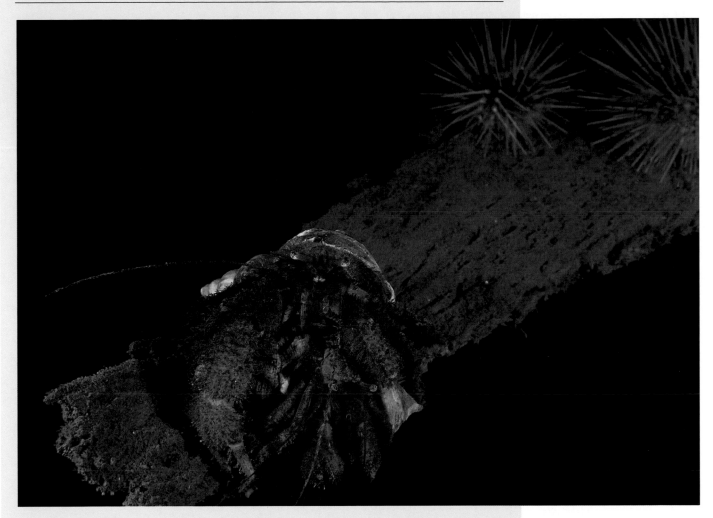

I photographed this pair of hairy hermit crabs in the Gulf of Maine during a night dive. There was a great deal of particulate matter in the water on this night (as is most often the case in this region due to strong currents) and backscatter was a prime concern. Since the crabs were perched on the end of an old wooden timber, I decided to frame them with the timber running diagonally and using a slight upward angle. This created a pleasing composition, as the viewer's eye naturally follows the diagonal line to the center of the frame. This composition also includes negative space above and behind the subject, and the contrast it provides nicely separates the subject from distracting objects closer to the bottom.

I positioned my two strobes at approximately 45-degree angles to the subject. This cut down on the amount of particulate matter, and therefore backscatter, that the strobes would illuminate. With the conditions present on this dive, the use of only one strobe would not have yielded good results. With two strobes I was able to reduce backscatter, eliminate harsh shadows, and light the subject evenly. This strobe angle gave the detail of the subject better definition in front. Depth is also added with the light wrapping around on the sides, especially highlighting the crab's shell.

Two Hermit Crabs

Brian Skerry

Camera and lens: Nikonos III with 35mm lens and 1:3 extension tube. **Film:** Fuji Velvia. **Aperture:** ƒ/22. **Shutter speed:** 1/60. **Subject distance:** 1:3 extension tube (lens focus preset at 2.75 feet). **Camera angle:** slightly upward. **Strobe:** two wide-angle strobes positioned at about 45 degrees to the subject.

REFLEX MACRO PHOTOGRAPHS

The PHOTOGRAPHS IN THIS CHAPTER are very similar to those in Chapter 7, "Extension Tube Photographs." Because they were made using variations on the macro technique, many of the images could have appeared in either chapter.

Here, equipment is the main distinguishing factor. Reflex macro photos are made with a macro lens—50mm or 60mm macro, depending on the manufacturer—on a housed SLR camera. The macro lens differs from other 50mm or 60mm lenses by its very close focusing capability. Depending on the lens and on the kind of port you use, you can focus closely enough to create a 1:1 image.

The main advantage of reflex macro photography is the freedom is gives. You choose your subject distance (and thus your frame size), and then you focus. You can photograph a 3-inch nudibranch then turn around and shoot a 2-foot fish! You get much more versatility in both framing and subject selection than extension tubes can give.

Another advantage is that your subject appears in the viewfinder just as it will appear in the photograph. You see what the lens sees! This gives you complete control over the composition of your subject and negative space.

The reflex macro system does have some disadvantages. Cost is the most obvious. But there are technical issues as well. An above-water camera in an underwater housing is much larger and heavier than a Nikonos. You need two hands to operate the housing (one to hold on, the other to focus), which means the strobes must remain attached to the housing. Also, aperture settings must be set according to subject distances. You cannot preset your aperture once and forget about it, as you can with extension tubes. You bracket exposures by altering the aperture settings, not strobe-to-subject distances.

But these are minor flaws in light of the system's benefits. You get the freedom to shoot subjects of many sizes on a single dive, and you get to compose your shots precisely. Ultimately, this means you can more fully use your imagination and creativity.

Deep Color Study
Howard Hall

ELEMENTS OF SUCCESS

Reflex macro photography is far more versatile than extension tube photography. It allows you to photograph subjects ranging in size from a few inches to several feet.

The average-size reef fish (10–18 inches long) is too large to be photographed with an extension tube. In addition, these animals are often rather uncooperative when it comes to placing an extension tube framer around them.

The photographs you see of fish or other animals in the 10–18-inch range, especially photos that are well composed and tightly framed, are almost certainly made with a reflex macro system. Subjects of those sizes can't be photographed with extension tubes and are difficult to compose with Nikonos rangefinder wide-angle lenses. (Nikon does make a close-up attachment for the Nikonos that produces images of subjects the size of small reef fish. This attachment, however, still requires a framer and limits your composition.)

Creating successful reflex macro photographs requires a slightly more complex range of equipment—at least in comparison to extension tube photography—but the concepts you must master to make reflex macro images are relatively simple. The following sections outline your equipment needs as well as the conceptual elements of this technique.

OUTFITTING YOUR CAMERA

The first thing you will need is an SLR camera. Not just any camera will do, however. You will be better off using one with an available sportsfinder accessory. The sportsfinder (or action-finder) is a large prism that replaces the regular viewfinder. It allows you to view your image from several inches away (through your mask under water) and still see the full frame. Both Canon and Nikon manufacture these types of cameras and accessories.

If you use a camera that does not accept a sportsfinder, you may be able to find a supplementary magnifier for your standard reflex viewfinder. Some manufacturers of camera housings produce these types of magnifying lenses (or diopters). This may not be as effective as a sportsfinder, but it can still be adequate.

After you obtain your camera and sportsfinder, you will need a macro lens (in the 50mm–60mm range). Then you can order your housing. There are many housings on the market for SLR cameras. Some of these are easier to use than others, as described in Chapter 4, "Underwater Photographic Equipment."

STROBES

Chapter 4, "Underwater Photographic Equipment," discussed the various options available for underwater strobes. Now that we're discussing housings, it is worthwhile to review these options as they relate to specific photographic subjects. The camera housing you purchase can be used to photograph both macro subjects *and* wide-angle subjects; therefore, you may want to buy a wide-angle strobe.

The best thing to do is to buy one wide-angle strobe for your wide-angle photography and two small strobes for your macro work. Because they're lighter, the small strobes are best for macro photography. They are also easier to carry and easier to manipulate under water. Buying three strobes, however, can be a rather expensive proposition.

As a compromise, you might start off with one strobe and work your way up to three over a period of time. One good option is to start with just one wide-angle strobe for use with macro and wide-angle photographs. Although the use of two strobes will greatly increase the quality of your macro shots, it is still possible to get excellent macro photographs with only one strobe. Later, you can augment your camera system by adding one small slave strobe. That combination would allow you to use a large strobe and a small slave for your macro work. Eventually, you could get a small sync strobe and then you would be all set.

Scorpion Fish
Howard Hall

If you are initially limited to buying just one strobe, then you should either buy one large strobe that is suitable for both macro and wide-angle photography or buy a small strobe and decide to specialize in macro photography.

EXPOSURE

Unlike extension tube photography, you do not preset your aperture in reflex macro. Instead, you rely on guide numbers. Guide numbers tell you what aperture to use at different subject-to-strobe distances. Before making a reflex macro photograph, you must estimate the subject-to-strobe distance and then set the proper aperture setting.

For a reflex macro system that incorporates two small strobes, and using ISO 50 film, the following settings provide a good place to begin:

- $f/16$ at distances from minimum focus to 1 foot

- $f/11$ at the 18-inch range

- $f/8$ at the 2-foot range

- $f/5.6$ at the the 3-foot range.

To ensure proper exposure, it would be wise to bracket around these four numbers. For instance, at a distance of about 1 foot, you would shoot at $f/22$, $f/16$, and $f/11$. These guide numbers will probably work well for your system although you may need to modify them slightly, depending on the strobes you use and the water conditions in which you are diving. Adding a second strobe will have little or no influence on your exposures in macro work such as this.

FILL LIGHTING

Fill lighting is also known as balancing the exposure. It is a technique that results in a brightly colored subject as well as a properly exposed background.

On a sunny day in tropical water at a depth of 25 feet, your available light exposure using ISO 50 film will usually be $f/8$ with a shutter speed of 1/60. This is, of course, merely an average exposure. Conditions will sometimes be lighter or darker than appropriate for an f-stop of $f/8$. This means that when you use a reflex macro system at distances of 18 inches to 3 feet, your guide number exposure will nearly match the available light exposure. A photograph is said to be "balanced" when the available light exposure is the same as the strobe exposure.

In a balanced photograph, because you have a brightly colored subject as well as a properly exposed environment behind the subject, most

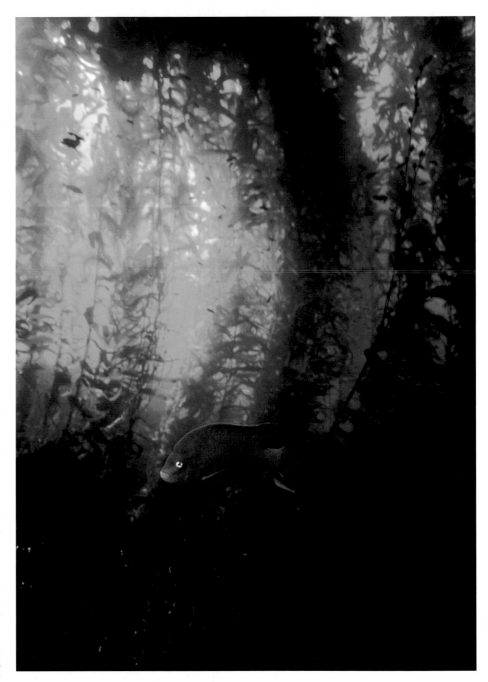

Garibaldi in Kelp
Howard Hall

viewers would not suspect that artificial light was used at all (because the colors look so natural). However, you know the colors would not be there without the artificial light. The strobe is used to simply paint in colors and fill in shadows rather than to increase the exposure.

Balancing your exposure gives depth to your photograph. The picture not only describes the animal in accurate color, it also tells something about the habitat in which the animal lives. A balanced photograph "places" the subject within its environment.

Baby Sculpin on Log
Brian Skerry

Studying a photograph's shadows will reveal lighting techniques.

In conditions of high ambient light, it is often difficult to avoid balancing your photographs. In fact, in bright conditions your available light reading may exceed the guide number. If this is the case, the available light reading takes precedence. If the available light reading is $f/11$ and the guide number is $f/8$, you should use $f/11$ (and bracket, of course). Instead of serving to increase the exposure, the strobe will simply fill in the colors left out by the available light. The available light is the light source that will make the primary exposure.

In deeper water, or in areas where the water is not as bright as in the tropics, you can still balance your exposures much of the time. This is done by angling your camera upward at the subject until your light meter reading matches your guide number.

HOUSING PORTS
Most camera housings are available with either a dome port or a flat port. A dome port is best for wide-angle photography. For macro photography, however, both dome ports and flat ports have their advantages. If you are photographing small subjects, you are better off with a flat port.

Due to refraction, the flat port magnifies your subjects by nearly 30 percent. If a dome port gives you a 3:1 image at minimum focus, a flat port will give you a 2:1 image. For most of

your macro photography you will find the flat port more versatile, as it enables you to successfully photograph smaller subjects.

If, however, you want to photograph a relatively large animal (perhaps a 2-foot-long fish) with the flat port, you will have to shoot from farther away than you would with a dome port. At distances greater than 3 feet, your strobes will have lost most of their effectiveness and the image will begin to scatter. For relatively large animals, therefore, you will be better off with the dome port. The dome port is probably the best way to start out. This way, you can do both wide-angle photography and macro. Later, when your budget recuperates, you can buy a flat port.

STROBE POSITION
Your strobe (or strobes) should be attached to your housing with a moveable arm (or arms). A variety of strobe arm manufacturers offer models that can be positioned pretty much wherever you wish to place them. Many of these systems are modular in design and can be "built" for specific photographic purposes. When you're making macro pictures of a subject that is directly in front of the lens, it is often necessary for you to be able to manipulate the strobe into a position very close to the port. Shorter arms with multiple joints tend to work best for this application.

Remember that in positioning your strobes,

you are trying to simulate light from the sky. If you are using one strobe, it should be positioned high above the subject and slightly off to one side. If you are using two strobes, you should have them on either side of the subject aimed downward at 45-degree angles. To create soft shadows on one side of the subject, position one of these strobes closer to the subject than the other.

The use of two strobes in an underwater photograph can usually be determined by examining the shadows in the picture. This photograph of the baby sculpin is a good example. If you inspect the photo, you will notice the prominent shadow to the right of the frame's center. This hole in the log was not filled by either strobe; however, the highlights noticeable on the sculpin's left side indicate the presence of a second strobe. The strobe on the left was obviously positioned closer than the strobe on the right. The goal in this case was not to completely eliminate shadows but to soften them and add some modeling detail to the sculpin's left side (such as the eye).

The orientation of the fish greatly influenced which strobe was to be primary (closer) and which was to be secondary (farther). Had the strobe on the right been the primary, there would have been a large shadow to the left of the fish. This would have placed the animal's face in shadow rather than in highlight.

MASTERING THE FUNDAMENTALS

Here are the points to remember for successful reflex macro photography:

- Before approaching your subject, decide how you would like to frame it, and reposition your strobes. Switching between vertical and horizontal frames requires considerable strobe adjustment. It is better to do this before you get close enough to disturb the subject.

- Frame the subject in the viewfinder after you approach it, giving careful consideration to subject size and negative space. Inspect every square millimeter of the frame before you fire the shutter.

- Choose the proper aperture setting based on strobe-to-subject distance. Or, if the ambient light is high, take a reading on the water behind the subject and compare that to the guide number, using the higher of the two.

- If ambient light levels are not high but you still wish to balance exposure, choose the proper guide number for the strobe-to-subject distance. Then angle your camera upward at the subject until the meter indicates that exposure. And, of course, remember to bracket your exposures.

EYE-CATCHING COLOR

The brilliant colors in this photograph of a hawk fish are what make it instantly appealing and eye catching. Although the fish is the primary subject, I wanted to frame the animal to include the background, which illustrates the camouflaging behavior. The use of a slightly upward camera angle gives the fish prominence in the picture. I also composed the shot so the fish's mouth was pointed at the upper right corner of the frame, with the hawk fish forming a nearly diagonal line within the photo.

The composition also includes about two-thirds negative space above the fish and one-third below. Such composition creates a more natural look to a photograph, especially when the animal (as in this case) is facing upward. The upward angle also created a background of black water, which gives a striking contrast to the red in the places it peeks through.

It is important to remember that you should make these considerations before you approach the subject. You can usually observe an animal from a distance while deciding how you wish to make the photograph. In this shot, I positioned my strobes at about 45-degree angles. While I framed the photo, my camera was positioned so the right strobe was slightly closer to the subject than the left. This resulted in a gradual fall-off in the light moving from the hawk fish's mouth toward its tail.

The great advantage of a reflex system is the ability it gives you to see everything within the frame before you fire the shutter. You can watch through the viewfinder as a subject such as this hawk fish moves slightly or looks in a more favorable direction. When everything is perfect, you can take the picture.

Hawk Fish

Howard Hall
Camera and lens: Nikon 8008 with 60mm lens. **Film:** Fuji Velvia. **Aperture:** ƒ/16. **Shutter speed:** 1/60. **Subject distance:** 1 foot. **Camera angle:** slightly upward. **Strobe:** two wide-angle strobes.

CAPTURING ANIMAL BEHAVIOR

This photograph of a sea cucumber has unique appeal because it shows behavior. The animal is using one of its arms to put food into its mouth. While any beautiful underwater photograph of an animal may be publishable, photos that depict behavior usually have the edge. This particular behavior is by no means rare; however, non-divers (and people that read magazines) generally find it especially interesting.

As with most underwater subjects, patience was key in making this photograph. I found my subject, and then I studied it to decide how best it could be framed. I decided to opt for vertical orientation, although a horizontal shot would have worked equally well. I waited until the arm at the upper right of the frame was feeding the mouth and fired the shutter.

Because the depth of field of the 60mm lens is rather shallow when working this close, I selected an aperture of ƒ/32 to maintain as much detail as possible. When working with a subject such as this, it helps if most of the elements of the photograph are close to being on the same plane. The sea cucumber's arms and their tips are all at about the same distance from the lens, and they remain in focus.

I used a Nikon F5 inside a Subal housing. The F5 has the ability to sync at shutter speeds up to 1/250. Although this type of macro photograph could have been made at a slower shutter speed, such as 1/60, I sometimes use higher shutter speeds, such as 1/250. I do this because ambient light is not a consideration, and the faster shutter speed is more likely to reduce any blurred edges. It is unlikely that any blurring would actually occur at 1/60, but faster shutter speeds do not detract in any way from image quality, so I often choose them just in case.

My strobes were positioned on the sides of the macro port at approximately 45-degree angles to the subject and set on full power.

Sea Cucumber
Brian Skerry
Camera and lens: Nikon F5 in Subal housing with 60mm lens. **Film:** Fuji Velvia. **Aperture:** ƒ/32. **Shutter speed:** 1/250. **Subject distance:** 9 inches. **Camera angle:** straight down. **Strobe:** two Sea & Sea YS-300 wide-angle strobes.

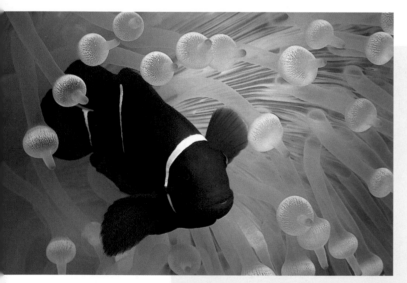

Spinecheek Anemonefish
Howard Hall
Camera and lens: Nikon 8008 in Subal housing with 60mm lens. **Film:** Velvia. **Aperture:** ƒ/16. **Shutter speed:** 1/60. **Subject distance:** 1 foot. **Camera angle:** slightly downward. **Strobe:** one Ikelite 200 set on TTL.

DEPICTING THE RELATIONSHIP BETWEEN YOUR SUBJECTS

This image of a spinecheek anemonefish within the anemone has value for two reasons. First, it illustrates the symbiotic relationship between these two animals. Second, the contrast of the brightly colored fish and the delicate, translucent anemone is especially appealing.

For this photograph, I used a single wide-angle strobe set on TTL. With subjects of great contrast, TTL is sometimes "fooled" into over- or underexposing parts of the frame (as explained in Chapter 13, "Automatic Focus and Exposure"). Because I wanted the eye of the fish to be the sharpest point of the photo, I focused there. In doing so, however, I allowed the camera's meter to use this portion of the frame for its TTL reading. The coloring of the anemonefish is close enough to medium gray for the strobe to provide the right amount of light to the overall scene. Had I focused on the white anemone, the scene might have been rendered underexposed. The TTL system would have reduced the light output based on the reflectivity of only this portion of the picture. At a distance of 1 foot from this subject, I used an aperture of ƒ/16 to be sure I had enough strobe light. From this distance, using an ƒ-stop of ƒ/22 or higher might not have permitted an accurate exposure.

The use of only one strobe created shadows that work nicely to add depth to the scene. Held above the lens and slightly to the side, the strobe softly lit parts of the fish such as the face, back, and pectoral fins. I also framed the fish to give slightly more negative space in the direction toward which it was oriented.

When working with a subject such as this, you may often wish to shoot every frame on the roll. Go with your impulse: shooting repeated frames of a good subject gives you better odds of producing a winner. It is very difficult to see everything that is going on in the viewfinder, especially when the fish is swimming around. It is helpful to remember as much as possible about photo elements like composition, strobe position, and negative space and then shoot as many frames as you can. You will usually be pleasantly surprised with the results. Sometimes the difference between a good photograph and a great one is subtle. It might be nothing more than the way the light looks or the expression of the animal.

BRINGING THE SUBJECT OUT OF THE BACKGROUND

This photograph of a red-gilled nudibranch was made off the coast of Rhode Island in March when the water temperature was 38 degrees. I especially remember thinking about the temperature as I knelt on the bottom waiting for this nudibranch to crawl into the right position!

I have photographed this species of nudibranch in various locations throughout New England, but I really liked the region I found this animal on because it was thick with baby mussels, barnacles, and sponges. I wanted to make a picture that showed the primary subject, the nudibranch, amidst a wide range of bio-diversity.

The concern with photographing a nudibranch against a "busy" backdrop, however, is that the primary subject can easily become lost or the photograph confusing. Two of the more identifiable features of this animal are the gills on its back and the rhinophore (its antennae-like appendages). To distinguish the nudibranch from the background, therefore, I needed to choose an angle that would accentuate these two features.

I waited patiently (freezing all the while) as the nudibranch slowly crawled over the sponge. I fired a few frames during its trek, but I shot the majority of the roll when the animal's head reached the end of the sponge. In this position, the translucent rhinophore were clear of the sponge, which allowed them to be accentuated. The slightly downward camera angle worked to accentuate the gills on the nudibranch's back. There was a modest current running at the time, and the gills were moving from side to side. A shutter speed of 1/250 helped freeze their motion.

My focus was concentrated on the rhinophore in an attempt to bring out their unique detail. Lighting was achieved with two wide-angle strobes set on full power and positioned on the sides of the macro port at about 45-degree angles.

Red-Gilled Nudibranch

Brian Skerry
Camera and lens: Nikon F5 inside Subal housing. **Film:** Fuji Velvia. **Aperture:** ƒ/32. **Shutter speed:** 1/250. **Subject distance:** 10 inches. **Camera angle:** slightly downward. **Strobe:** two Sea & Sea YS-300s.

Blenny in Bed of Anemones

Howard Hall

Camera and lens: Nikon F2 with 55mm lens inside Oceanic housing. **Film:** Kodachrome 64. **Aperture:** ƒ/16. Shutter speed: 1/60. **Subject distance:** 7 inches. **Camera angle:** slightly upward. **Strobe:** two small SR 2000 strobes.

The unique appeal of this photograph is the alien-looking creature (the blenny) surrounded by an alien-looking landscape (anemones). The blenny's eyes help engage the viewer, as does the brilliant red bed of anemones in which he has made his home.

Because the blenny was facing toward the right, I choose to frame him on the far left of the frame and thus create the all-red negative space to the right. This composition helps suggest that the blenny is looking out at something in particular. It also allows nicely for this photograph to be used in a double-page spread in a magazine, since the primary subject is not directly in the center of the frame.

As I composed the picture, the blenny regularly retreated into his hole and then emerged from it seconds later. During one of his retreats, I focused on the area where I thought his face would return. Before it did, I recomposed the frame with the blenny hole on the left. When the blenny popped his head back out, I moved the housing in and out ever so slightly until the blenny appeared sharp in the viewfinder and fired the shutter.

I used two small macro strobes to light this photograph and positioned them evenly to each side of the housing at about 45-degree angles. I bracketed several frames from ƒ/11 to ƒ/22, with ƒ/16 being the best.

CAPTURING AN ELUSIVE SUBJECT

I made this photograph of a rarely seen octopus in the Gulf of Maine during a December night dive. This elusive octopus is about the size of a golf ball and could easily fit in the palm of your hand. This image was made as the octopus drifted downward through the water column.

Night is one of the best times for macro photography since there is usually a wide variety of subjects from which to choose. To help me focus under such conditions, I have mounted a small dive light to the top of my housing. The light is mounted on a short, flexible arm that permits adjustment, depending on your photo subject.

My main concern as I photographed this tiny octopus was backscatter. The nutrient-rich waters of the Gulf of Maine attract an incredible amount of marine life, but the nutrients themselves (plankton) can ruin many photographs, creating a snowstorm of backscatter. This is especially true for subjects framed against an open water backdrop. To reduce the amount of backscatter, I positioned my strobes at 45-degree angles about halfway down alongside my macro port. I also composed the subject so that not too much of the background water would comprise the frame.

When I saw this subject, I switched from manual to auto-focus. Swimming at night in mid-water trying to photograph a tiny, moving octopus would be difficult enough without having to constantly adjust focus. Since my N90 has pretty reliable auto-focus, I decided to give it a try. The focusing light mounted on top of my housing provided plenty of light for the camera to lock in focus.

I bracketed between ƒ/11 and ƒ/22, with ƒ/22 looking the best. I shot the entire roll on this little octopus, knowing that I might never see one again. It's a good thing I did, too. Although several frames looked good, many had compositions that were simply not as compelling. Film is cheap in the scheme of things. Better to be liberal when exposing film, especially if the subject is unique.

Octopus
Brian Skerry
Camera and lens: Nikon N90 with 60mm lens inside Subal housing. **Film:** Velvia. **Aperture:** ƒ/22. **Shutter speed:** 1/60. **Subject distance:** 1 foot. **Camera angle:** horizontal. **Strobes:** two Sea & Sea YS-50s.

MARINE WILDLIFE PORTRAITS

PORTRAITS OF MARINE WILDLIFE may be taken with all types of equipment, from extension tubes to wide-angle lenses. Wildlife portraits can be found not only in this chapter but also throughout this book. It should be noted that this chapter is not about specific equipment or techniques. Instead, it is about the philosophy behind composing wildlife portraits. You may think that the high-impact photographs of marine wildlife displayed in magazines are the result of pure genius. Well, perhaps some are. More often than not, however, they are the natural outcome of competent photographers using rather basic concepts of composition.

There are many ways to photograph animals. Identification photographs, for instance, show a side view with all the animal's parts in proper proportions. There are photographs of animals in action (feeding, schooling, or swimming), and there are photos that picture the animal in its habitat (placing equal emphasis on both the animal and its environment). But the most common, and perhaps the most striking, type of creature photograph is the portrait.

The portrait photograph captures not only the way the animal looks but something of its personality as well. The portrait photographer's goal is to create an image that communicates the animal's expression and temperament. In short, a successful portrait conveys character.

Zebra Eels
Howard Hall

APPROACHING THE PORTRAIT

There are some important concepts that influence wildlife portraits. The animal in the photograph should seem to be aware of the viewer and its expression should communicate some aspect of its personality. In order to achieve this, the photographer should approach the animal as if attempting to carry on a conversation. Although this idea may seem a little foolish (if not a whole lot foolish, given that we're under water), the concept is very important.

BODY POSITION

The angle of the animal's body is also important. It is better not to photograph the animal straight on, although this approach can be effective at times. You are usually better off framing the animal at an angle of about 45 degrees. This will allow you to see most of the animal's body, making the subject more recognizable and less confusing while still keeping the face in a position of forward prominence. Even at very close range, a slight angle often adds depth to the photograph.

The portrait should "speak" to the viewer, and there are several unwritten rules about conducting a conversation. You do not converse with a person while looking down at the top of his head or while looking at the back of his head. Nor do you conduct a conversation with someone while inspecting his tail (if people had tails) or while he's walking (or swimming) away from you. And you do not talk to someone from clear across the room. When you conduct a conversation, you should be face-to-face, close, and looking at the subject's eyes and mouth.

The eyes are of primary importance. When the viewer looks at the photograph, the animal's eyes should be the first thing the viewer notices when looking at the photograph. For this reason, the eyes must be very prominent in the photograph. The eyes must also be the point of critical focus. If the eyes are soft, then the photograph will be unpleasant to look at and must take its rightful place in the round file.

The depth of field must be manipulated so that the eye and everything in front of the eye (like the nose and mouth) is in focus. If the eye is sharp but the face of the animal forward of the eye is soft, the softness will be very distracting. The area behind the animal's eye can go out of focus without much loss of impact.

Generally, getting the eye and the facial features forward of the eye in focus is not a very scientific process. You simply focus on the eye, and depth of field will take care of the rest.

CAMERA ANGLE

Another very important concept is your physical relationship to the subject, which is expressed in the camera angle you choose. It is a well-known fact that tall people have a psychological advantage over shorter people in conversations. Teachers and ministers on raised podiums have extra power over their audiences simply because they are situated above them. This concept can be used in animal portraiture. If you want the photograph to have added power and impact (and why wouldn't you?), then make the animal appear to stand above you in the frame. If the animal is above you in the photograph, it will appear to be a towering monster that might gobble you up at the slightest provocation. But if you are above the animal and looking down at it (a far easier angle to achieve), the creature becomes something small and negligible that you could easily step on.

LIGHTING

Lighting can be a problem in portraits. Because most portraits are taken at close range, artificial

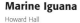

Marine Iguana
Howard Hall

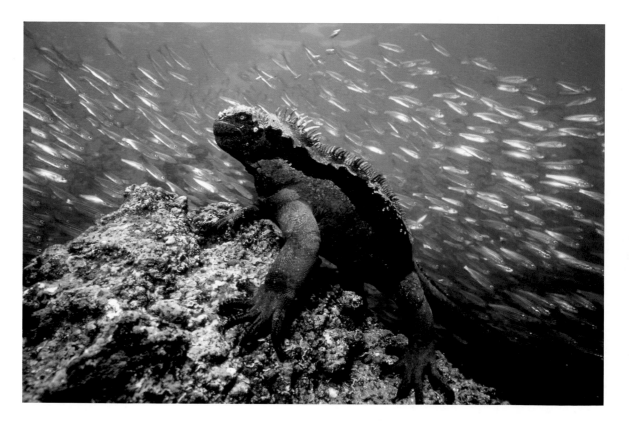

light is often used to allow small apertures and increased depth of field. The use of one strobe will generally illuminate one side of the animal's head while leaving the other in a very harsh shadow. Or, if the strobe is held directly above the subject, there will be a very large dark shadow below the animal's chin. This is why portraits taken at close range with extension tubes or a reflex macro system are best taken with two strobes.

Each strobe should be positioned to one side and above the animal so that light comes down at 45-degree angles on either side of the creature's face. One strobe should be powered down or moved farther away than the other so that at the subject, the brightness ratio between the two strobes is about 2:1. This ratio will produce soft shadows on one side of the animal's face and highlights on the other.

In situations where there is plenty of ambient light (as in the tropics) or where the animal is large enough to allow the use of a wide-angle lens, one strobe can be used as a fill light. The fill light will fill in the colors and remove shadows on one side of the face while ambient light softens shadows on the other. In this case, a light meter should be used to determine the ambient light exposure. Then strobe power (or strobe-to-subject distance) should be manipulated to balance the two exposures.

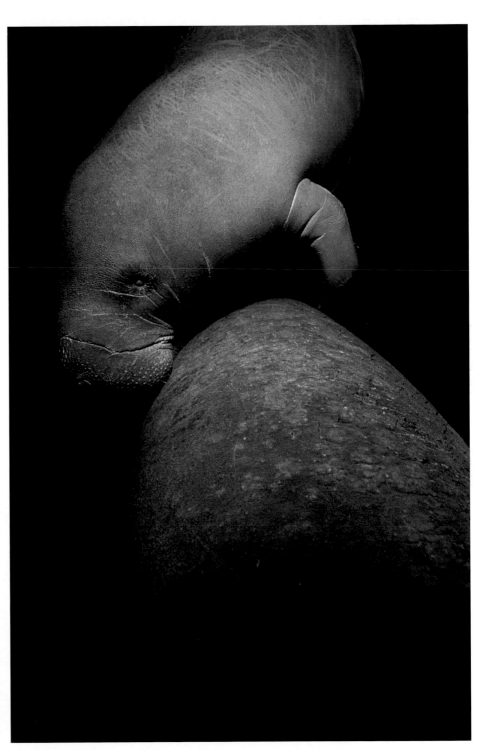

Manatee Portrait
Brian Skerry

This portrait of two manatees was photographed to elicit a more somber feeling than other brightly lit, more cheerful pictures of these animals. Photographed in the early morning with nearly no ambient light, a small aperture was also employed to render a completely black background. Strobe light was used to bring detail to the animal's features and skin. 20mm lens inside a housing.

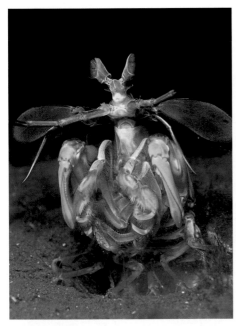

Mantis Shrimp
Howard Hall

MASTERING THE FUNDAMENTALS

Here are the points to remember for taking successful marine wildlife portraits:

- Before you approach your subject, take a moment to inspect the animal from a distance. Decide how you want to approach and frame it before you move in.

- Pre-position your strobes so that one will be on either side of the animal's face (with one a little closer than the other) pointing downward at about 45 degrees.

- Next, select your aperture.

- Then move in. Get close enough for the animal to fill at least half of the frame. Its body should be face first and at about a 45-degree angle away from the lens.

- Position yourself as low as you can and aim at an upward angle if possible. Make any necessary minor adjustments to the strobe positions.

- Focus (or position the extension tube) so that the eye and the parts of the creature's face that are in front of the eye will be in focus.

- Take the picture. Bracket your exposures. Bracket your camera position.

LEADING THE VIEWER'S EYE INTO THE IMAGE

This portrait of a Caribbean reef squid was made using a reflex macro system. A 60mm lens was used at a subject distance of about a foot. At this distance, the squid occupies about half of the frame. Although the camera angle is nearly horizontal, the subject is positioned face-first at about a 45-degree angle from the lens. The squid's arms and tentacles are also oriented toward the bottom-right corner of the frame, leading the viewer's eye into the photograph.

This photograph was made late in the afternoon, when ambient light levels were very low. At $f/16$ and a shutter speed of 1/60, the background exposure went black. The black background works to accentuate the colorful nature of this squid. A single strobe was used to light this portrait. Given the 45-degree angle of the subject toward the lens, the single strobe did not create harsh shadows and evenly lit the animal. The strobe was positioned above and to the left of the lens port.

Unlike most animals, squid have quite a lot of their body in front of their eyes. Normally, focusing on the eye of your subject assures that facial features in front of the eye will also be in focus, but with a squid things are a bit different. Still, I focused on the squid's eye, and the aperture of $f/16$ held the focus for nearly the entire animal.

**Caribbean
Reef Squid**

Howard Hall
Camera and lens: Nikon 8008 with 60mm lens inside Subal housing. **Film:** Kodachrome 64. **Aperture:** $f/16$. **Shutter speed:** 1/60. **Subject distance:** 1 foot. **Camera angle:** horizontal. **Strobe:** one Ikelite AI 150.

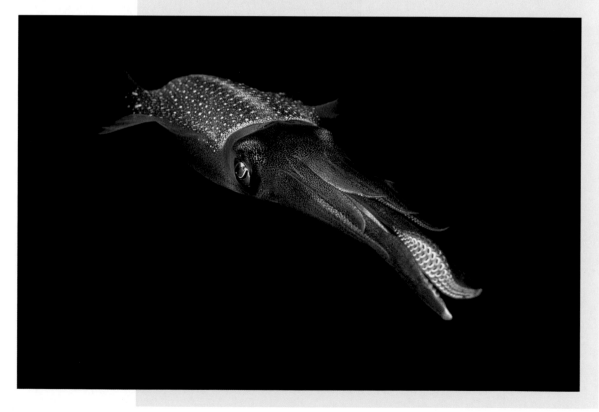

CAPTURING A NATURAL POSE

I photographed this wild beluga whale in a small bay in Nova Scotia, Canada. The task of making marine wildlife portraits is clearly made much easier when working with a cooperative animal. This animal actually seemed to be posing for her portrait!

The whale was approximately 12 feet in length. Visibility varied in this region from as much as 30 feet to as little as 2 feet, depending on weather and tide. My primary lens for this assignment was a 20mm inside a housing.

I had been swimming with the beluga when she stopped and oriented herself vertically, hanging just a few feet beneath the surface. I metered the background water off to the side of the whale and set my aperture at ƒ/5.6 and my shutter speed at 1/60. I knew that to achieve successful results at ƒ/5.6 with the wide-angle strobes I was using (based on my own guide-number testing) and at a distance of 6 feet, I needed to set the strobes on half-power.

Turning my housing vertically meant that my strobes would be pointed at the very top and bottom of my frame. This might be acceptable for some images; however, I was most interested in lighting the face of the whale and letting the light gradually fall off toward the tail. I repositioned my left strobe so that it directed light toward the animal's right side (the side facing the camera) and aimed the right strobe toward the front of the whale's beak. The right strobe was also a bit farther away so that it would not cast too much light on the face. Sunlight from above lit the top of the beluga's head.

The sunbeams add a nice element to this picture, but they would have been even more dramatic had I selected a faster shutter speed. With the Nikon F3 camera that I was using, however, a sync of 1/125 was not possible.

The camera angle in this shot is slightly upward and framed from a body position angled at nearly 45 degrees . The photo was also framed to allow a little space above the whale's head and at least twice as much space below the tail. This framing achieves the goal of a portrait in the sense that from this photograph you can imagine "speaking" to the whale. I focused on the eye, and the 20mm lens' depth of field held the focus on pretty much everything else.

Beluga Whale

Brian Skerry
Camera and lens: Nikon F3 with 20mm lens inside Aquatica housing. **Film:** Kodak Lumiere. **Aperture:** ƒ/5.6. **Shutter Speed:** 1/60. **Subject distance:** 6 feet. **Camera angle:** slightly upward. **Strobe:** two Sea & Sea YS-200s on half-power.

GIVING A PORTRAIT ANIMATION AND IMPACT

A portrait is not necessarily a photograph of just an animal's face. As in this picture of a mako shark, a portrait can include the entire animal. It is the position of the animal's body and the prominence of the face that gives a portrait animation and impact.

Although it is much easier to take photographs of animals as they swim by or away from you, the approaching angles will have the most impact. It is best to wait for the animal to come your way. It does not have to be coming directly at you—in fact direct head-shots are sometimes a little confusing—but it should be coming at some angle in your direction.

This photograph was taken with a Nikonos 15mm lens focused at five feet and a wide-angle strobe. It could be argued that a better way to photograph a fast-moving creature like a mako shark would be to use a faster shutter speed and no strobe. It is true that 1/60 is a slow shutter-speed for such an animal. However, the mako stayed around our shark cage for hours, allowing me plenty of photo opportunities. I also knew that the strobe would add a very small amount of subtle color to this photograph in a very strategic area—the mouth. The color in the mouth and the detail of the teeth make this a superior shark photograph. Of course, I bracketed many times and discarded the photographs that were out of focus.

Mako Shark

Howard Hall

Camera and lens: Nikonos III with 15mm lens. **Film:** Kodachrome 64. **Aperture:** $f/8$. **Shutter speed:** 1/60. **Subject distance:** 5 feet. **Camera angle:** approximately 45 degrees upward. **Strobe:** one large wide-angle strobe set at low power and held to the left of the frame.

Shorthorn Sculpin

Brian Skerry

Camera and lens: Nikon N90 with 60mm lens inside Subal housing. **Film:** Kodachrome 64. **Aperture:** $f/16$. **Shutter speed:** 1/60. **Subject distance:** 1 foot. **Camera angle:** slightly upward. **Strobe:** two Sea & Sea YS-50s.

INCREASING THE IMPACT OF FACIAL EXPRESSION

The expression on this shorthorn sculpin gives this photograph an almost amusing quality. Although portraits are usually best made from a side angle, this direct head-on angle works well with this subject. The photo also has appeal because it illustrates this fish's camouflaging behavior, which matches it to the coloration of the surrounding substrate.

There was a great deal of particulate matter in the water column when this photograph was made, and backscatter was a major concern. I shot nearly the entire roll of film on this subject, bracketing exposures and strobe position. This frame proved to be the best. I used two macro strobes and positioned them at the sides of my macro port angled at about 45 degrees. I focused on the eyes, and the $f/16$ aperture held everything else in focus.

Before arriving at my shooting distance of 1 foot, I studied the animal from farther away and thought about how I wanted to make this picture. I gradually inched my way closer, moving very slowly so as not to disturb the fish. I decided that the sculpin should be framed tightly to increase the impact of the facial expression, with a slight bit of headroom given at the top of the frame. The camera angle was almost horizontal, but I pointed the camera slightly upward to further increase the portrait's impact.

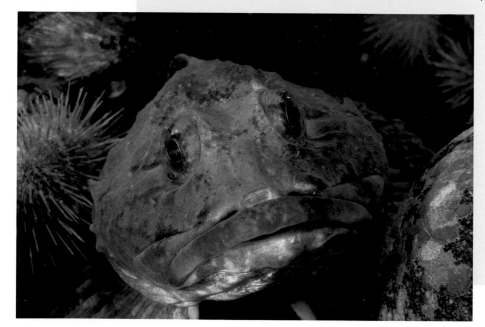

MAKING A "LUCKY" SHOT

This portrait of an elephant seal was made because of luck. But remember that in terms of underwater photography, "luck" is defined as preparedness combined with opportunity. I was swimming through the kelp forest searching for subjects. Before actually locating a subject, I preset my lens and strobe for a balanced exposure so that I would be ready just in case. I turned around to see this elephant seal right behind me!

I shot three fast photos before he swam away. Fortunately, having everything preset made all the difference. Had I needed to take the time to obtain a light meter reading, adjust the lens, and find my strobe power setting, the animal would have been gone and I would have been left with only a great story of the "one that got away." Presetting your camera, lens, and strobe is always a good idea, especially when you're working in areas where something exciting might swim by (which could in reality be anywhere).

The elephant seal's body position was oriented perfectly for a portrait, and the tremendous angle of coverage of the Nikonos 15mm lens included enough of the kelp forest to give the photograph a sense of the environment. The upward camera angle helped to increase ambient light levels as well as give the seal prominence in the photograph.

Elephant Seal

Howard Hall

Camera and lens: Nikonos III with 15mm lens. **Film:** Kodachrome 64. **Aperture:** ƒ/5.6. **Shutter speed:** 1/60. **Subject distance:** 8 feet. **Camera angle:** 45 degrees upward. **Strobe:** one Ikelite 150 strobe set on low power.

Atlantic Wolffish

Brian Skerry

Camera and lens: Nikon N90, 28mm lens, with +3 diopter inside Subal housing. **Film:** Fuji Velvia. **Aperture:** ƒ/16. **Shutter speed:** 1/60. **Subject distance:** 18 inches. **Camera angle:** about 45 degrees and slightly upward. **Strobe:** two Sea & Sea YS-300s.

GRASPING THE PERFECT OPPORTUNITY

Atlantic wolffish are most often found hiding in small rocky caves, so when I saw this animal swimming out in the open I knew it was a perfect photo opportunity. The wolffish came to rest on a bed of stalked tunicates on the edge of a rocky outcropping. I too settled down, about 10 feet away and at the edge of visibility, and set my camera lens and strobes before moving closer. I positioned my left strobe at a 45-degree angle on the side of my dome port and positioned the right strobe slightly farther out to the side. I set my aperture first at ƒ/11, but I changed to ƒ/16 as I inched closer to the fish.

I had added a +3 diopter onto the 28mm lens I was using because I was planning to shoot wide-angle close-ups and wanted to be able to focus as close as possible. I was using two wide-angle strobes, and both were set on full power. The water in which this animal was found was not very clear, and at my depth of 80 feet, there was very little ambient light present. I moved into a position to the side of the wolffish's face in order to give his eyes and teeth prominence but also framed the shot to include his eel-like body trailing off.

I bracketed between ƒ/11 and ƒ/22, with ƒ/16 offering the best exposure.

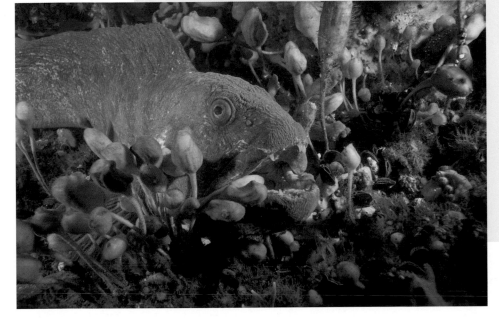

PHOTOGRAPHING PEOPLE

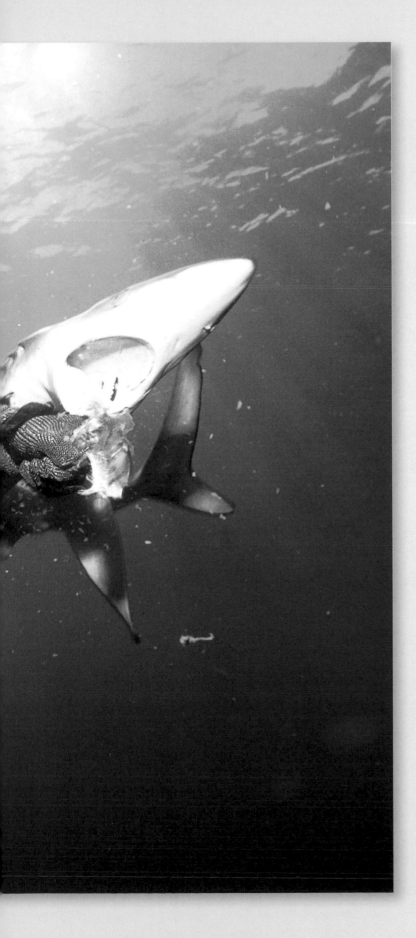

D IVERS ARE PERHAPS the most common subjects for underwater photographers. They are not, however, easy subjects to photograph successfully. There are a number of reasons for this. When you make a photograph of a fish and the color is slightly off, or a fin is in the wrong place, or the eyes are looking at you in an odd way, it usually makes no difference. Nobody knows what the fish's colors are really supposed to look like—not even the photographer—or just what the fish should be doing with his eyes or fins.

It is different with people. If their skin tones are strange, or their eyes are crossed, or their arms and legs are positioned in a slightly awkward fashion, everyone will notice. Unfortunately, divers often look like this. You will find yourself discarding many photographs that are technically perfect except that the diver looks like he or she is being shocked with an electric cattle prod.

Feeding the Blue Shark
Brian Skerry

Underwater people pictures can often portray a sense of adventure, such as with this diver wearing chain mail and feeding a blue shark.

ELEMENTS OF SUCCESS

To create a successful underwater photograph that features people, you have to pay attention to several elements unique to this type of image. How to produce natural skin tones, how to keep people's faces from appearing distorted, and how to create a natural pose are all topics covered in the following sections.

COMPOSITION

Despite these difficulties, good diver photographs are still a dime a dozen. To make one that is really valuable, you need to do one of two things (and hopefully both). You need to photograph a diver doing something interesting, and you need to include good negative space.

Photographing the diver doing something of interest is important if you want the picture to say something more than "Hi, Mom." Capturing good negative space is important because photographs of divers will always be pictures of "divers in the underwater environment" and never just pictures of "divers." In most cases, the negative space in diver photographs is more important than the subject, given that the subject is just another diver (and certainly not an endangered species).

Divers are large creatures, and they do not often hold still long enough to be photographed. You will need at least two things to be successful: a wide-angle lens, and a model. You can usually find a dive buddy who will be willing to act as a model. Together, the two of you should plan out exactly what kinds of photographs you want, and you should review the hand signals you will use. You should also brief your buddy on two important things: the dangers of stirring up the bottom, and what to do with his or her eyes.

When a viewer looks at a photograph of a diver, the eyes are the first thing to be noticed (assuming they are visible, of course). The eyes tell you what the diver is seeing, thinking, and feeling. Therefore, what your model does with his or her eyes is critical. If the model is looking at the lens, the photograph will usually say simply "Hi, Mom." It is best if the model looks almost anywhere but at the lens.

If you want the diver's face in the photograph, however, the model's facemask should be turned almost directly at the lens; not the diver's eyes, just the mask. If the mask is turned away from the lens at too great an angle, the diver's face will appear to be distorted by the way light refracts through water and then through the air behind the mask.

So where should the diver's eyes be directed? At whatever he or she is doing, of course. Hopefully, you can photograph the diver doing something interesting. If the diver is just looking off into blue water, the photograph will say nothing more than "diver under water." Certainly this is not always a bad thing to say, and if the negative space is spectacular, the statement can be very effective. But the photo will be more effective still if the diver is engaged in some activity within that spectacular environment.

NEGATIVE SPACE

Because negative space is so important in underwater photographs, it is important to balance your exposures. In bright tropical waters, this is seldom a problem. Take a light-meter reading on the water behind the subject, and then fill in the colors and shadows with your wide-angle strobe. After taking that reading, try setting your aperture down one stop for less light. This *slightly* darkened background water tends to produce more pleasing results.

In darker temperate waters, ambient light is very low. Often the strobe can overpower the available light, creating an underexposed negative space surrounding the diver. Most wide-angle strobes are powerful enough for general underwater photography. In low ambient light conditions, however, it is very useful to have a strobe that you can power down so that you can balance your exposures.

Mahi Mahi with Background Diver

Brian Skerry

Although the mahi mahi is clearly the primary subject in this photograph, having a diver in the distance adds some perspective and scale.

In situations of low ambient light, you can increase your available-light reading by using upward camera angles. If you know that your strobe will give you an $f/5.6$ exposure at a subject distance of 4 feet, you can get below the subject and increase your upward angle until the light meter reads $f/5.6$. In dark temperate waters, this is often the only way you can balance your exposures.

Negative space becomes progressively more important to the photograph when the diver occupies only a small portion of the frame. Photographs in which the diver is swimming in the distance are really photographs of the environment, with the diver as a primary point of interest. In these photographs, your care in selecting and composing negative space is extremely important.

SKIN TONES

Due to color absorption, divers' skin tones often appear unrealistic. All the other colors in the photograph may seem fine, even if they are slightly off. But we are so familiar with the appearance of proper skin tone that if the color is a bit off, it will be very noticeable.

There are a few things you can do to improve skin tones. The most practical of these is simply to get close. Photographs of divers with exceptionally realistic skin tones are made from very close range, usually from less than 6 feet away (as with the example photograph "Children Under Water," on page 103). In order to photograph from such close range and still get the entire diver with lots of negative space in the photograph, you must use a very wide lens. Suitable choices include 14mm, 15mm, 16mm, 18mm, and 20mm lenses for diver photographs.

While getting close to the subject is the best technique for realistic skin tones, film choice is another important consideration. Traditionally, Kodachrome 64 has been used to render natural skin tones under water due to its tendency to produce warmer colors (oranges and reds). Other films, however, such as Fuji Velvia and Kodak's E100 VS (very saturated) now also deliver warmer tones and will produce natural-looking skin colors as well.

Some photographers use a CC30R color correction filter to warm skin tones when photographing divers. This can be a practical technique, especially when using "cooler" films. Gels can also be used over the strobes to warm skin tones under water.

BODY POSITION

All divers look awkward at times. Unfortunately, they seem to look most awkward just when you are trying to take their pictures. There are a couple of things you can instruct your model to do in order to minimize the problem.

When photographing models on the ocean floor, have them kneel or stand in an upright position. Although it is often easier for divers to do things from a horizontal position, it looks unnatural and awkward unless they are swimming. When they're doing things with their hands, have your models keep their hands low to keep their faces unobstructed.

When photographing divers swimming through scenes, it is often tempting to have them stop right where you want to take the photograph. But when a diver stops kicking, his or her fins begin to do rather odd things, often sticking out at unnatural angles. Your model does not have to swim through the frame at a fast pace, but should continue kicking in order to keep the fins moving and maintain a natural appearance.

Your model's arms should be kept close to his or her body. Sometimes models seem to think that stretching out their arms and legs like a skydiver will make the photograph more interesting. It does not. Instead, it makes the photograph look contrived.

EQUIPMENT

To photograph people under water, you need a camera system with a wide-angle lens. Various wide-angle lenses are made for use with the Nikonos camera, including 12mm, 15mm, 16mm, and 20mm lenses. The 28mm lens will provide acceptable results, but it cannot compete with the results you will get by using wider-angle lenses. There are a variety of wide-angle lenses that can be used with a housed camera and dome port, including 14mm, 15mm, 16mm, 18mm, 20mm, 24mm, and more. You are better off selecting a lens that offers an angle of coverage of 85 degrees or more.

Small strobes have beam angles that cover 60 degrees or less. To cover your wide-angle photograph of a diver, you will need one of the larger (and more expensive) wide-angle strobes. You can also try adding a diffuser to a strobe with a smaller beam angle in order to increase its coverage area. The strobe you use should have a beam angle of at least 90 degrees, wider if possible. It should also have variable power so you can balance exposures in low ambient light conditions. In addition, you should have a reliable light meter, one that's either built into the camera or separate from it.

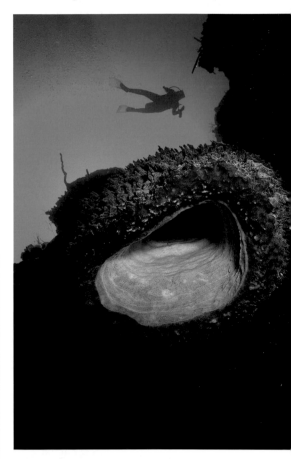

Diver in the Distance
Howard Hall

DIVER'S DRESS CODE

The diver's appearance is an important consideration when choosing a model. Divers often look like whoever dressed them had a bizarre sense of humor (black wetsuit, garden gloves, athletic socks, and a life vest "borrowed" from under the seat of an airplane). It is a great advantage to have a model who wears a colorful suit, gloves, and compensator. Dressing your model like Spiderman, however, might be overkill!

It is best to use a little taste and good color coordination. It is also helpful if the model's mask allows most of his or her face to be seen. Clear silicone masks are ideal because they allow the strobe to illuminate the face from nearly any angle.

MASTERING THE FUNDAMENTALS

Here are the important tips to remember for taking successful photographs of people under water:

- Choose a colorfully and tastefully dressed model.

- Spend some time instructing the diver how to model for you (what you want him or her to do and not to do). Discuss activities that your model can be involved in for the photograph, like feeding fish, examining marine life, or acting as a photographer.

- Review the body positions you want your model to use. Remind him or her to always position the mask toward the camera, if possible. Also discuss what you want your model to do with his or her eyes.

- Once you're under water, look for an area where the negative space is exciting. Position your model within the negative space so you can aim from a position that gives you good separation. This usually means an upward angle.

- For realistic skin tones, move in as close as you can while still maintaining your ability to frame the diver's entire body. Cutting off part of the diver's body, such as his or her legs, detracts from the photograph.

- Take a light meter reading on the water behind the diver and choose a strobe setting (or estimate the strobe-to-subject distance) that will balance the exposure.

CREATING A CENTRAL POINT OF INTEREST

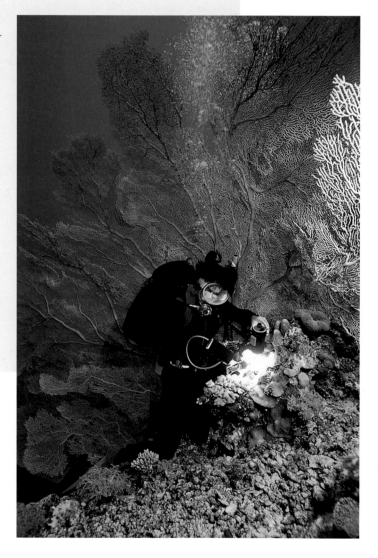

This is a photograph of Michele Hall, taken in the Coral Sea. The photograph shows Michele taking extension tube photos; however, in reality she is posing for me while I do the photographing.

The primary subject in this photo is Michele, but it is the giant gorgonian coral that makes this photograph a winner. Without the gorgonian, the photograph would lose 99.9 percent of its impact. The gorgonian provides effective negative space.

Obviously, the gorgonian is not in the background by accident. Michele and I swam around looking for good negative space in which to position her. When I spotted the gorgonian, I immediately recognized the potential for this photograph. I could have photographed the gorgonian by itself, but I knew that the photograph needed a central point of interest. And, without the diver in the frame, there would have been no size perspective.

To better simulate the act of taking pictures, Michele had her slave strobe turned on. When you use a slave strobe in this fashion, make certain that the strobe is not pointed at your lens. If it is, it will produce a nasty flare.

This photograph exemplifies the importance of using a wide-angle strobe. You can see that the 100-degree beam of the strobe did an excellent job of covering the 94-degree lens angle of the 15mm Nikonos lens. A small macro strobe would have produced a spotlight effect, which would have made the use of artificial light too obvious.

Michele in Coral Sea

Howard Hall
Camera and lens: Nikonos III with 15mm lens. **Film:** Kodachrome 64.
Aperture: ƒ/5.6. **Shutter Speed:** 1/60. **Subject distance:** 7 feet.
Camera angle: 30 degrees upward. **Strobe:** one wide-angle strobe set on medium power, handheld 2½ feet above the lens.

TIMING THE PORTRAIT

This photograph of a snorkeler (Jonathan Bird) with a manatee was made very early in the morning. We arrived at Crystal River in Florida at dawn knowing that manatees are usually grouped together and easily located early in the day, before they swim off to feed. We swam out into the shallow water, picked a spot, and waited to see if manatees would come to investigate.

Sure enough, those curious marine mammals began to approach. When this animal got to within a couple of feet of Jonathan, he extended his hand, which is permitted diver/manatee protocol. There was almost no ambient light penetrating the water and certainly not enough to register with ISO 64 film. Still, I wanted to capture the moment of human and manatee interacting.

I positioned my strobes out fairly wide on either side of my housing and set them for a 2:1 lighting ratio, with the left strobe on full power and the right strobe on half-power. When working just below the surface it is often possible to photograph the subject's reflection as we see in this photograph. The bright colors of Jonathan's wetsuit help to add to the scene.

The interactions of divers with marine animals are matter for some of the most rewarding images you can produce. It is these images that help non-divers to better understand the marine environment. In the case of endangered animals, like the manatee, such photographs might actually serve to bring awareness that can result in positive action.

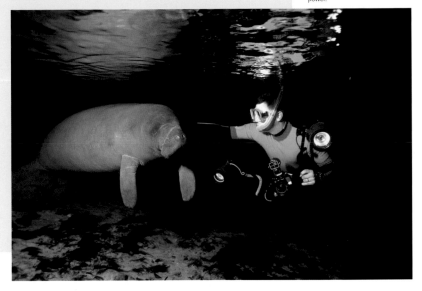

Diver with Manatee
Brian Skerry
Camera and lens: Nikon N90 with 20mm lens inside Subal housing. **Film:** Kodachrome 64. **Aperture:** ƒ/5.6. **Shutter speed:** 1/60. **Subject distance:** 6 feet. **Camera angle:** slightly upward. **Strobe:** two Sea & Sea YS-300s, left strobe on full power, right strobe on half power.

PREPARING TO ENCOUNTER THE AWESOME

When photographing large marine animals, such as this sperm whale, it is easy to become lost in the awe of the moment. Encounters with animals like this do not happen every day, and the adrenaline coursing through your body can make it difficult to remain focused (pun intended!). Maintaining discipline will pay off, however, with extremely dramatic photographs. In spite of the action, you must force yourself to think about the image and concentrate on the fundamentals.

This shot of Bob Cranston filming a sperm whale is primarily an ambient exposure. The use of a wide-angle strobe adds a little definition and helps to separate the subjects from the water. When photographing under these conditions, I often use the half-power setting on my strobe to decrease the recycle times, even though full power may produce a better fill light exposure.

I had metered the background water at ƒ/11 at 1/60 and knew that at a distance of 15 feet, a half-power setting would provide just a bit of detailing on the closest parts of the whale. If the water had not been this clear, the strobe would have offered little help in this regard.

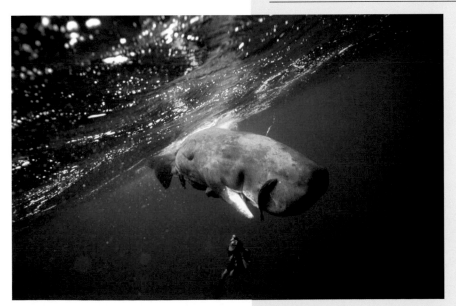

Diver Filming Sperm Whale
Howard Hall
Camera and lens: Nikonos III with 15mm lens. **Film:** Kodachrome 64. **Aperture:** ƒ/11. **Shutter speed:** 1/60. Subject distance: 15 feet. **Camera angle:** about 45 degrees upward. **Strobe:** one Ikelite 150 set on half-power.

I positioned myself in front of the whale and dove down as the whale slipped beneath the surface. I got myself into a position that would allow about a 45-degree angle on the whale and would also include Bob in the frame. The presence of the diver adds scale to the photo as well as action.

INTERACTING WITH THE SUBJECT

I made this photo of Graham Cove with a silky shark off of Nassau, Bahamas. We had been inducing silky sharks with tonic immobility, and this image shows one of the sharks being released afterward. Tonic immobility is a method of sedating sharks by turning them upside down. Scientists are unsure as to exactly why this works, but with certain species it is quite effective. We were using tonic immobility to sedate the sharks while we removed fishing hooks and lines from their mouths.

For better or worse, sharks and divers always make for dramatic photographs. In this case, the story behind the image is perhaps even more interesting. The primary subject, of course, is Graham with the shark, yet the presence of the second observing diver (Tom Mulloy) adds to the scene. As a rule it is best if the diver is not looking directly at the camera; however, in this photograph, it does not detract from the photo's overall impact.

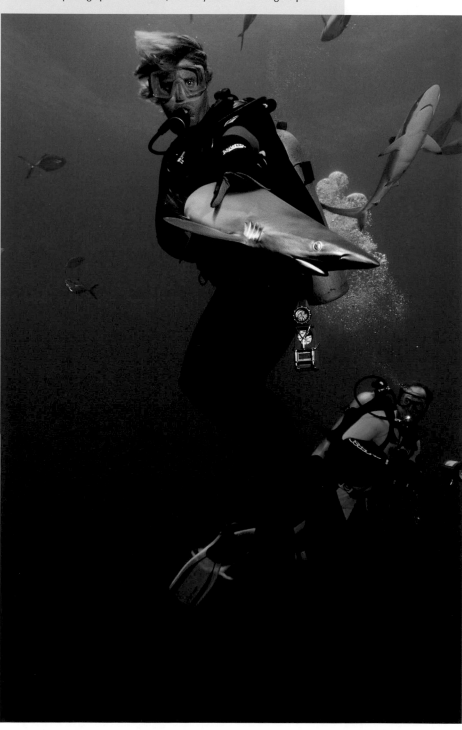

Because the diver was oriented vertically in the water column, it made sense to frame the photo as a vertical. I used an Ultra Light Pivot Tray, which is designed to permit a camera housing to be flipped vertically while the strobes remain horizontal. This design allows for even lighting across the upper and middle portions of a vertical photograph. In this case it allowed me to softly light the diver's face and the shark while also letting the light gradually diminish toward the bottom of the frame.

I selected a shutter speed of 1/125 to better freeze the motion, and I metered the ambient light to select an aperture of ƒ/8. At a distance of 7 feet from the subject, with ISO 100 film and an aperture of ƒ/8, I chose to set my two wide-angle strobes on half-power. Had I been shooting in darker water, such as in New England or California, I may have needed full power to properly expose the subject with fill lighting. In the clear Bahamian water, however, half-power did the trick.

Diver Releasing Silky Shark

Brian Skerry
Camera and lens: Nikon N90 with 24mm lens inside Subal housing.
Film: Kodak E100SW. **Aperture:** ƒ/8. **Shutter speed:** 1/125.
Subject distance: 7 feet. **Camera Angle:** 45 degrees upward.
Strobe: two Sea & Sea YS-300s on half-power.

HAVING FUN IN THE WATER

This photograph of a group of Philippine Muro Ami divers has been extremely popular. Even if viewers are unfamiliar with the specifics, the image of young people having fun in the water is instantly appealing. Seeing an image such as this published in a magazine makes the viewer stop and want to know more.

Because these divers are not scuba diving or engaged in a task under water, it is acceptable for them to be looking directly at the camera. Their colorful clothing also adds to the overall quality of the image. Framing this photo at an upward angle produced two major positive results. First, it provided separation of the subject from the darker water below; second, it gave me an ambient reading of ƒ/11 that added to the depth of field. A single wide-angle strobe set on full power was used to fill-light the divers.

I framed the photo to include enough of the surface to convey the sense of the children's being under water. Because of this framing, this photograph has been published vertically as well as horizontally.

Children Under Water

Howard Hall
Camera and lens: Nikonos III with 15mm lens. **Film:** Kodachrome 64.
Aperture: ƒ/11. **Shutter speed:** 1/60.
Subject distance: 8 feet. **Camera angle:** 45 degrees upward. **Strobe:** one Ikelite 150 set on full power.

Spearfisherman

Brian Skerry
Camera and lens: Nikon F5 with 20mm lens inside Subal housing.
Film: Fuji Velvia. **Aperture:** ƒ/8.
Shutter speed: 1/8. **Subject distance:** 4 feet. **Camera angle:** about 30 degrees upward. **Strobe:** two Sea & Sea YS-300s set on half-power.

ADDING A SENSE OF MOTION

I made this photograph of a spearfisherman on the south coast of Cuba. It was late in the day and light levels were low. While following the diver, I continually metered the background water. I knew from the low ambient light that to produce an interesting image I would need to shoot at an upward angle and use a slow shutter speed. Although the slow shutter speed would result in some blurring, I believed that the effect would look good, adding a sense of motion to the scene.

As the diver worked with the speared fish, I positioned myself within about 4 feet and pointed my camera up until I achieved a meter reading of ƒ/8 (having already preset the shutter and aperture). I had also already positioned my strobes pretty far out to the side and about midway down the height of my housing. Both wide-angle strobes were set on half-power. I moved around on the bottom until the composition looked good, with the diver as the primary subject and the fish and environment as secondary subjects.

This image works for several reasons. The diver is engaged in an activity, there is action, and there is color.

SHIPWRECK PHOTOGRAPHS

ELEMENTS OF SUCCESS

More than most other types of photographs, creating good shipwreck photographs requires careful forethought and planning. The following sections describe how to equip yourself as well as how to approach the wreck to give yourself the best chance of capturing great images.

RIGGING FOR WRECKS

Shipwrecks can be found in all depths of water and are accessible to all levels of divers; however, the wreck environment presents some unique challenges in terms of the equipment it demands. In some respects, shooting shipwrecks can be compared to wildlife photography. Photographers must know the "behavior" and "anatomy" of their sunken subjects, such as how to tread lightly so as not to disturb silt and decayed matter, which could obscure the image, or how to recognize a camouflaged artifact as significant and worthy of making an image.

Parallels can also be drawn between wreck photography and mountaineering and alpine photography, with the shipwreck as a sunken peak. We can view shipwrecks as an underwater edifice, if you will, whose face is ever changing, sculpted not by wind and ice but by the sea. Rather than climbers pursuing a summit, burdened with lines, carabineers, and boots, we find divers burdened with tanks, carabineers, and drysuits, pushing downward to the wreck. As clouds and mist might obscure the mountainscape, turbidity and silt can cloud the wreckscape. If favorable conditions prevail, however, a majestic image of a rusting submarine alp can be the reward.

The first thing to realize, in photographic terms, is that shipwrecks are huge subjects and that the use of wide-angle lenses is therefore imperative. Unless the water is exceptionally clear, it may be difficult to actually photograph the entire wreck, but wide-angle lenses will serve to capture large sections of it. In conditions where visibility is poorer, the great depth of field of the wide angle will allow the photographer to get close to smaller identifiable subjects, such as a porthole or the ship's wheel, reducing the amount of dirty water between the camera and subject. An amphibious Nikonos camera can be used with a 20mm lens that offers 78 degrees angle of coverage. Their versatile 15mm lens offers an impressive 94 degrees of coverage. The depth of field on the 15mm lens ranges from 9 inches to infinity and is especially well suited to shipwreck photography.

With a 35mm reflex camera inside an underwater housing, wide-angle lenses of 24mm or wider are most productive. The rangefinder Nikonos lenses are designed with controls on the lens exterior for setting the camera-to-subject distance and aperture. Focusing then is simply a matter of setting the distance scale. With a reflex camera in a housing, however, focusing is a bit more difficult, especially with wide-angle lenses in conditions of low ambient light. Autofocus systems can help with these dark, encrusted, submerged subjects, although even they may find focusing a bit difficult. (See Chapter 13, "Automatic Focus and Exposure.") One way to overcome this dilemma is to create focusing scales for each of the lenses used in this type of work. Make a focusing scale by calibrating your lens in a swimming pool in bright, well-lit conditions. Measure out various distances, rack in the focus until sharp, then get out of the water and put a mark on the lens focus gear inside the housing (after removing the dome port). Once the various distances have been calibrated onto the front of the lens gear, a corresponding scale can be made on the focus control of the housing for quick focusing. Calibrating your lenses in this way assures that the image will be in focus when shooting on a shipwreck, even if your eye (or the camera's auto focus) cannot tell when or where the image is sharp.

Most divers exploring shipwrecks appreciate having an underwater light with them to illuminate dark spaces beneath fallen timbers or to search the interiors of intact wrecks. Since it is difficult to hold a camera in one hand and a

You can make a handwritten focusing scale for the focusing control on your housing. Paint corresponding calibrations onto the front of the lens focus gear inside the housing.

light in another while taking pictures, the remedy is to mount a light on your camera system. With an amphibious camera, like a Nikonos or Sea & Sea, the light can be easily mounted to the camera tray, although it may be necessary to drill a hole. With a housed system, the light can be affixed beneath one of the handles or at the base of the housing if threaded holes already exist. With a light attached to the camera system, the photographer can see and shoot at the same time.

The attachment of a lanyard is also a helpful addition to the "wreck-rigged" camera system. You can purchase commercially produced lanyards or you can make one quite simply from materials such as shock cord or surgical tubing. Mounted to the tray or housing, the lanyard is worn loosely around the wrist and will prevent loss when you find yourself in a situation where you need both your hands and setting down the camera is not an option. Lanyards are good additions to camera systems regardless of the subject, but they are especially handy when you are working in the shipwreck environment.

Since shipwrecks tend to be very abrasive environments, it is critical that you protect the lens or dome port if you're going to return with images unblemished by scrapes. Most wide-angle lenses made for amphibious cameras are designed with lens shades extending beyond the front element, offering protection. These cameras tend to be smaller and more manageable in the water than a housing, and the provided shade is quite suitable. The more likely system to suffer scratches and scrapes is the underwater housing with a large dome port. This too, however, can be protected with the addition of a dome shade. Some housing manufacturers offer such shades for their ports, it's well worth the investment to get one. If a dome shade is not available, one can be made using the proper diameter PVC, which can be turned down on a lathe and scalloped out to prevent vignetting. Set screws can be added to secure the shade to the ring of the dome port.

LIGHTING

Some of the most dramatic photographs of shipwrecks are those that show the entire wreck lying on the sea floor. In most cases, such photographs are available-light photographs that employ techniques such as those discussed in Chapter 5, "Available-Light Photographs." If the wreck lies bathed in bright clear water on a

A NY SHIPWRECK PHOTOGRAPH can be categorized as any of the several other types of photographs defined in this book, such as available light, silhouette, people, close-focus wide-angle, or even macro. Shipwrecks get their own, separate chapter because they are unique underwater environments and as such require a slightly different photographic approach.

Shipwreck photographs can convey a powerful sense of exploration, intrigue, adventure, and discovery. The romantic vision of swimming into the deep to find a lost and forgotten ship lying quietly on the ocean floor is the stuff of dreams. Since man first ventured forth upon the waves in ships, there have been shipwrecks in nearly every body of water and in all parts of the world. Therein lies the opportunity. The opportunity for an underwater photographer is not gold doubloons or silver bars but treasures of a different kind—unique images.

Images of shipwrecks appeal to the innate human quality of curiosity. They are silent sentinels committed forever to the sea, and it is photographers who bring their stories to life. For the underwater photographer, shipwrecks present a unique opportunity indeed. As with any specialized subject, a bit of preparation will prevent a lot of aggravation.

Submarine Hunley Under Water

Brian Skerry with Ira Block

The U.S. Civil War submarine photographed under water inside a massive conservation facility in Charleston, South Carolina.

white sandy bottom, then obtaining available-light images should be quite simple. A glance at the light meter will probably get you the only real information you need to make the shot.

It should be emphasized that even under conditions such as those just outlined, a typical meter reading may only be $f/2.8$ or $f/4$ at 1/60 with ISO 100 film. Although the scene appears bright to your eye, the absorption and refraction of light is significant. In spite of these wide-open settings, beautiful images can still be made. When shooting a wreckscape, fine detail is not overly critical, and shutter speeds as slow as 1/30 of a second will produce acceptable results. A photograph such as this can be quite dramatic, however, as it allows for a splash of color—and even more impact—to easily be added.

Using the same technique described above (metering for the ambient light surrounding the wreck) you can use a strobe to add a bit of detail and color to a prominent subject in the foreground. Generally, positioning the camera approximately 3 feet from the foreground subject and using a wide-angle strobe will allow you to separate that subject from the rest of the wreck, resulting in a more dramatic photo. Your camera should be set to achieve a pleasing ambient exposure, and you should adjust the strobe power setting and/or the distance in order to balance exposures. (See the "Balancing Exposures" section in Chapter 8.)

When shooting shipwrecks in darker or poorer-visibility water, a strobe becomes essential. Impressive wreckscapes may not be possible, however, with artificial light. Because wide-angle lenses are most-often used, the angle of coverage of the strobe is perhaps the single most important feature. Most underwater wide-angle strobes offer coverage angles of 105–110 degrees. Such coverage will provide adequate light for even the 94-degree coverage of a 20mm lens in a housing or for the Nikonos 15mm lens.

The most common problem encountered with strobe photography on wrecks is backscatter. Shipwrecks are almost always carpeted in fine layers of sediment from the surrounding bottom. Inside the wreck, rust particles and decayed matter billow into clouds with the slightest disturbance. Light from a strobe hitting this suspended sediment creates a maelstrom of mirrors, each reflecting light back at the lens.

With such obstacles to crisp, clean images ever present, strobe positioning becomes critical. Pointing the strobe directly at the subject generally results in much greater backscatter. The strobe position best suited for reducing backscatter is one that directs the light evenly and straight ahead. If only one strobe is being used, it should be placed above the camera and out to the side, and it should be aimed straight, on the same plane as the lens. With the center of the light off to the side, particles in front of the lens will be illuminated only by the softer edges of the strobe light coming in at an angle. To further reduce the backscatter problem, two strobes should be used in the same manner as described above, spreading them even farther out to the sides and feathering the light falling on the primary subject. (See Chapter 3, "What Happens to Light Under Water," for more information.)

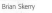
Brian Skerry

Adding a dome shade, lanyard, and a light will customize your housing for the shipwreck environment.

Abandoned to the Water
Howard Hall

PHOTO PLAN

Every experienced photographer would agree that planning can make all the difference in consistently returning with great images. This is never truer than when you're shooting in a place where you are limited by time. Under water, the clock is always ticking, and time becomes a matter of air supply or decompression obligation and cannot be wasted.

The first consideration in the photo plan is subject matter. While this may seem a bit obvious, closer scrutiny reveals the advantages of forethought and familiarity with your subject. In the same way a topside wildlife photographer studies a subject, the wreck photographer should also know something of his or her quarry. Even a basic knowledge of ship construction will lead to more interesting photos and help to tell a story. While swimming aimlessly and shooting everything in sight *can* produce results, it is more productive to jump in armed with a bit of research. For instance, it would be good to know where on the wreck

you might find the ship's wheel that the helmsman used to turn the ship into the path of an approaching freighter, thus causing the wreck. What was the vessel's cargo, and how might it look today after years beneath the sea? Where on the wreck might the ship's name be inscribed? These questions can be answered with a bit of research—answers that just might produce interesting and dramatic photos.

Although most shipwreck photographs will be wide angle, do not overlook the potential for macro subjects on wrecks. On many shipwrecks you can find smaller artifacts or personal effects such as coins, a flashlight, or a pocket watch, any of which would make wonderful macro photos. The inclusion of subject matter such as this will also contribute greatly to a photo story, should you wish to sell your work. (See Chapter 14, "Selling Underwater Photographs," for more information.)

The photo plan should also include a strategy with your dive partner if you intend to

include another diver in the picture. The presence of a diver in the image can add a real sense of exploration or discovery and can also give scale to objects to which the general public may not immediately relate. Communication under water is difficult and time consuming, so a detailed discussion beforehand will eliminate any misunderstanding on the bottom.

Here's a final thought regarding subject matter on shipwrecks. Even though the ship may be the primary subject, the photographer should not ignore the marine life there. Sunken ships relegated to a watery grave may never again serve sailors, but they do not lack inhabitants. From the moment of its sinking, a shipwreck becomes a dynamic ecosystem providing a home to a wide range of marine creatures. Some of the most interesting shipwreck photos are those that illustrate animals now living in and around the once-proud ship. The combination of historical wreck photos along with marine life photos can create a very powerful essay.

Shuffleboard Court on *Andrea Doria*

Brian Skerry

Research conducted prior to diving can reveal the location of interesting photo subjects, such as this shuffleboard court on the wreck of the luxury liner *Andrea Doria.*

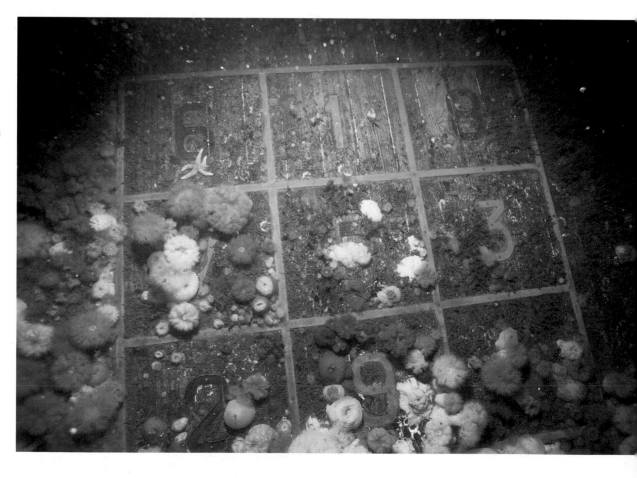

MASTERING THE FUNDAMENTALS

The techniques for photographing shipwrecks are essentially the same as for other types of underwater photographs. To effectively photograph wrecks, much of your work lies in the preparation. This includes preparing your camera equipment to function better in the shipwreck environment and preparing yourself with some research and a well-thought-out photo plan. A photo plan will eliminate wasted time and will usually result in photos of recognizable objects, rather than simply hunks of undistinguishable twisted metal.

As with any specialized area of photography, understanding one's subject and visiting it often are keys in obtaining positive results. Shipwreck photography is relatively young and the field of interpretation is wide open. Sunken ships are perfect subjects for experimentation with multiple lighting set-ups and other creative techniques. As more photographers become interested in diving, and as more divers get turned on to photography, we will undoubtedly see an increase in the dramatic images from these rusting castles in the sea.

HOLDING FOCUS THROUGHOUT THE SCENE

This wreckscape of the German U-boat U-352 was made off the coast of North Carolina at a depth of 118 feet and would be classified as an available-light photograph, given that no strobe was used. Visibility was around 100 feet on this day, so I chose to make a photograph that would show as much of the submarine as possible. I metered the water just above the top of the wreck and set my Nikonos 15mm lens to *f*/4 and the camera to 1/60. The tremendous depth of field of the Nikonos 15mm lens held the focus throughout the scene, even at an aperture of *f*/4. Although I bracketed between *f*/2.8 and *f*/5.6, the *f*/4 setting produced the best results.

I framed the scene so that a small portion of the white, sandy bottom was visible. This helps to give placement to the subject and also serves to lead the viewer's eye toward the subject. In this case the white sand actually worked as a bit of a reflector as well, shedding some light on the section of the wreck closest to the bottom. Ideally there would have been a diver or two swimming over the submarine to add a sense of discovery; however, the photograph works even without this element. The techniques for making this type of available-light photograph are quite simple and are discussed in Chapter 5 "Available-Light Photographs."

German U-Boat Wreckscape

Brian Skerry

Camera and lens: Nikonos III with 15mm lens. **Film:** Kodachrome 64. **Aperture:** *f*/4. **Shutter speed:** 1/60. **Subject distance:** 6 feet from the closest forward section of the submarine. **Camera angle:** about 45 degrees upward. **Strobe:** none.

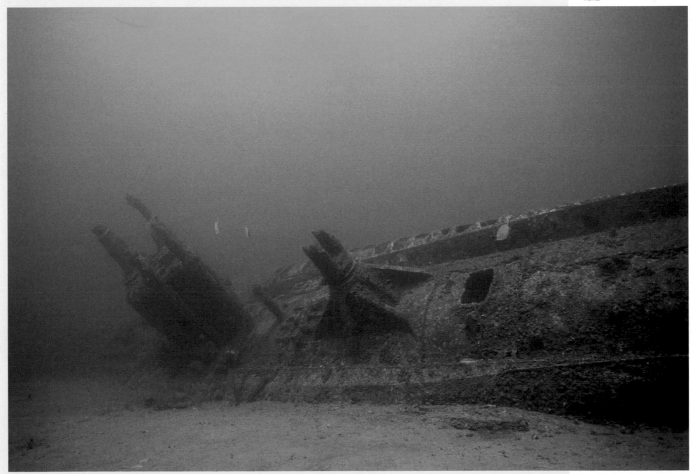

WORKING INSIDE A SHIPWRECK

This photograph of human remains was made inside the wreck of the U-853 off the coast of Rhode Island. I swam into the submarine's control room and practically came face to face with the remains. When working inside a shipwreck, it is useful to work as quickly as possible. Exhaust bubbles from your regulator will often rise to the ceiling and dislodge pieces of rust and debris. In a matter of minutes you will find yourself in the middle of a rusty rainstorm that will wreak havoc with your photography. Since the U-853 rests at a depth of 130 feet, working quickly was also necessary from the standpoint of air and bottom time.

To help reduce backscatter, I positioned my strobes well out to the side so that the sides of the beams would illuminate the subject. I got down as low as possible to create a slight upward angle in order to give prominence to the skull as the primary subject. I also composed the shot from slightly off center, at an angle that would give depth to the subject. Since there was no ambient light inside the wreck, all lighting came from the strobes. I set both strobes on full power and bracketed from ƒ/4 to ƒ/16 just to make sure I got the picture. I was fairly confident, however, that the correct exposure would be closer to ƒ/8 or ƒ/11 (with the ƒ/8 exposure being selected here).

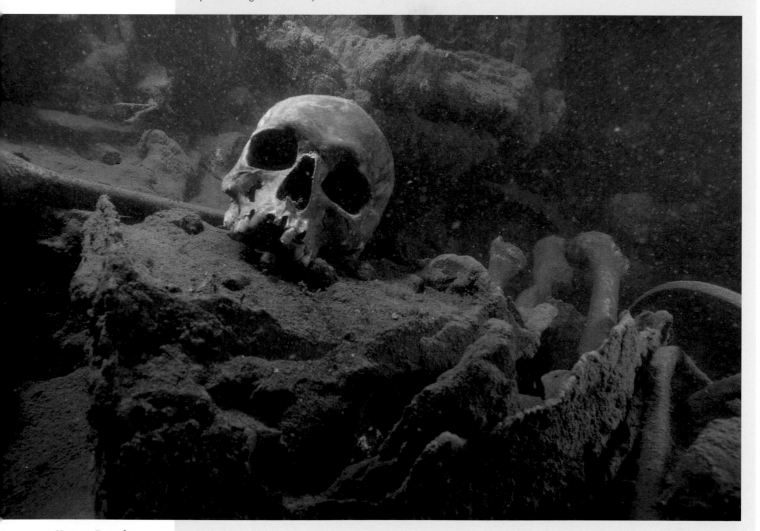

Human Remains

Brian Skerry

Camera and lens: Nikon F3 with 20mm lens inside an Aquatica housing. **Film:** Kodachrome 64.
Aperture: ƒ/8. **Shutter speed:** 1/60. **Subject distance:** 3 feet.
Camera angle: slightly upward.
Strobe: two Sea & Sea YS-200s set on full power.

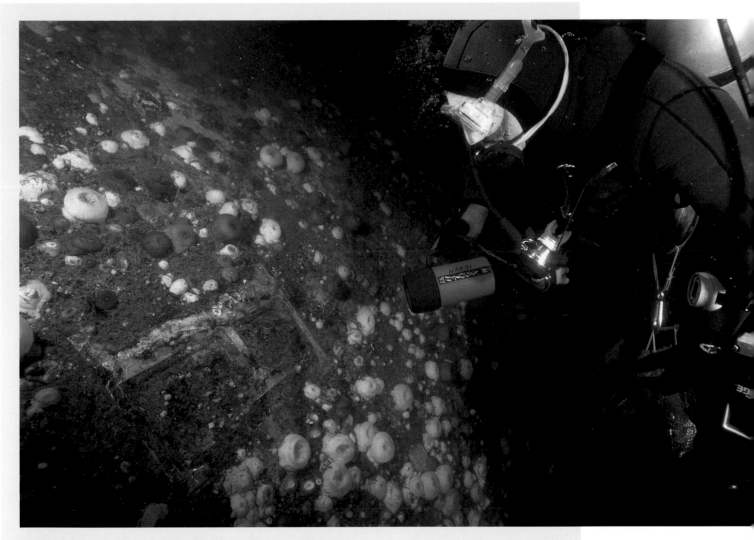

PLANNING AND RESEARCHING THE DIVE

This photograph was made on the wreck on the Italian luxury liner *Andrea Doria*. It shows a diver, Frank Nardi, examining the large bronze letter "E" on the stern of the *Doria's* hull.

The dive team did a bit of research before making this photograph. The group of divers I was working with decided to dive on the stern section of this nearly 700-foot-long wreck. Because we were planning to be in this section, I began discussing with my dive buddies the possibility of locating the ship's name, which I hoped to photograph. We studied blueprints and historical photographs of the ship to see exactly where the name was located.

On our first dive, we swam to the area where we believed the name was located. But after lying for nearly 40 years on the bottom of the North Atlantic, the ship was covered in marine growth, making it difficult to discern features with low relief. We began scraping away some of the growth, and sure enough, the name *Andrea Doria*—Genoa was revealed. The name was spread out over a large portion of the rounded stern, however, and visibility was limited to 10 feet, so only individual letters could be photographed.

At a depth of 210 feet very little ambient light was present, so I made the photograph using strobes as the only light source. Although I also photographed the letters by themselves, the presence of the diver adds discovery and adventure to the scene. The fact that this diver was wearing a red drysuit also helped make the image more colorful and appealing.

A photograph like this illustrates the importance of doing some homework before making the dive. Had I simply taken my camera and gone diving, I might not have found an identifiable subject to shoot, especially with precious little bottom time at this depth. With a bit of research (and the help of good dive buddies), shipwreck photographs tell a better story.

Diver on
Andrea Doria

Brian Skerry
Camera and lens: Nikon F3 with 20mm lens inside an Aquatica housing. **Film:** Kodachrome 64.
Aperture: *f*/8. **Shutter speed:** 1/60. **Subject distance:** 4 feet from the letter "E" on the hull.
Camera angle: slightly upward.
Strobe: two Sea & Sea YS-200s set on full power.

PORTRAYING THE WRECK AS HABITAT

These two photographs of marine life were both made on shipwrecks. The sand tiger shark was photographed on the wreck of the U.S. submarine *Tarpon,* located off the coast of Hatteras, North Carolina, in a depth of 140 feet. The shrimp was photographed living inside a boiler tube on the wreck of the *Mexicano* off Nags Head, North Carolina, also in 140 feet of water.

The shark photo is simply a wide-angle photograph where strobe provided the primary light source. For reasons that are unclear, these sand tiger sharks often school on some of the wrecks off of North Carolina. This animal was surrounded by baitfish and presented a unique photo opportunity. Although I had not planned to take this photo, I seized the moment when it presented itself.

For work on the wreck of the *Mexicano,* I brought down a reflex macro set-up with the specific intention of finding macro subjects to photograph. I had already spent time photographing other sections of the wreck with wide-angle lenses and wanted to round out my coverage with images of the tiny animals that made their homes there. The exposed boiler tubes on many shipwrecks serve as an underwater apartment building of sorts for a variety of creatures. This little shrimp was just one of the "tube dwellers." Macro marine life photography is often a good choice on dives when the visibility is not especially good or when you wish to tell a more-complete shipwreck story.

Shrimp
Brian Skerry
Camera and lens: Nikon N90 with 60mm lens inside Subal housing.
Film: Kodachrome 64. **Aperture:** ƒ/22. **Shutter speed:** 1/60.
Subject distance: 8 inches.
Camera angle: horizontal.
Strobes: two Sea & Sea YS-50s set on TTL.

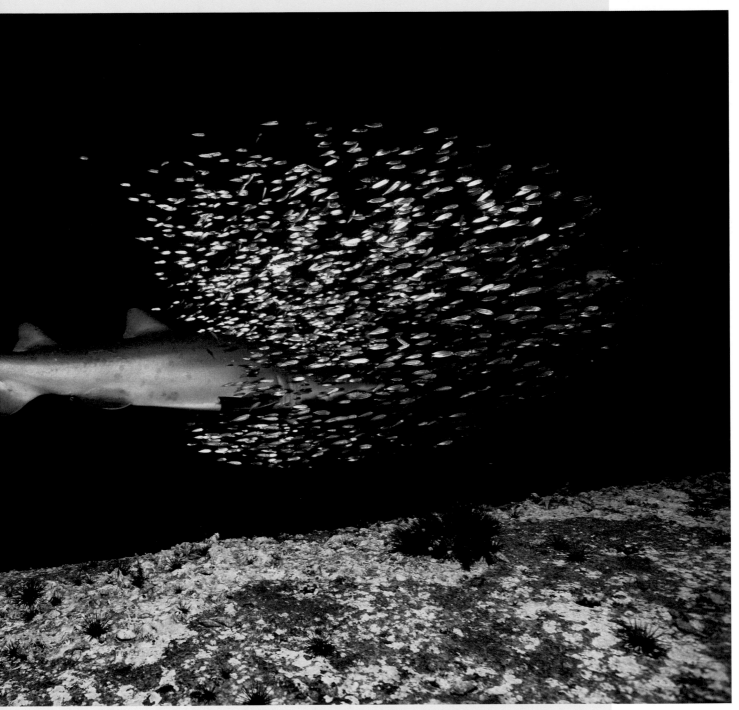

Sand Tiger Shark

Brian Skerry

Camera and lens: Nikon F3 with 20mm lens inside Aquatica housing. **Film:** Kodachrome 64. **Aperture:** ƒ/5.6. **Shutter speed:** 1/60. **Subject distance:** 6 feet. **Camera angle:** horizontal. **Strobes:** two Sea & Sea YS-200s on full power.

EXPERIMENTING WITH BLACK AND WHITE

**Diver in Debris Field
(Black and White)**

Brian Skerry
Camera and lens: Nikon F3 with
20mm lens inside Aquatica housing.
Film: Kodak TMax 3200 ISO.
Aperture: ƒ/5.6. **Shutter speed:**
1/60. **Subject distance:** 20 feet.
Camera angle: about 45 degrees
downward. **Strobe:** none.

I made this photograph in Cape Cod Bay on the wreck of the oil tanker *Pinthis*. It was a cold April day, and the water in the bay was especially clear. Visibility was nearly 100 feet. I was experimenting with high-speed black-and-white print film on shipwrecks and wanted to try it out under such good conditions.

I had landed on the highest part of the wreck's overturned hull and could easily see my buddy, Tom Mulloy, exploring the debris field nearby. Tom was kneeling next to the *Pinthis'* rudder, which had fallen off to the side of the wreck. As a rule, downward camera angles are not usually very productive, but in this case I liked the scene I had composed through my viewfinder.

I metered the overall scene and was amazed at the reading of ƒ/5.6 at 1/60. The sandy bottom contributed greatly to the brightness as it reflected the light penetrating through the unusually clear water. I then focused on Tom and fired the shutter.

Black-and-white film can make for a nice change in underwater photography. Although you may never wish to use it when photographing colorful soft coral, it can be extremely effective with more monochromatic subjects like shipwrecks. Print film also has greater dynamic range, or latitude, than slide film, making it useful in situations when available light is low. The 3200-speed film used in this photograph is especially useful on shipwrecks with dark but clear water.

DISPLAYING THE DRAMA

This photo of a diver swimming over the listing conning tower of the sunken U-352 is an example of a silhouette photograph. As discussed in Chapter 6, "Silhouette Photographs," these images are quite simple to make. They are often very useful in shipwreck photography since they portray the wreck in a dramatic fashion.

For this shot I positioned myself on the bottom at a depth of 118 feet and composed the wreck to occupy about half of the frame. I knew that my buddy, Nick Caloyianis, would soon be swimming into the frame and simply waited for this to happen. Getting a shot of Nick surrounded by baitfish was a bonus.

I had been diving on this site for several days for a television documentary project and had begun to think about the wreck as a tomb. I wanted to make a picture that would portray the lost submarine as just that: a sunken tomb. A silhouette achieved that goal, lending a somber feeling to the image.

I metered the light about midway up the water column and set my aperture accordingly. Although I would have preferred a slightly faster shutter speed, there simply was not enough light at this depth. I opted for the higher aperture of ƒ/8 instead in order to give myself better depth of field.

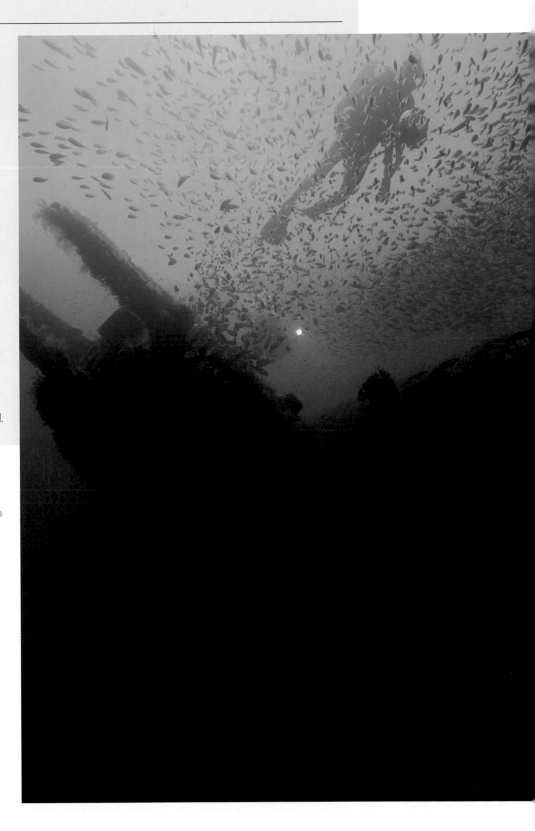

Silhouetted Diver and Submarine

Brian Skerry
Camera and lens: Nikon F3 with 20mm lens inside Aquatica housing. **Film:** Kodachrome 64. **Aperture:** ƒ/8. **Shutter speed:** 1/60. **Subject Distance:** 20 feet from diver. **Camera angle:** nearly straight up. **Strobe:** none.

CLOSE-FOCUS WIDE-ANGLE PHOTOGRAPHS

**Looking up
from the Depths**

Howard Hall

C LOSE-FOCUS WIDE-ANGLE (CFWA) photographs are perhaps the most beautiful type of photograph that can be made under water. They feature the beautifully rich colors of a macro shot combined with the expansiveness of wide-angle, available-light, and silhouette photography. Well-known underwater photographer Jerry Greenberg made some of the earliest CFWA photographs. When these images first appeared the technique seemed to be magic, but in time others learned the secret.

The idea is to take advantage of the extreme depth of field that wide-angle lenses are capable of delivering. For example, when set to $f/16$, the 15mm Nikonos lens has a depth of field from 1 foot to nearly infinity. It is therefore possible to get an average-sized starfish nicely framed in the foreground with a diver swimming through a kelp forest in the background, all in focus at the same time. The trick is to balance exposures.

ELEMENTS OF SUCCESS

With just a little attention to technique, you can create striking CFWA photographs. The following sections describe the concepts you will need to master.

BALANCING EXPOSURES

Since you will often be using small apertures such as $f/16$ and $f/11$, you will balance exposures by photographing the subject (in the foreground) with a strobe held as close as possible and at high power, just as you would with an extension tube photograph. In order for the background to balance, you simply aim either straight up or close to it. Because the lens is so wide, the sun can be in the top of the frame and your subject in the bottom. CFWA photos are usually taken vertically. The result is a colorful subject with spectacular negative space.

PERSPECTIVE

Perspectives in underwater photographs, and especially in CFWA photographs, are often deceiving. It is not normal for us, as land dwellers, to go around looking straight up. As a result, we tend to view photos that were made at strange angles as if they were more or less level.

When you look at the examples in this chapter, you may have some difficulty believing that they were shot at extreme upward angles, most, in fact, almost straight up. But if you look closely, there are some clues. In some of the shots you can actually see the sun. To get the sun in the frame, you have to point the lens at an extreme upward angle, if not straight up. Depth of field and bright backgrounds also indicate that this technique was used. CFWA photographs can also be taken at less extreme angles or even level, but some depth of field must be sacrificed due to the wider apertures necessary.

NEGATIVE SPACE

The CFWA photograph is a combination of brilliant subject and magnificent negative space. The subject will be the primary point of interest in the photograph, but it is a good idea to have a secondary point of interest in the background. Divers, boats, schools of fish, sea lions, or sperm whales are all good subjects for silhouettes in the background. Divers, however, are the easiest to properly frame since, with a little cooperation, you can direct them to swim into the picture.

If you plan to use a diver as your model, ask him or her to swim naturally through the frame about 20 to 40 feet away. Some models have a tendency to stretch their arms and legs out in a spread-eagle fashion. Others may go where you direct, but in a Charlie Chaplin stance. Poses like these are unnatural and often look silly in the photograph. Ask your model to repeatedly swim through the frame at a slow pace. It is also best if the model continues to kick, since the moment he or she stops, his or her fins will begin to do awkward things.

**Chrysaora
Jellyfish Pair**
Howard Hall

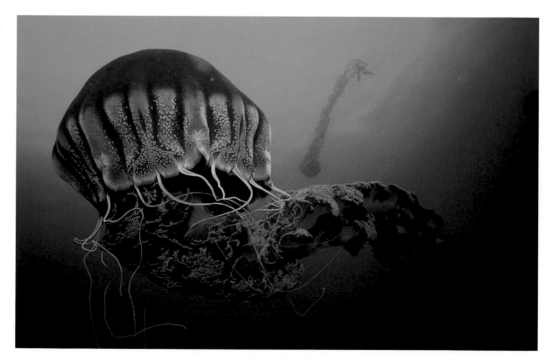

MASTERING THE FUNDAMENTALS

Here are the important tips to remember when taking successful CFWA photographs:

- First, make sure that the lens you are using has a picture angle of 80 degrees or better and that it is capable of focusing to nearly 1 foot.

- Once under water, look for subjects that are positioned so that you can get well below them to aim at extreme upward angles. Vertical drop-offs are excellent places to find such material.

- The subject should be about 1 foot or larger in diameter. Even at a focusing distance of 1 foot, a subject that is a foot in diameter will occupy less than half the frame of a lens with an 85-degree picture angle. Smaller subjects are simply too small to carry any impact.

- Given that your subject is 1 foot or larger in diameter and that the strobe will be held very close, the strobe should have a wide enough beam angle to cover the subject at that range. This is why wide-angle strobes are recommended for this type of photograph.

- If you are using a Nikonos and the subject distance is 1 foot, set the lens focus so that the depth of field indicators just include 1 foot. If the lens does not have depth of field indicators or if it is part of a reflex system, then simply set the focus at the subject distance (of 1 foot).

- Next, take a light-meter reading on the water directly behind the subject. If you are shooting directly into the sun and the surface is visible, your reading should be very high. You would bracket your exposures around $f/11$.

- If the surface is not visible, your reading may be less. You will have to settle for poorer depth of field. Even if you have to shoot at $f/5.6$, however, the results can be effective. Normally, you should be bracketing around $f/11$, especially if the surface and sun are visible in the frame.

- Note: The important exposure is the one on the subject. Even if the negative space is a stop over- or underexposed, it may still be an effective photograph as long as the subject is properly exposed. In the examples in this chapter, the background might still have been effective with as much as two stops difference in exposure.

- After taking your light-meter reading on the water behind the subject, set the lens to the proper aperture setting and move in on the subject. Position the subject at the bottom of the frame (if you are shooting a vertical photograph) and then inspect the background for negative space.

- Hold the strobe close enough to obtain the proper exposure and take the photograph.

CLOSING THE GAP BETWEEN SUBJECT AND LENS

This photograph of a Garibaldi fish was taken with a 15mm lens set at 2 feet. The subject is almost too small in the frame to catch the viewer's attention, but the animal's bright color and the separation in the photograph makes it appealing.

This photograph illustrates why the CFWA technique only works on subjects at very close range. Had the subject been any farther from the lens, it would have appeared as little more than an orange speck.

Perspective in this photograph is deceiving (as it is in many CFWA photographs). The photo seems to have been taken at a relatively level angle. If this is the way the photograph appears to you, then take a second look at the water surface. The only way the surface and the sun could appear as they do in this photograph is if the camera were aimed at an extreme upward angle. In this case, the camera angle was about 45 degrees upward.

My exposure setting was $f/8$, which my strobe-to-subject distance determined, along with the strobe's guide number for that distance. This exposure worked well on the fish, but it nearly overexposed the background.

The subject exposure is of primary importance in CFWA photographs, while the negative space can afford considerable latitude. The background in this photograph would probably have been equally effective if it had been exposed as much as two stops darker.

Diver and Garibaldi

Howard Hall

Camera and lens: Nikonos III with 15mm lens. **Film:** Kodachrome 64. **Aperture:** $f/8$. **Shutter speed:** 1/60. **Subject focus distance:** 2 feet on the fish. **Camera angle:** 45 degrees upward. **Strobe:** one wide-angle strobe set on full power, with the diver about 30 feet away.

CREATING A SECONDARY POINT OF INTEREST

This photograph of a feather sea star was taken at a depth of 110 feet in the Coral Sea. Water visibility was exceptional, allowing our 85-foot dive boat to act as a secondary point of interest in the negative space. The position of the boat makes the extreme upward camera angle a little more obvious than if the boat had not been there. This photograph was taken by aiming the camera almost straight up. The real trick in CFWA photographs is to balance the exposures and maximize the depth of field. The best camera angle that accomplishes this is nearly straight up.

The subject, a feather sea star, or chrinoid, is about 1 foot in diameter. I used a 15mm Nikonos lens set at 1 foot and an aperture setting of ƒ/16. Then, I used my wide-angle strobe set at full power and handheld it as close as I could to the starfish.

The exposure on the ocean surface during daytime and with average visibility is going to be ƒ/11, ƒ/16, or ƒ/22. After selecting one of these exposures, the strobe must then be held close enough to the subject to give it the same exposure. Remember that the exposure on the subject is critical. If the background is somewhat over- or underexposed, it will have little influence on the acceptability of the results.

Chrinoids are very abundant in this area of the Coral Sea. Therefore, I did not merely photograph this one with the boat "accidentally" in the background. Instead, I specifically searched for an appealing chrinoid to photograph against the negative space of the distant boat. As is the case with macro photographs, to take a good CFWA photograph, you will often spend your time looking for good negative space and then search for subjects to photograph within that space.

Sea Star and Boat
Howard Hall
Camera and lens: Nikonos III with 15mm lens. **Film:** Kodachrome 64. **Aperture:** ƒ/16. **Shutter speed:** 1/60. **Subject focus distance:** 1 foot on the sea star. **Camera angle:** straight up. **Strobe:** one wide-angle strobe handheld at 1 foot from the subject.

Photographer and Gorgonian
Howard Hall
Camera and lens: Nikon F2 with 24mm lens and +2 diopter inside housing. **Film:** Kodachrome 64. **Aperture:** ƒ/16. **Shutter speed:** 1/60. **Subject focus distance:** 1 foot, on gorgonian. **Camera angle:** nearly straight up. **Strobe:** one wide-angle strobe on full power and 1 foot away from the subject.

COMPOSING AROUND A PRIMARY SUBJECT

This photograph of a gorgonian coral was taken at a depth of 120 feet in California waters. I used a 24mm lens on a Nikon camera in an underwater housing with a diopter lens in front of the 24mm lens. The subject was about 1 foot in diameter and was photographed from about a foot away. The diver in the background was about 30 feet away.

The camera angle was almost straight up. The sun, though not visible from this depth, was located just above the top of the gorgonian coral. Even from this depth, the extreme lens angle gave me an exposure of ƒ/16.

My wide-angle strobe was set on full power and positioned on a ball joint arm to within a foot of the gorgonian, just above the lens (causing some backscatter at the top of the frame). This power setting and strobe-to-subject distance gave me the proper exposure on the gorgonian coral at ƒ/16.

The background, however, is underexposed. But this underexposure does not detract from the photograph's effectiveness. Had the background exposure been increased by as much as two stops, the photograph would probably still be acceptable.

The diver is slightly out of focus in this photograph. Since he is not the primary point of interest or even part of the actual subject, the softness is unimportant. The diver is part of the negative space. Even with the extreme depth of field that a wide-angle lens gives at this aperture, the background will often be slightly soft in some CFWA photographs. Because the background is negative space, however, and not the photograph's subject, the softness is acceptable.

CHOOSING THE EXPOSURE FOR SUBJECT (AND BACKGROUND)

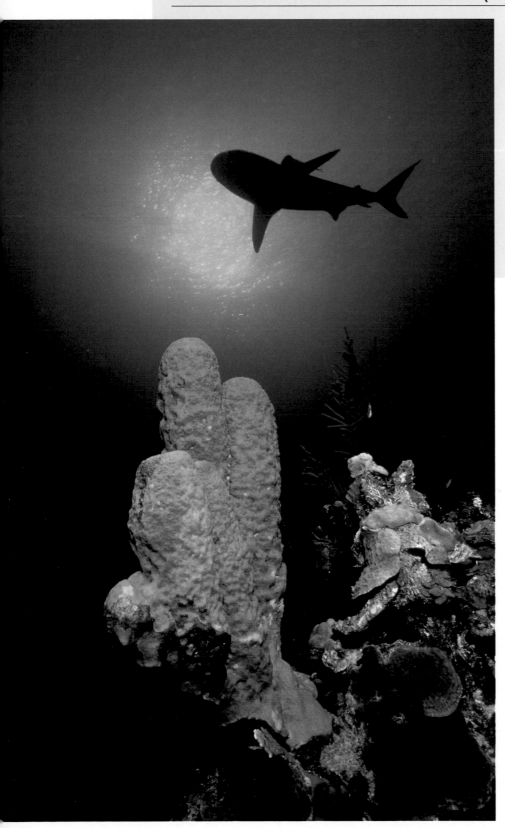

This CFWA photograph was made off of Little Cayman Island. While diving on a reef, I noticed a few Caribbean Reef Sharks cruising around. The water was clear and ambient light plentiful, so in my mind's eye I began to create a CFWA shot that would include both a shark and the colorful reef.

I swam around until I found a beautiful tube sponge that would serve as a perfect primary subject. I aimed the camera straight up and took a meter reading of ƒ/22. To match this ƒ stop with my strobe, I needed to be no farther than a foot away from the sponge. I focused my 15mm Nikonos lens to 1 foot, positioned my strobe, and waited for a shark to swim into the frame.

At ƒ/22, the depth of field on the 15mm lens is tremendous. It rendered both the sponge and shark silhouette in sharp focus.

Reef Shark and Sponge

Howard Hall

Camera and lens: Nikonos III with 15mm lens. **Film:** Kodachrome 64. **Aperture:** ƒ/22. **Shutter speed:** 1/60. **Subject focus distance:** 1 foot, on the sponge. **Camera angle:** almost straight up. **Strobe:** one Ikelite 150 set on full power.

AUTOMATIC FOCUS AND EXPOSURE

Troupe of Rays
Howard Hall

ACCORDING TO WOODY ALLEN, "Eighty percent of success is showing up." In underwater photography the percentages might be a little different, but there is certainly something to be said for this concept.

Being under water with your camera when a sperm whale devours a giant squid in front of you or when great white sharks begin to mate will certainly increase your odds of success. Taking advantage of technology however, might increase your chances as well.

We've been discussing techniques for producing a variety of underwater photographs. These techniques rely on proven methods for composition, strobe placement, calculating exposures, and so on. With mastery of these methods, you can achieve tremendous results with even the most basic camera system.

But photographic technology is always advancing, and it is worth your while to investigate any tool that makes your job easier. One such tool is automatic strobe exposure, or TTL. With TTL ("through the lens") the camera measures the light that bounces back from the subject and sets the exposure accordingly. In theory, TTL exposures eliminate much of the strobe-related calculation. If you set the strobe to TTL, the computer sets the exposures and you can concentrate on composition.

Many pros choose to maintain full manual control over the creative process. This is a valid choice. Proper exposure is not an absolute. A "perfectly" exposed photograph might also be stopped down to produce deeply saturated colors. The "perfect" exposure might look better printed and hanging on the wall, while the underexposure might look much better projected.

Using TTL or not is an individual decision. Automatic exposure technology can work well, and it can make underwater photography simpler, but you should test it out thoroughly. Before you begin, some background information might be helpful.

APPLYING TTL TECHNOLOGY

The abbreviation TTL stands for "through the lens." This can refer to how viewing is achieved with SLR cameras, but more frequently it is used to describe automatic exposure. There are several applications of TTL technology.

AUTOMATIC EXPOSURE AND TTL

Automatic exposure works with technology that allows the camera to "talk" to the strobe. In TTL exposures, the camera's meter reads the light that the strobe emits as the light reflects off of the subject. When enough light has been emitted to achieve the proper exposure on the film, the camera tells the strobe to shut off.

The camera's computer generally evaluates a scene based on 18-percent gray, the same baseline that light meters use. While few underwater subjects actually are 18-percent gray in color, many will fall into an acceptable color range that TTL technology will process well. Difficulties tend to arise when a subject is very light or very dark. Since TTL computers seek to average scenes toward their programmed 18-percent gray, white subjects will often be underexposed and made to appear gray. The reverse is true of dark or black subjects, with TTL producing overexposures.

It is also important to decide what light-metering mode will work best for your application. As we discussed in Chapter 2, "Funda-

mental Photographic Principles," most SLR cameras offer multiple metering options, such as spot, center-weighted, and matrix.

TTL exposures are based on reflected strobe light that is measured off of your subject. Choosing different metering modes can therefore have an impact on your results. Spot metering mode reads a very small portion of the subject, and the matrix mode reads the entire scene corner to corner. Either of those choices can work equally well, given a specific application. Center-weighted metering, however, is probably the general all-around best choice when using TTL.

MACRO TTL

Even the most dyed-in-the-wool proponents of manual exposure will usually admit that TTL strobe exposure works well in macro applications. In fact, if used properly, TTL can result in a whole roll of perfect exposures.

In macro photographs, the subject usually occupies most of the frame, unlike with many wide-angle photographs. TTL works extremely well under such conditions. This is true regardless of whether you are using extension tubes or a reflex macro system.

As with manual exposures, your aperture should be set at $f/22$ (or higher with an SLR) when making macro underwater photographs. The TTL is capable of producing good exposures

at any aperture; however, maximum depth of field is best achieved at these higher f-stops.

You should still minimize the strobe-to-subject distance when employing TTL. With most strobes set at full power, a good 1:3 macro exposure will be produced when the strobe is held about 10 inches from the subject. If a TTL strobe is positioned farther away than this, it may not be capable of producing enough light for proper exposure.

For example, if the strobe is set 18 inches from the subject, the TTL meter will tell the strobe to use all the power it has (or give a "full dump," as it is sometimes called), and this still will not be enough light. When positioning the strobe for macro TTL photographs, place it close to the subject—about 6 to 8 inches away.

Although the use of TTL removes the control you have over exposures, it is still possible to bracket exposures. You can do this by manipulating the ISO film speed dial on your camera. You might want to consider ISO manipulation should you be photographing an especially light or especially dark subject or if you encounter a "once-in-a-lifetime" subject that justifies shooting an entire roll of film.

If you are using ISO 100 film, you should take the majority of your photographs with the film speed set on ISO 100. Then, if you want to darken some of your exposures, you can change the ISO setting to 150 to reduce expo-

Fish Peeking Through Anemone
Michele Hall

With a subject of medium tonal range (not too white and not too black), TTL delivers beautifully exposed photographs.

sure by half a stop, or you can change the setting to 200 to reduce the exposure by a full stop. It is unlikely that you will even need any further reduction in exposure, but the same procedure can be followed should you wish more. By changing the film speed dial to 75, you can add a half stop of exposure.

After reviewing the results of several rolls of film, you may decide that you like your photographs exposed a little lighter or a little darker. If so, you can set the film-speed dial accordingly and avoid bracketing while under water. Remember that doubling the ISO number will result in halving the exposure produced by the strobe, and halving the ISO number will result in doubling the exposure produced by the strobe.

WIDE-ANGLE TTL

Wide-angle TTL photography under water is a bit more complicated than macro photography. If the wide-angle photograph and subject you are shooting do not involve ambient light, then the procedures for TTL exposure are much the same as with macro subjects. For balanced wide-angle photographs and close-focus wide-angle (CFWA) photographs, however, there are two exposures you must manipulate: the strobe exposure, and the ambient light exposure.

You want both of these exposures to be optimum and balanced. Because the portion of the frame that is to be exposed by the strobe may both be small and off center (surrounded by blue water), it is easy for the TTL microcomputer, as smart as it is, to become confused. This is especially true if you have selected the matrix-metering pattern in your housed ISO. Rather than reading only the small portion of the frame you wish to light with the strobe (such as a fish), the meter and TTL sensor will try to light the entire scene, including the blue water behind, resulting in overexposure.

Because of these factors, using TTL for balanced wide-angle and CFWA photography does not produce the consistently perfect results that it does with macro photography. It therefore usually requires some form of exposure compensation. Since both the portion of the frame that is reflecting back light and the degree of reflectivity are highly variable from subject to subject, there is no standard correction that can be recommended to produce consistent results. There are, however, techniques that can be employed that will deliver positive results. Once again, the key is experimentation. Once you have tried the following techniques with wide-angle TTL photographs, you will gain a better understanding of what works best in various situations.

CLOSE-FOCUS WIDE-ANGLE TTL

CFWA photography with TTL follows much the same set of rules as balanced wide-angle photography. Since most of the frame is open water, the TTL will tend to overexpose the relatively small subject.

You bracket your CFWA photographs exactly the same way you bracket balanced wide-angle photographs. It is important to remember, however, that when shooting straight up into the sun and using $f/22$ or $f/16$, the strobe must be extremely close to the subject to produce an exposure. The TTL system will not put more light on the subject than the strobe is capable of at manual full power. And at manual full power and $f/22$, the strobe-to-subject distance should be about 1 foot (depending on film speed). So if your TTL CFWA photos are coming out underexposed, it may be your strobe-to-subject distance that is at fault, not the TTL system.

Yellow Shrimp
Michele Hall

This photograph of a shrimp was made using a Nikonos camera with an extension tube and two small strobes set on TTL.

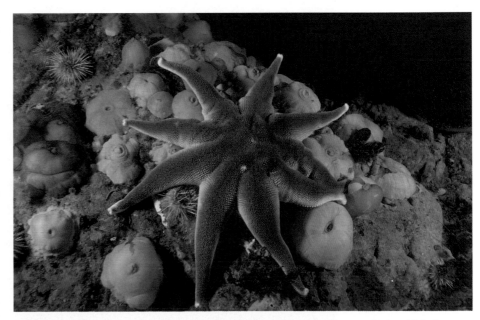

Smooth Sun Star
Brian Skerry

TTL works especially well for wide-angle photographs in which the subject fills most of the frame.

Silhouetted Diver and Brain Coral

Howard Hall

This CFWA photograph was taken with a Nikonos V, a Nikonos 15mm lens focused at 1 foot, and a Nikonos SB-102 TTL strobe.

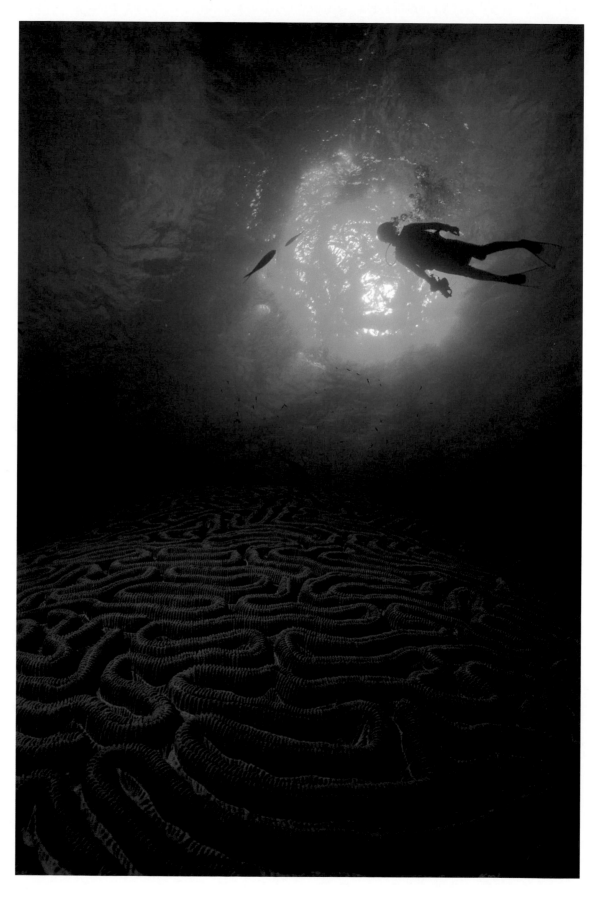

BALANCED WIDE-ANGLE PHOTOGRAPHY

That old stand-by, bracketing, still gives you the best chance of a perfect exposure. With balanced wide-angle photographs, multiply the film's ISO number by one and a half, and set the result as your film speed for your first bracket. Double the film's ISO number for the second bracket, and double it again for the third bracket. One of these, usually the middle bracket, is almost always perfect.

Example: Film ISO number = 100

Bracket #	Film Speed Dial Setting
1	150
2	200
3	400
4	100

Remember to first meter the ambient light, usually behind the primary subject, and to set your camera for that exposure. The *f*-stop you select must produce good background color and balance with your strobe exposure. In low light, choose a slower shutter speed. In low light, you can often shoot at shutter speeds of 1/30 or even lower if necessary. In housed systems with the appropriate technology, flash compensation is another technique for delivering TTL exposure. It programs the camera by reducing the amount of light the strobe puts out. Flash compensation tends to work best in predictable situations. As with everything discussed in this chapter, experimentation is crucial.

There is another way you can make things easier using state-of-the-art cameras. Most cameras that are designed to be used in housings today can be used manually, or they can be set to either aperture-priority or shutter-priority mode. In aperture-priority mode, you set the aperture, and the camera sets the shutter speed. In shutter-priority mode, you set the shutter speed, and the camera sets the aperture. Either mode frees you from measuring and setting the ambient exposure.

The problem with flash compensation is that it works less well when conditions change. It's best with subjects located in the center of the frame, and it does not deal well with multiple subjects moving throughout the frame. This is because the TTL sensor reads only the light reflected off the subject within the metering pattern. If you selected matrix metering, and you had many sharks in the frame, you might end up with a perfectly exposed photograph. But in matrix metering mode, and shooting just one shark in a lot of blue water, the shark would be overexposed.

Flash compensation is basically another tool that can be used effectively in underwater photography. Like other tools, it must be tested and perfected by the individual photographer. You may very well find times when, with TTL, flash compensation, and a priority-shooting mode, you can capture images not otherwise possible.

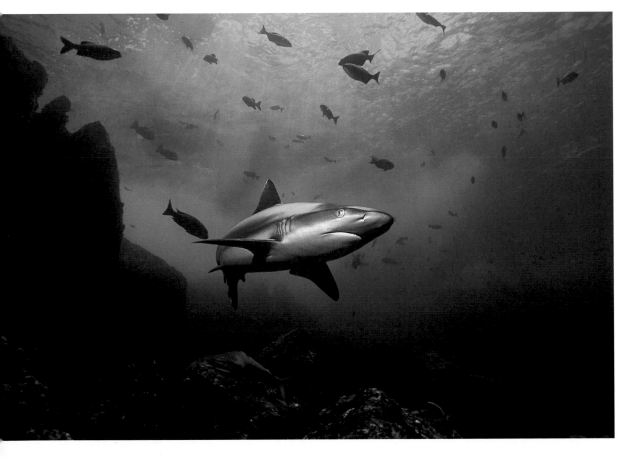

Sharks in Blue Water

Ethan Gordon

This photograph of reef sharks in the Seychelles was made using a flash compensation of -2 EV, with the camera's light-meter pattern set on center weighted and two wide-angle strobes set on TTL.

AUTOMATIC FOCUS

Another technological tool available with many ISO cameras is automatic focus. While focusing manually may not be especially difficult in most situations, there are certainly occasions in which automatic focus can make things much easier. The advantages of automatic focus under water are perhaps best demonstrated in dynamic situations, such as when you need a free hand to maintain position in strong currents or when you're bouncing around inside a shark cage. Even in controlled situations, the use of auto focus can reduce the amount of time spent you spend tweaking the focus on your subject. And time, of course, is always precious under water.

There are generally two automatic focus (AF) modes: single servo, and continuous servo. In the single servo AF mode, the camera locks in on the subject when you lightly depress the shutter release. The shutter only fires when focus is locked. Continuous servo is designed to permit constant focusing when tracking a moving object. Unlike single servo, the shutter can be released at any time, and it does not require the subject to be in sharp focus (although in theory it will be, given that the camera is continuously tracking and adjusting focus).

Although there may be occasions when you will want to use the continuous servo mode, it is best to choose single servo for most underwater subjects. The camera will fire only when it achieves focus, so using the single servo mode will result in fewer out-of-focus photographs. The speed and accuracy of the auto-focus mode will vary from manufacturer to manufacturer and from camera model to camera model. However, most systems work well with a wide range of subjects when conditions include plentiful ambient light.

Problems with automatic focus tend to occur when light levels are low, visibility is poor, or when your subjects possess little contrast. In wide-angle photography, when the camera continually "searches" for the precise focus, this is especially noticeable. It can also be extremely frustrating, for example when your subject is swimming by and you only have one shot at it before it is gone. In macro photography, however, you have less of a problem because you are working close up and the camera can easily lock in on the subject.

Another potential concern with auto-focus is the danger of locking in focus on a less important part of your subject. With wildlife photographs, it is the animal's eye that we generally try to keep sharp. Cameras and lenses do not know the difference between an eye and a dorsal fin, however, so it is critical to maintain precise composition. In single servo mode, it is possible to begin by locking in focus on an animal's eye and then recomposing the picture while keeping the shutter release lightly depressed (or by using the camera's auto-focus lock control). Either of these methods allows you to keep the eye in focus and still creatively compose the scene as you wish.

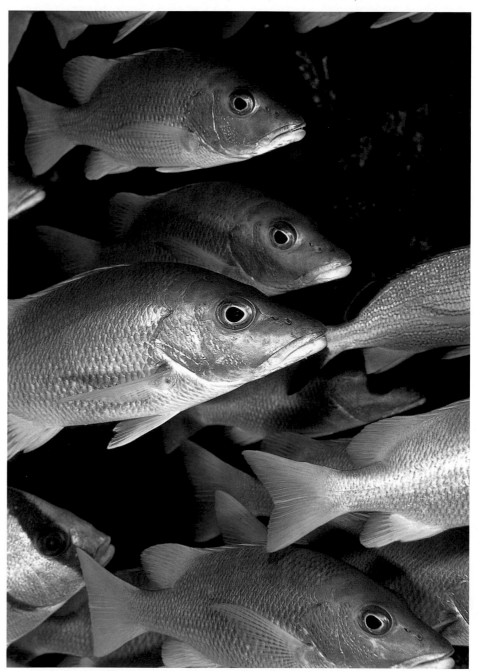

Snapper Fish in Cuba
Brian Skerry

A Nikon F5 camera with 60mm lens set on auto-focus inside a Subal Housing was used to make this photograph. Auto-focus works especially well under water when plentiful ambient light is present.

MASTERING THE FUNDAMENTALS

To make underwater photographs, we must use a variety of equipment. The equipment we use is continually evolving and improving, creating new opportunities for photographers. This technology is not magic, nor is it foolproof. Tools like TTL and auto-focus are available to photographers to free them from mechanical tasks and allow them to concentrate on other aspects of making pictures. These tools should be evaluated individually and employed when they can benefit the photographer. It would therefore be wise to examine these possibilities as well as any new technology that might give you a new view of the underwater realm.

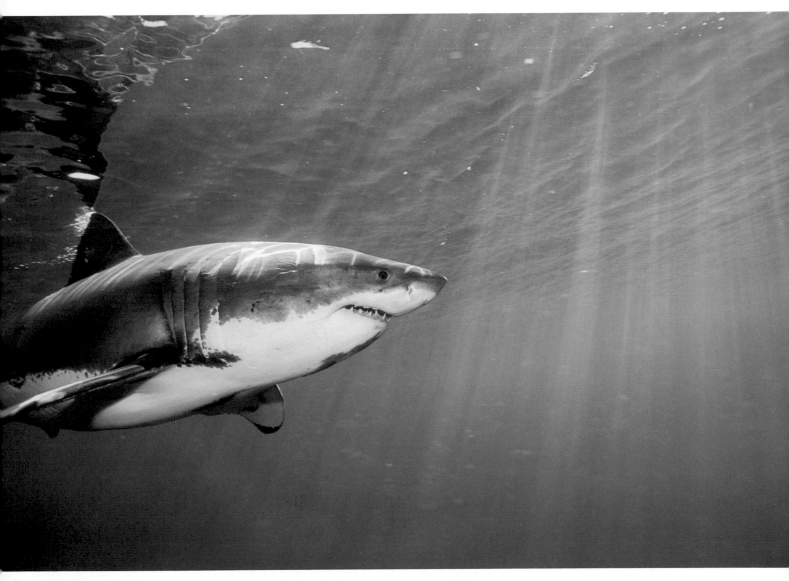

Great White Shark

Brian Skerry

Auto-focus is especially appreciated in situations like this, when you're bouncing around in the tight quarters of a shark cage with a prize-winning subject swimming nearby.

SELLING UNDERWATER PHOTOGRAPHS

T HE MOST COMPELLING REASON for taking up underwater photography is that it enhances your enjoyment of diving. After diving for a year or so, you will have seen the common underwater sights. A specific, challenging underwater activity will definitely help maintain your interest in the sport. The more you enjoy underwater photography, the more you will enjoy diving.

To become a better photographer, however, you will need to do something with your pictures. You can do lots of things, including any of the following:

- Print your photos to decorate your home.

- Develop slide shows for friends or club members. Most people on this planet will never see the world under the surface of the sea. Your photography can be of real value in giving them an appreciation of this environment.

- Collect your photographs. Instead of fish watching (collecting names of various fish in a notebook) you can collect photographs of various species of fish in your area, always trying to expand the number of species in your library.

- Sell your photographs. It is possible to make a living as an underwater photographer. But breaking into the publishing market can be difficult and frustrating. The only way to do it is to place greater importance on love diving and photography more than the idea of getting rich. It can take years before underwater photography becomes your full-time work, but those years can be some of the most enjoyable. As is so often the case, the journey is often the reward.

No matter what your motivation, you should know a few things first about selling photographs if you are going to give it a try. First on that list is the three primary reasons that publishers buy photographs.

Sea Lion in Sunlight
Howard Hall

ELEMENTS OF SUCCESS

The process of selling your underwater photographs includes several steps. You must create beautiful, compelling images that meet the needs of publishers. It's an additional bonus if you can write the article that your photographs are meant to illustrate. The following sections describe these elements in detail, and the example photographs in this section demonstrate the qualities of saleable underwater images.

SPECTACULAR PHOTOGRAPHS

One of the reasons that publishers buy photographs is that the photographs submitted are absolutely spectacular. You will not go out and make this kind of photograph every day or even every year. If you spend hundreds of hours in the water, you may occasionally get "lucky." Remember, however, that luck is a combination of opportunity and preparedness. If you do not spend those hundreds of hours in the water, then you are not likely to have the opportunity. And if you do not take your camera with you on every dive (and know how to use it), you will not be prepared when the opportunity comes along.

There are a wide variety of underwater subjects that make spectacular photographs. Generally, large marine animals are the most common subjects. Whales are about as large as marine animals get, and that makes them very marketable subjects. You will be much more successful, however, if you photograph a species that has not already been excessively photographed.

Even if you make good pictures of humpback whales, you may have a hard time selling them. Humpbacks have already been widely photographed and published. If a publisher needs a humpback whale photograph, he or she will request it from an already-established photographer. On the other hand, if you have a good underwater photograph of a much less photographed species, you might easily be able to sell it many times.

Photographing a giant marine creature may be a tough approach to the professional photographer's market. Instead, you might concentrate on animal behavior. If you can make clear photographs of animals engaged in behaviors that have not been widely photographed before, you will have something of value. Certainly, it would be most advantageous to get large animals engaged in behavior. A photograph of a sperm whale eating a giant squid would be nice. But even photographs of small

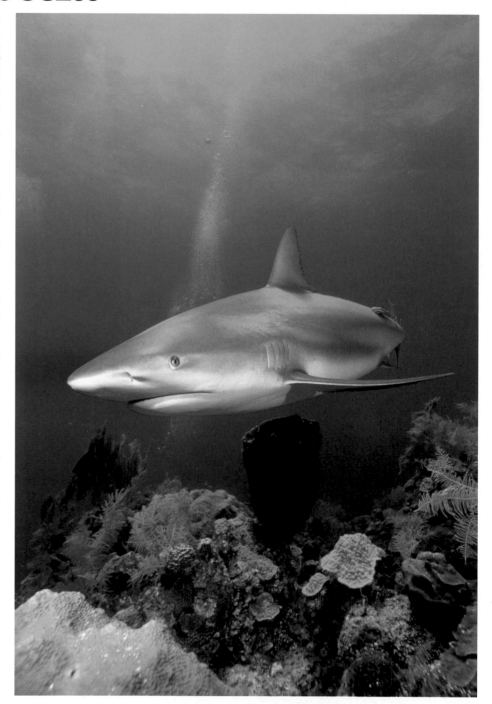

Caribbean Reef Shark, Bahamas
Brian Skerry

Sharks sell! Whether you love them or fear them (hopefully you love them) good images of these animals are always in demand.

animals doing unusual things will sell.

One such example in this chapter is a photograph of two starfish spawning (page 136). Howard made this photograph during a beach dive off the coast of San Diego, California. Although this species of starfish has been photographed thousands of times before, this photograph has been sold many times because photographs of this behavior are rare.

Another kind of spectacular photograph is one that shows a diver interacting with a marine animal. The photograph of the diver riding the manta (page 138) is a good example. Mantas have been photographed before, but the diver clinging to the creature's back gives the shot a whole new dimension. People (and publishers) identify with the diver, and therefore interest in the photograph soars. It should be noted that this photograph was made many years ago; today, riding mantas is not encouraged. Swimming alongside them, however, is just fine.

You might, of course, photograph divers feeding fish. Because this kind of photograph is relatively common, your pictures will not carry the impact of being unique. If you were to photograph a diver feeding garden eels, however, you would probably sell the pictures right away, since this has not been done before.

SPECIFIC PUBLISHER NEEDS

Your chance to photograph something spectacular will come if you dive long enough. You should not expect it to happen next week, but certainly be prepared if it does. In the meantime, keep in mind that the second reason publishers buy photographs is that they have a specific need for them at the time.

If a publisher is doing a story about starfish, and you just happen to submit good starfish

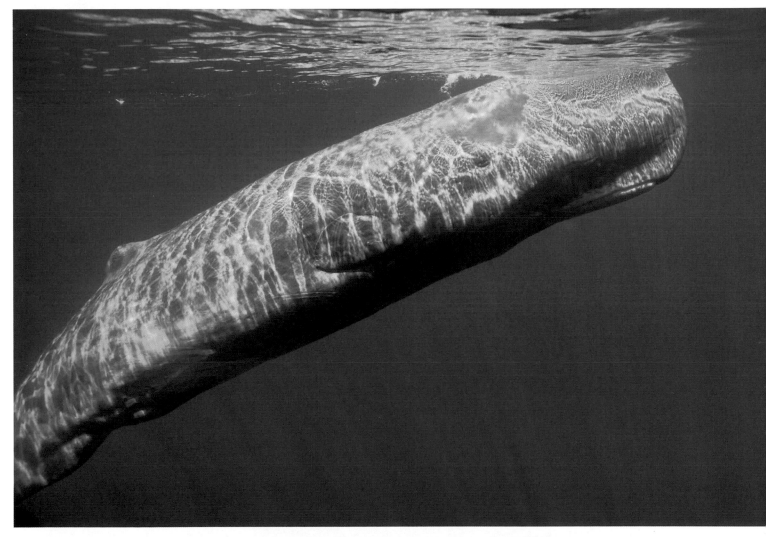

THE ROUND FILE

One of your most valuable tools in improving your photographic library is the round file, also known as the trash can. When you sort through your recently developed photographs, make certain that you would be proud to see them in print before you decide to keep them. If the photographs you take are not of publishable quality, throw them away. Photographs that are not publishable will clutter your library. If you send second-rate material to publishers, you take the chance of damaging your blossoming reputation. If your work does not measure up to the state of the art, then chuck it in the round file.

Sperm Whale
Brian Skerry

Big animals like this sperm whale make for very marketable photographs. That's due partly to public interest and partly to the fact that fewer photographers have such photos in their files.

photographs that day, you will probably sell some. Timing is important. If the publisher needed the starfish photographs last week, or won't need them again until next year, he or she will probably send them back.

You may not like it when your photographs are returned with nothing but a short rejection slip, but it is something to which you must become accustomed. Even well-known photographers see many more rejection slips than letters of acceptance. If you cannot take rejection with a smile on your face, you are headed for the wrong business.

It does, of course, help to know what a publisher will need ahead of time. You can often find this out simply by inquiring. Many magazines will not take the time to tell you what they are planning in the future, but some will. If a magazine lets you know that they are planning a story on lobsters next year, you will be in a better position to sell your photographs—assuming, of course, that you have photographs of lobsters. This is where a well-developed, carefully organized photographic library comes in handy.

If you have been taking underwater photographs for only a year or two, you usually will not have the specific photographs that the publisher requests. It takes a long time to develop a comprehensive library of underwater photographs. Developing such a library, however, is 90 percent of the fun of underwater photog-

raphy. The more you dive with your camera, the larger your library will grow. Eventually you will begin to have the material publishers come looking for.

This does not mean that you must wait several years before you take a chance at publishing your first photograph. There is something you can do while developing a library, which brings us to the third reason that publishers buy photographic material. You can create photo stories.

WRITING

If you write an article based on an interesting series of your photographs, you have a much better chance of selling your material than if you were to submit the photographs alone. Your article saves the publisher the enormous time and trouble of having to request photographs for manuscripts submitted without them. Therefore, your manuscript is considerably more appealing than one submitted by a writer who has not supplied photographs.

The photographs you submit with the article must, however, represent complete photographic coverage. Your photographs must tell a story that supports the manuscript. This is called a photo story.

If you write a story about moray eels, your photos should show as many aspects of moray life as possible. You should show morays feeding, morays mating, baby morays, morays

defending territories against natural enemies, and as many other aspects of moray life as you can capture on film. Although you should probably include a good moray portrait, by itself a good portrait will probably not be enough to make your story sell. You must approach moray eels as a photojournalist, not just a hobby photographer.

Shooting a comprehensive photo story will certainly take time, probably a lot more than one dive and perhaps more than dozens of dives. But the result will be far more valuable and marketable than a box of unrelated photographic material. Shooting underwater photo stories is also totally absorbing, a learning experience, and a whole lot of fun.

What do you do if you cannot write? Concentrate on shooting photo stories anyway. If you have completed a photo story, you should have little difficulty finding a good writer who can finish the package. Writers who are non-photographers have the same problem as photographers who are non-writers.

If you cannot find a writer to work with, then submit your photo story to a publisher by itself. If the images tell the story successfully all on their own, a publisher can always find a writer to prepare the manuscript. You will certainly have a much easier time selling a photo story than a collection of unrelated "pretty pictures."

Once you have material prepared, the next question concerns choosing a likely publisher for your work. Go to the magazine rack and look for magazines that have articles about wildlife or science. Keep in mind that publications that regularly publish underwater articles probably have established underwater contributors. Look for suitable publications that do not carry large amounts of underwater material.

What about dive magazines? Understand that major diving magazines may receive well over 100 manuscripts per month. If you put together a story that you feel can compete, then go ahead and submit it. But keep in mind that your prospects are better elsewhere.

As you compile your photo stories, your library will grow. Eventually you will begin to have the photographs that publishers request. As you spend hundreds of hours under water developing your library, sooner or later you will also stumble across that opportunity to make a really spectacular photograph that sells all by itself. The whole process simply takes lots of time and dedication.

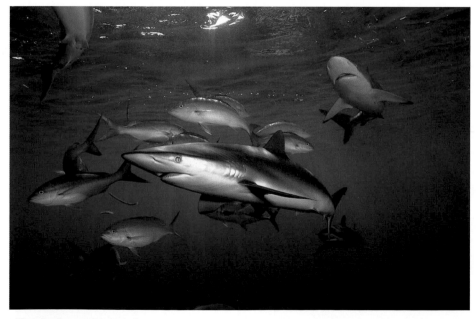

Silky Sharks on the Prowl
Brian Skerry

Dramatic light, silky sharks, and a unique location (Cuba) are all factors that helped this photo sell.

SAMPLE PUBLISHABLE PHOTOGRAPHS

These example shots exemplify the types of photos that publishers most often look for. A couple of photo stories close out the chapter, one shot by Howard Hall and one of mine.

PHOTOGRAPHING A LARGE SUBJECT

This photograph of a California gray whale was taken with a Nikonos camera, a 21mm lens, and a large wide-angle strobe. Although this was a small animal (as whales go) of only about 25 feet, it was still a very large object to photograph under water.

In addition to the usual difficulties of photographing large animals under water, visibility in the kelp bed near San Diego was only about 20 feet. This eliminated the possibility of getting a photograph of the entire animal, so I concentrated on capturing portraits of the animal's face.

Two qualities make this photograph easily marketable. First, the subject is a very large marine animal. The larger the animal, the more interest viewers seem to show in the photograph. The second quality is rarity: there aren't many underwater photographs of this animal. The combination of these two factors has helped me sell this photograph (and others taken at the same time) over and over again.

When photographing a large, fast-moving subject like this whale, you do not have time to carefully select your camera angle and position your strobes as you would if you were photographing a reef fish. It is best to have a few general ideas in mind and then quickly shoot as much film as you can before your opportunity evaporates. In this case, after attempting to photograph gray whales for months, I was able to make four dives with a relatively cooperative animal. I shot four rolls of film, concentrating on portraits of the whale's face. Of these, about half a dozen photographs turned out to be publishable.

I used the 21mm wide-angle lens to capture as much of the animal in the frame as possible from a minimum distance. The strobe was used to fill in color and definition in the face. Without the strobe, the photo would have been an unrecognizable silhouette. (The Seacor 21mm lens I used in this shot has not been available for quite some time; however, many wide-angle lenses available today would have worked just as well in making this photograph.)

Gray Whale

Howard Hall

Camera and lens: Nikonos II with Seacor 21mm lens. **Film:** Kodak Ektachrome ISO 160. **Shutter speed:** 1/60. **Subject distance:** 4 feet. **Camera angle:** slightly upward. **Strobe:** one wide-angle strobe at upper right, set on low power.

STRIKING OUT AFTER AMAZING THINGS

This image is proof that if you dive often enough, you *will* see amazing things. I made this photograph of the extremely rare oarfish in the waters off of Nassau, Bahamas. I had been photographing silky sharks when off in the distance something caught my eye. At first I thought what I was seeing was some type of large fishing lure being deployed by a sport-fishing boat above, but I could hear no boats. Curiosity got the best of me and I struck out after the silvery apparition. As I drew closer, I saw that this was a living animal drifting vertically in the water column. It was about 10 feet long, 3 to 4 inches wide, and shiny silver in color. I did not know exactly what it was, but I assumed it to be a species of deep-water fish. I also knew it had to be rare and immediately began to shoot.

I was using an Ultra-Light Pivot Tray with my housing and rotated it to the vertical position, leaving my strobes in the horizontal position. I noted my light meter reading and set my strobes accordingly. As I fired the first frame, the oarfish began to "sink" vertically, as if it was a sword dropped into the sea. I only managed three frames before it disappeared into deep water.

I learned later that this was the very first time an oarfish had ever been photographed. Since this animal was responsible for centuries of sea serpent legends (according to scientists), it made the encounter and the photograph truly unique. Because of this, I have sold this photograph (and one of the other frames) many times in countries around the world.

Although you can never predict when a moment like this will happen, exciting subjects will present themselves if you dive often. And as we have mentioned before, luck is preparedness meeting with opportunity.

Oarfish
Brian Skerry
Camera and lens: Nikon N90 with 24mm lens and +3 diopter inside Subal housing. **Film:** Kodak Lumiere. **Aperture:** f/11. **Shutter speed:** 1/125. **Subject distance:** 5 feet. **Camera angle:** slightly upward. **Strobe:** two Sea & Sea YS-300s, with left strobe on full power, right strobe on half-power.

RECORDING UNUSUAL ANIMAL BEHAVIOR

Unlike other photographs in this section, the subject here is neither large, rare, nor threatening. Nevertheless, I have repeatedly sold this photo year after year. The reason is behavior. This photo shows natural wildlife behavior, and behavior sells.

You may have the most beautiful photograph of a starfish that a publisher has ever seen, but a good photo showing starfish behavior is worth ten of the pretty shots. Photographs demonstrating animal behavior give the publishers something to write about in the text or the captions, and they provide interest for the readers. Behavioral photographs have something to say.

This photo of two blood sea stars was taken near San Diego, California, in La Jolla Cove, the area's most commonly dived spot. The starfish are engaged in what is probably spawning behavior, although some authorities suggest that they may be filter-feeding instead.

The photograph was taken with a housed Nikon camera and a 55mm lens. I used two small strobes to evenly light the subjects.

Taking behavioral photographs like this one does not require travel to exotic diving sites or super-sophisticated equipment (this photo could have been made with an extension tube). What it does require is enormous amounts of underwater time and considerable determination. Purposefully spending hundreds of hours under water studying wildlife is one of underwater photography's greatest rewards. Hopefully, this will be reward enough, since years may go by before you begin selling your photographs. But if you put in the time, opportunities will occasionally present themselves. Behavioral photographs sell because they are unusual and interesting, whether the subjects are manta rays or blennys.

Spawning Starfish
Howard Hall
Camera and lens: Nikon F2 with 55mm lens inside a housing. **Film:** Kodachrome 64. **Aperture:** f/11. **Shutter speed:** 1/60. **Subject distance:** 1 foot. **Camera angle:** slightly upward. **Strobe:** two small strobes positioned above and at 45-degree angles to either side of the subject.

CAPTURING ANIMALS IN HUMAN POSES

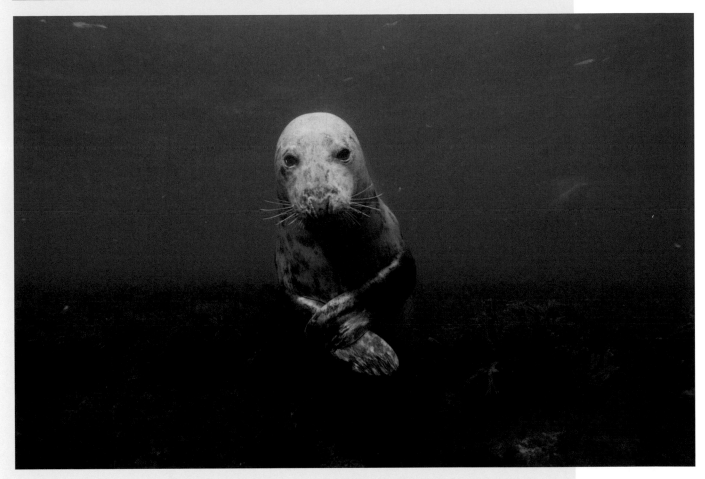

Gray Seal

Brian Skerry

Camera and lens: Nikon F3 with 20mm lens inside Aquatica housing. **Film:** Kodachrome 64. **Aperture:** ƒ/5.6. **Shutter speed:** 1/60. **Subject distance:** 5 feet. **Camera angle:** slightly upward. **Strobe:** two Sea & Sea YS-200s on full power.

Other wildlife photographs that sell are those that are anthropomorphic. Capturing animals in human poses always makes for a real winner. This is especially true when the animal is a marine mammal like this gray seal that I photographed in the Gulf of Maine.

I had situated myself in an area just offshore from where a large colony of seals was sunning. Wearing a drysuit and a set of double tanks, I patiently waited in the chilly water for seals to find me. Within a few moments of my arrival, the seals came cruising by. They tended to be curious but still kept their distance. Although I could see them, it was quite some time before any of them approached close enough to be photographed.

Eventually these playful animals worked up their courage and approached closer, but they mostly did so from behind me. Every so often I could feel one tugging on my fins with his mouth. Whenever I turned around, however, the seal would swim off. This game continued for some time when I noticed one seal swimming towards me from the front. He made a couple of slow passes at a close distance, allowing me some great photo opportunities. He then swam to within a few feet and stopped near the bottom. The front half of his body slowly floated up and he crossed his flippers in front of him. I fired the shutter and in that instant, he swam away. I only managed the one frame.

I was using a wide-angle lens inside a housing and two wide-angle strobes. I had been regularly metering the ambient light and adjusting my settings accordingly. When the moment occurred, I was ready.

I wound up spending about five hours in the water on the day that this photograph was made. This shot was made closer to the end of that five-hour stint. As most wildlife photographers will attest, patience is crucial for capturing great images. Rarely do magic moments happen the minute you arrive on the scene.

PROVIDING HUMAN INTEREST WITH A SENSATIONAL SUBJECT

This is one of the most valuable photographs I have ever taken. It shows a diver and a manta ray. The manta provides a sensational subject, and the diver provides human interest.

It is the activity in which the diver (Gordy Waterman) is engaged that makes this photograph especially spectacular. Not only is he riding on the manta's back, but he is also using the large remoras as handlebars! This gives the photograph enormous human-interest value. You cannot help but be empathetic with the diver and wonder what such an experience must have been like.

Technically, this photograph is far from perfect. The original is underexposed (resulting in considerable loss of quality when reproduced) and it is not quite sharp. Nevertheless, the subject value is so high that it has sold time and time again—alone, or as the climax to photo stories about mantas or manta riding.

I took the photograph with the Nikonos and 15mm lens, and I used a wide-angle strobe to enhance colors and definition. I was able to take only two photos before I ran out of air, and this was the better of the two.

Diver on Manta Ray

Howard Hall

Camera and lens: Nikonos III with 15mm lens. **Film:** Kodachrome 64. **Aperture:** *f*/4. **Shutter speed:** 1/60. **Subject distance:** 15 feet. **Camera angle:** 45 degrees downward. **Strobe:** one wide-angle strobe set on medium power.

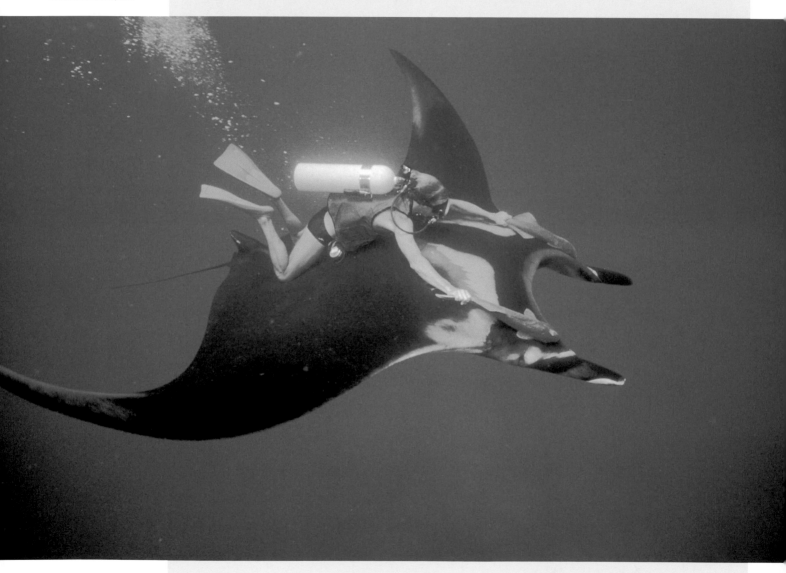

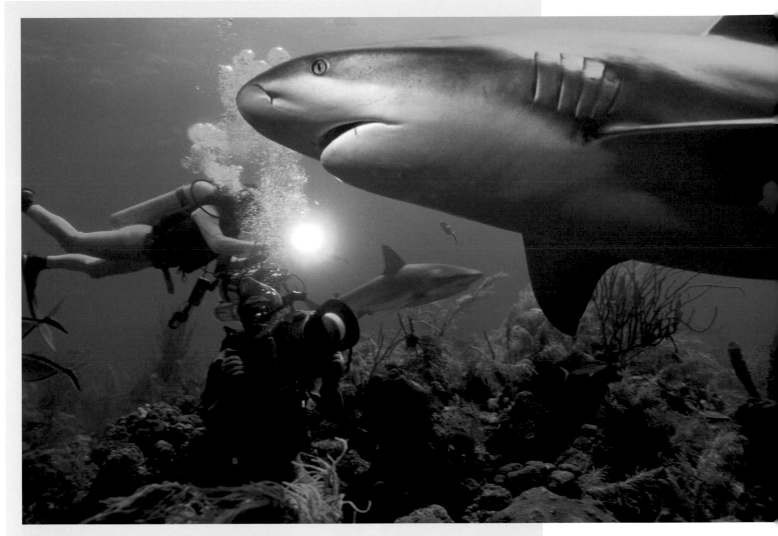

ADDING AN ELEMENT OF DANGER

I made this photograph in the Bahamas while working on a television documentary about sharks. I was shooting stills of filmmaker Nick Caloyianis, who was filming the sharks with a movie camera. My goal was to capture the action of this type of film shoot, and I therefore needed to have both divers and sharks in the frame.

I picked a spot to kneel that allowed me to frame the divers. I then simply waited for sharks to swim into the frame. Two key elements add to the value of this photograph. The first is the shark in the foreground. The viewer's eye is immediately drawn to this subject. The HMI light being held by the lighting assistant adds a second key point of interest. The light brings the viewer from the shark to the divers, therefore adding the element of danger (or at least perceived danger). Without the light, the photo would have less impact.

I metered the background water and set my aperture, and then adjusted my strobes to light the sharks that were swimming close to me. The 20mm lens I was using had great depth of field; however, the shark in the foreground is not tack sharp. Still, the photo works and I have sold it numerous times. It is valuable whenever stories of people diving with sharks are being published.

Filming Reef Sharks

Brian Skerry
Camera and lens: Nikon N90 with 20mm lens inside Subal housing.
Film: Kodak E100 SW. **Aperture:** *f*/8. **Shutter speed:** 1/60.
Subject distance: about 2 feet from the shark, about 8 feet from the divers. **Camera angle:** slightly upward. **Strobe:** two Sea & Sea YS-300s on half-power.

PHOTO STORY: SQUID

Howard Hall

The following photographs comprise a photo story about squid as it might appear in a magazine.

1. Three squid involved in a frenzied mating behavior.

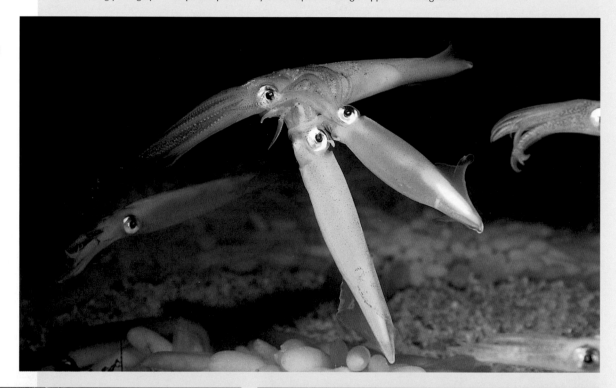

2. A female squid plants her egg casing in the sand among countless other casings just like it.

3. Each egg case holds over a hundred baby squid.

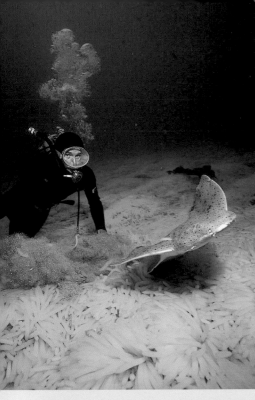

4. Dr. William Long discovers an angel shark among the squid eggs.

5. An angel shark feeding on a squid.

6. A blue shark eats its way through the giant schools of mating squid. (It is this dramatic photograph that would sell the package to publishers.)

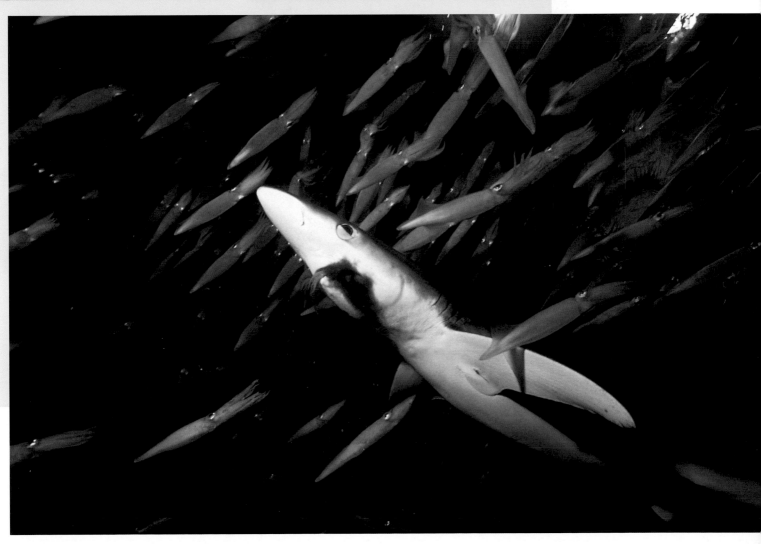

PHOTO STORY: PIRATE SHIPWRECK

Brian Skerry

The following photographs comprise a photo story about the archaeological excavation of a pirate shipwreck. Note how the use of surface photos helps tell the story.

1. Diver Chris McCourt dressing in drysuit and full face mask with communications.

2. Diver using underwater metal detector to locate artifacts.

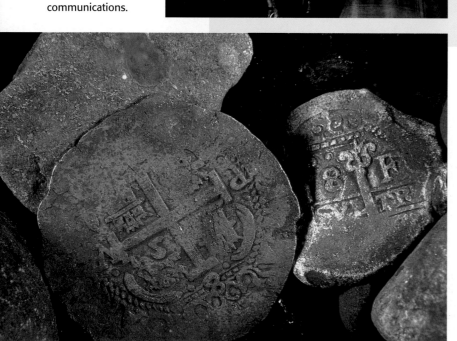

3. Spanish pieces of eight (antique coins) discovered along cobblestone bottom.

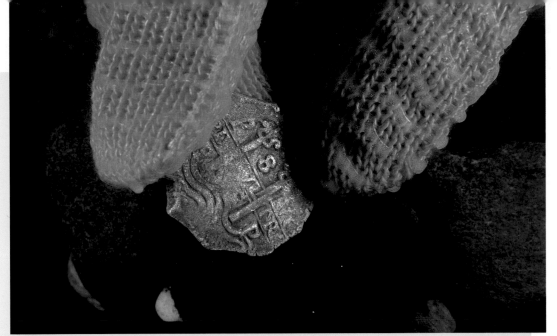

4. Diver's hand (wearing yellow glove) extracting a coin from the bottom.

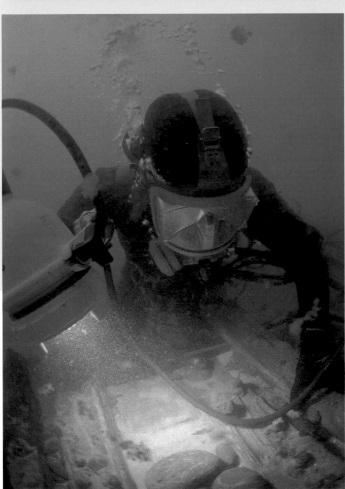

5. Diver examining section of wooden ship's hull.

6. Archaeologist Catherine Harker examining stone grinding wheel recovered from wreck site.

INDEX

Actionfinder, 38–39
Anthropomorphic images, 137
Aperture, 18, 24
Aperture priority mode, 127
Automatic focus, 87, 106,
 128–129
Available light, underwater
 qualities of, 28–29, 49
Available light photographs
 of shipwrecks, 106–107, 109
 techniques, 50–57

Backscatter, 32, 33, 70, 87, 107,
 110
Balancing exposures, 30, 81–82,
 107, 118
Batteries, 44
Behavioral photographs, 84, 136
Black-and-white film, 114
Black background, 75, 76
Blue background, 70
Body position
 in animal portraits, 90
 of divers, 99, 100
Bracketing exposure, 69–70, 127

Camera angle, 54, 55, 56, 57,
 62, 90
Cameras
 amphibious models, 36
 digital, 46
 housing ports, 28, 82
 housings, 38–39
 light meters, 19
 shutter speed, 17
 SLR, 80
Center-weighted metering, 19,
 124
Close-focus wide-angle (CFWA)
 photographs, 11, 40,
 116–121, 125
Close-up lens, 28, 118
Color absorption
 imbalance problem, 29
 strobe light and, 30, 31
 subject-to camera distance, 29,
 32, 51–52
Color contrast, 50, 70
Color-correction filter, 30, 32, 99
Color film, 16
Composition
 camera angle and, 54, 55, 56,
 57, 62
 horizontal/vertical format, 53,

74, 76
 natural, 65
 negative space and, 52, 53, 56,
 57, 70, 73, 98–99, 118
 people in, 98
 separation of subject, 51, 53,
 55, 56, 57, 70, 85
 subject size, 70
Connectors, strobe, 44–45
Contrast
 color, 50, 70
 shade, 50, 54, 63
Depth of field, 24, 117
Diffusers, 42
Digital photography, 46
Diopter, 28, 118
Diver photographs, 28, 96–103,
 108, 118
Diving techniques, 33
Dome ports, 28, 82, 106, 118

Exposure
 balancing, 81–82, 98, 107,
 118
 extension tube photographs,
 69–70, 72, 74
 factors in, 16–18
 reflex macro photographs, 81
 silhouette photographs, 60, 62
 TTL, 84, 123–127
Extension tube, 68
Extension tube photographs,
 66–77

Facial expression, in animal
 portraits, 94
Fill lighting, 30, 81–82, 91
Film, 16, 114
Film speed, 16, 124–125, 127
Filters, color correction, 30, 32,
 99
Flash. See Strobes
Flat ports, 28, 82
Focus, 22, 28
 automatic, 87, 106, 128–129
Focusing scales, 106
Framing the subject, 70, 83
f-stop, 18, 21, 127

Horizontal format, 53, 74, 76
Housing ports, 28, 82
Housings, underwater, 38–39

Image size, 28

ISO rating, 16

Lanyards, 106
Lens
 close-up, 28, 118
 focus settings, 24
 selecting, 25, 40, 52
 See also Wide-angle lens
Lens angle, 25
Lens shades, 106
Light. See Available light; Strobes
Light meter, 19, 99, 100, 124

Macro lens, 40
Macro photographs
 in available light, 52
 dome v. flat ports, 28
 extension tube, 66–77
 lenses, 40
 reflex, 78–87
 of shipwrecks, 108, 112
 TTL exposure, 124–125
Matrix metering, 19, 124

Negative space, 52, 53, 56, 57,
 70, 73, 98- 99, 118
Nikonos cameras, 36

People photographs, 28, 96–103,
 108, 118
Photo stories, 134, 140–145
Portrait (animal) photographs,
 88–95
Primary source lighting, 30
Publishable photographs,
 130–143

Reflex macro photographs, 78–87
Refraction, 28
Round file, 133

Saleable photographs, 130–143
Scatter, 28–29, 51
Sea & Sea cameras, 36
Separation of subject, 51, 55, 56,
 57, 70, 85
Shade contrast, 50, 54, 63
Shipwreck photographs,
 104–115, 142–143
Shutter priority mode, 127
Shutter speed, 17, 18, 127
Silhouette photographs, 58–65,
 115
Skin tones, divers', 99, 100

Slave strobe, 44, 100
Spot metering, 19, 124
Strobes
 arms, 45, 82
 backscatter and, 32, 33, 107,
 110
 color absorption and, 30, 31
 connectors, 44–45
 in extension tube photographs,
 30, 69, 71, 72, 76, 77
 freezing motion, 17
 guide numbers, 21
 multiple, 32, 71, 72, 76, 77
 placement of, 32, 71, 82, 91
 in portrait photographs, 90–91
 power supply, 44
 in reflex macro photographs,
 80–81
 in shipwreck photographs,
 107, 111
 slave, 44, 100
 small, 44, 71, 80, 118
 TTL exposure, 123–127
 wide-angle, 42, 44, 80, 98, 99,
 100, 107, 118
Subject size, 70
Subject-to-camera distance, 29,
 32, 51–52, 62, 119
Sun, position of, 51, 53, 54, 57,
 64, 73
Sunburst effect, in silhouettes, 60

TTL exposure, 84, 123–127

Vertical format, 53, 55, 74, 76
Virtual image, 28

Wide-angle lens
 in available light photographs,
 52
 close-focus wide-angle (CFWA)
 technique, 11, 40,
 116–121, 125
 in diver photographs, 99
 focusing, 28, 118
 scatter and, 29
 selecting, 25, 40
 in shipwreck photographs, 106
 TTL exposure, 125, 127
Wide-angle strobe, 42, 44, 80,
 98, 99, 100, 107, 118

Zoom lens, 40